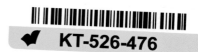

Chair of the 2015 Jury
Michele McNally

2014 was an unrelenting news year. It brought us conflicts in Ukraine and Gaza, the dissolution of the Arab Spring, and an Ebola epidemic. Syria continued on a course of demolition, as the group that calls itself Islamic State went on with its brutal campaign. Photographers around the world bravely navigated these treacherous and dangerous situations, and provided images of places most of us would never see. These historic events are well represented in the winning images.

This year, World Press Photo received 97,912 pictures. Specialized juries for documentary, nature, news, portraits, and sports, reduced that to a manageable number for the general jury to judge. The general jury members came together, face-to-face in Amsterdam, to view the selection, and to engage in the most thoughtful, high-caliber, respectful discussions. It was a very diverse group, but the members gelled, the conversations were persuasive, and minds changed. Everyone's opinion was carefully heard and considered, and together we reached consensus.

The World Press Photo of the Year is an intimate look at a gay couple in St Petersburg, Russia. It is gentle and aesthetic, yet it makes an impact and is memorable. This kind of storytelling imagery takes patience. Sharing as intimate a moment as this requires trust. Navigating such a situation can also be very complex and difficult, when the people portrayed are harassed and persecuted for the love they share. This is something that affects millions of men and women in myriad countries—even those we consider modern and advanced, as recent events have shown. Sexual minorities are being discriminated against, both legally and socially, not only in Russia, but across the world. The picture is a powerful one, but its power lies in its subtlety. It is universally human. It is emotional. It has impact. It starts a dialogue.

When the winning image was unveiled, many tears flowed. If a picture can make people cry, it is extraordinary. This image can do that, and that is as good as it gets.

Michele McNally
New York, NY, USA

World Press Photo of The Year 2014
Mads Nissen

Denmark, Scanpix/Panos Pictures

Jon and Alex, a gay couple, share an intimate moment at Alex's home, a small apartment in St Petersburg, Russia. Life for lesbian, gay, bisexual and transgender (LGBT) people is becoming increasingly difficult in Russia. Sexual minorities face legal and social discrimination, harassment, and even violent hate-crime attacks from conservative religious and nationalistic groups. →

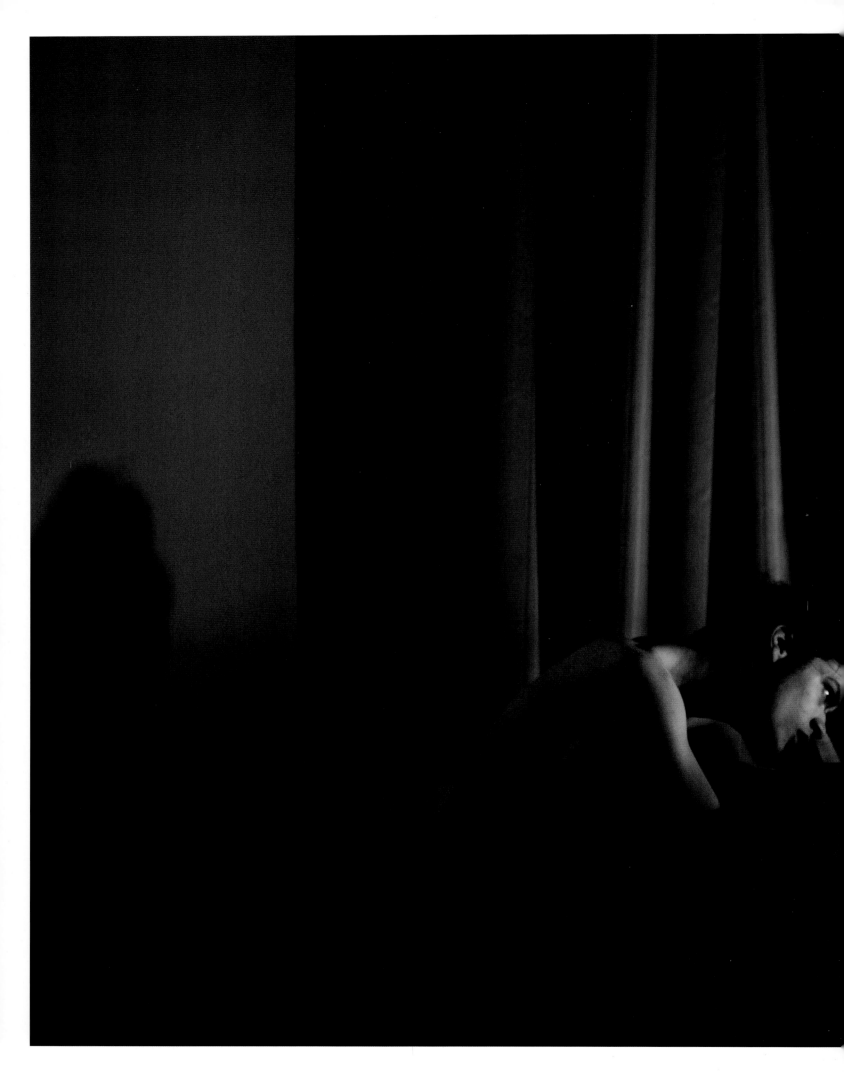

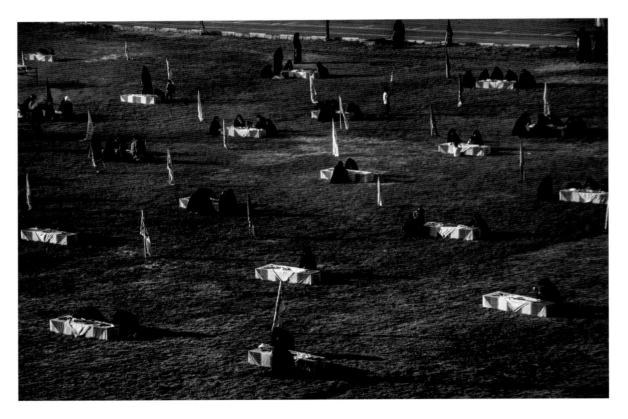

The Iran-Iraq War (1980-88) was one of the bloodiest conflicts of the 20th century. More than 10,000 Iranians were reported missing in action in Iraq. Bodies are still being discovered and repatriated. Top: Anbar Jaberi, who has waited 23 years for news of her son, weeps over his old clothes. Below: Mothers welcome bodies returned to Iran in 2013.

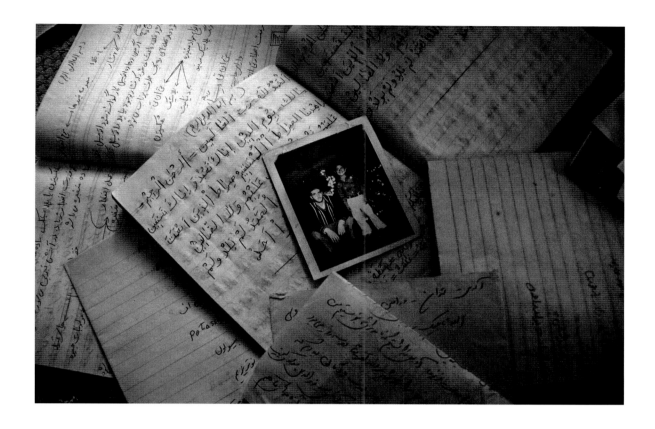

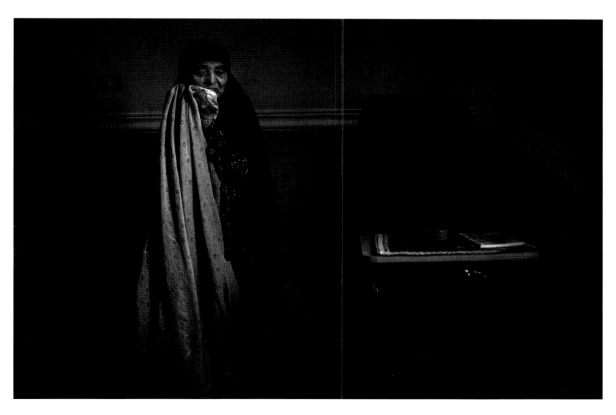

Many mothers of missing soldiers live in hope of seeing their sons again or finally having a body that they may bury. Top: Notes and photos belonging to Mohammad Tajik, killed when he was 18. Below: Shirin Fahimi (75), the mother of Safdar Fahimi, killed aged 21, has been waiting 27 years to recover her son's body.

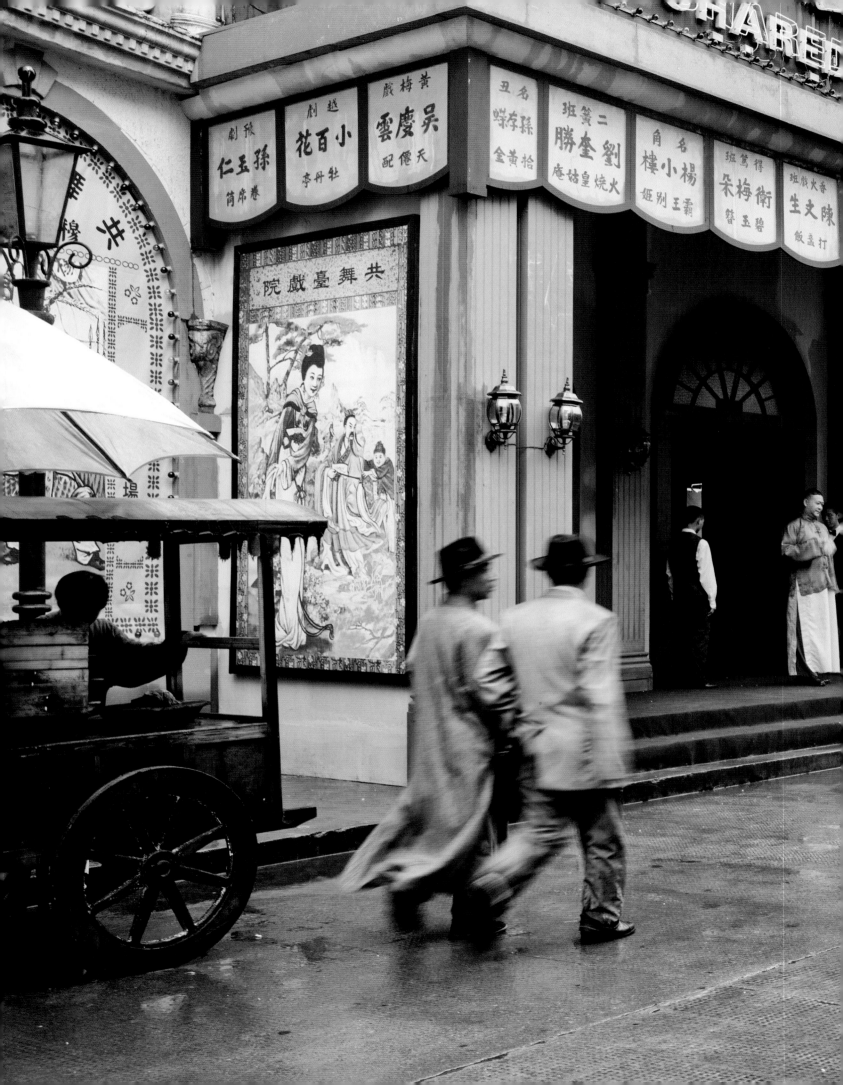

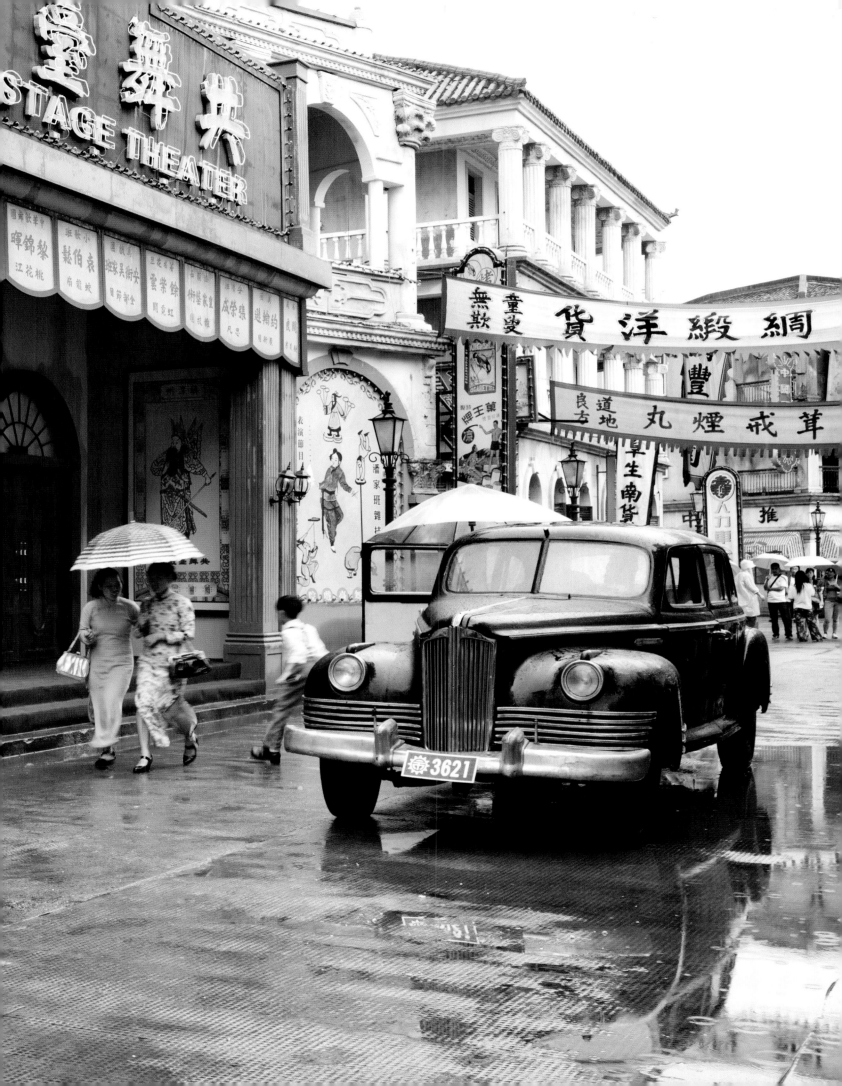

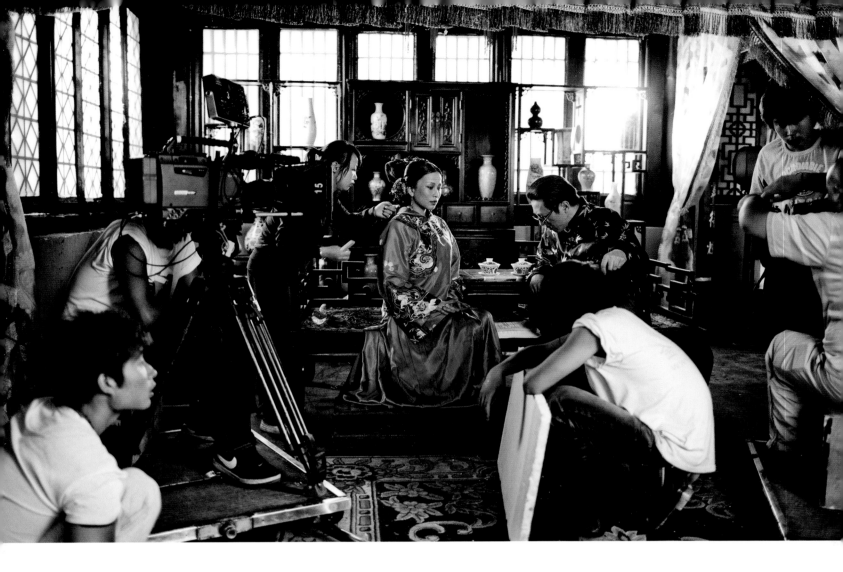

The Chinese film industry is booming, and China already forms Hollywood's largest export market. The Chinese Ministry of Culture and rich local investors see the industry as an instrument of soft power. Films made in China can shape how the country is viewed abroad, as well as uphold traditional values at home. For its part, and in order to circumvent restrictions in China that permit the screening of only 34 foreign films annually, Hollywood has embarked on major co-productions with Chinese studios. In these films, additional charac- ters may be introduced, and scenes tailored, to meet the tastes and censorship requirements of the Chinese market. Previous spread: A period street scene is shot at Hengdian World Studios. The studio is the largest in Asia, and features a 1:1 scale repro- duction of the Forbidden City. Above: A scene for a TV series is shot at Hengdian World Studios. Facing page, top: On the set of one of the year's major co-productions, a sci-fi movie by Chinese director Lu Chuan. Below: People watch a 3-D movie at the Wanda International Cineplex, in Beijing.

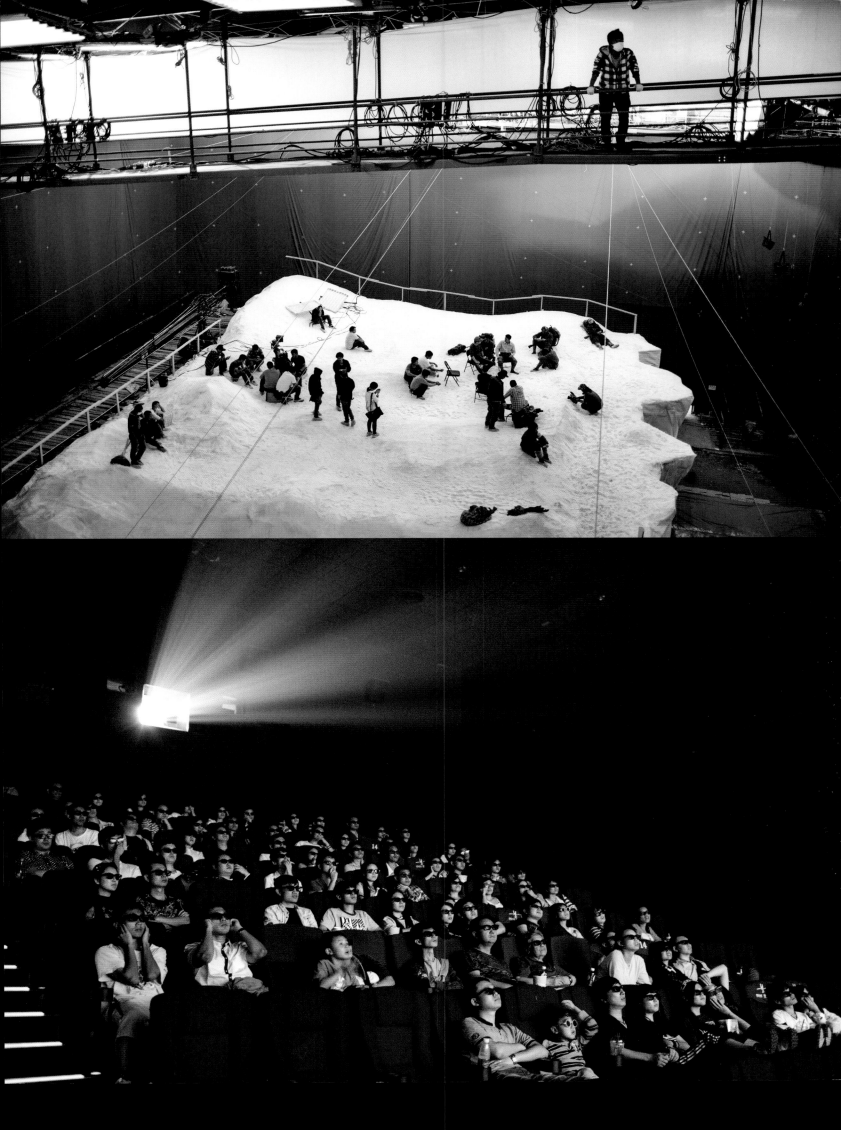

CONTEMPORARY ISSUES / 2nd Prize Stories

Since 2002, the US has used unmanned aerial vehicles (UAVs, or drones) to collect intelligence and carry out airstrikes in Pakistan, Yemen and Somalia. The aircraft are guided via satellite by distant operators. The attacks have resulted in a large number of fatalities, including hundreds of civilians. The photographer bought a small drone, fitted it with a camera, and flew it in the US over the sorts of gatherings that have become habitual targets for airstrikes abroad—weddings, funerals, groups of people praying or exercising. He also used it to photograph settings in which drones are used to less lethal effect, such as oil fields, prisons, and the US-Mexico border. Facing page: A wedding in central Philadelphia. In December 2013, fire from a US drone reportedly struck a wedding in Rada, central Yemen, killing 14 people and injuring 22. (continues)

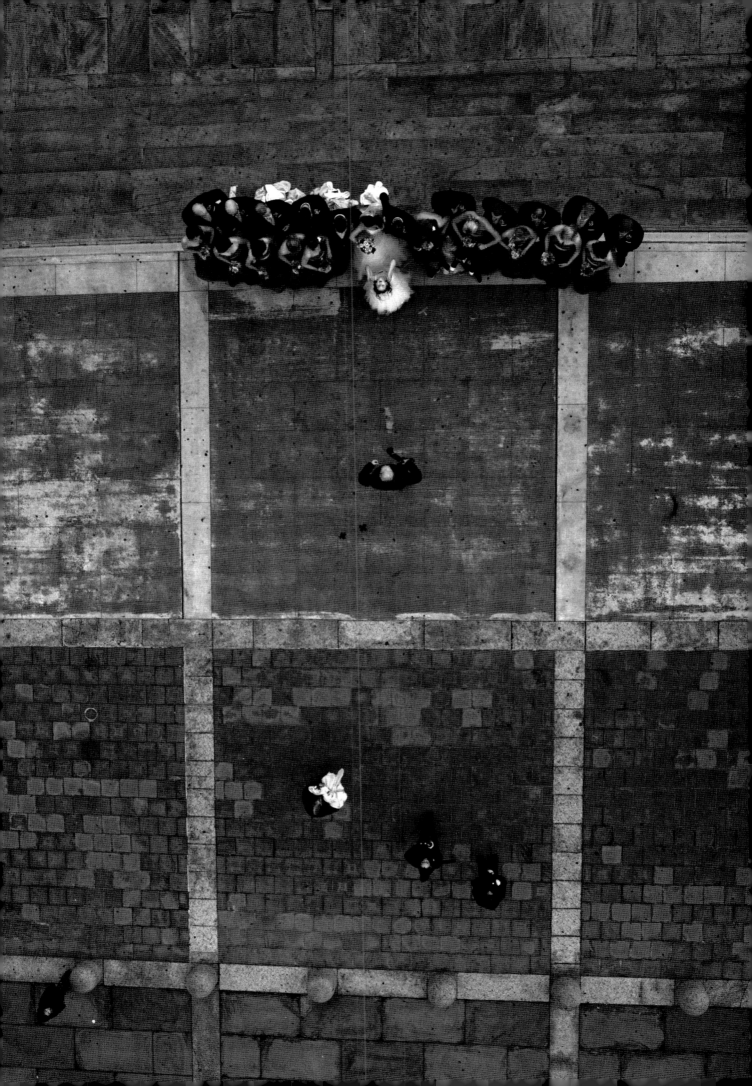

(continued) People exercise in a public park in San Francisco, viewed from a drone. California is a major center for the development and manufacture of military UAVs. (continues)

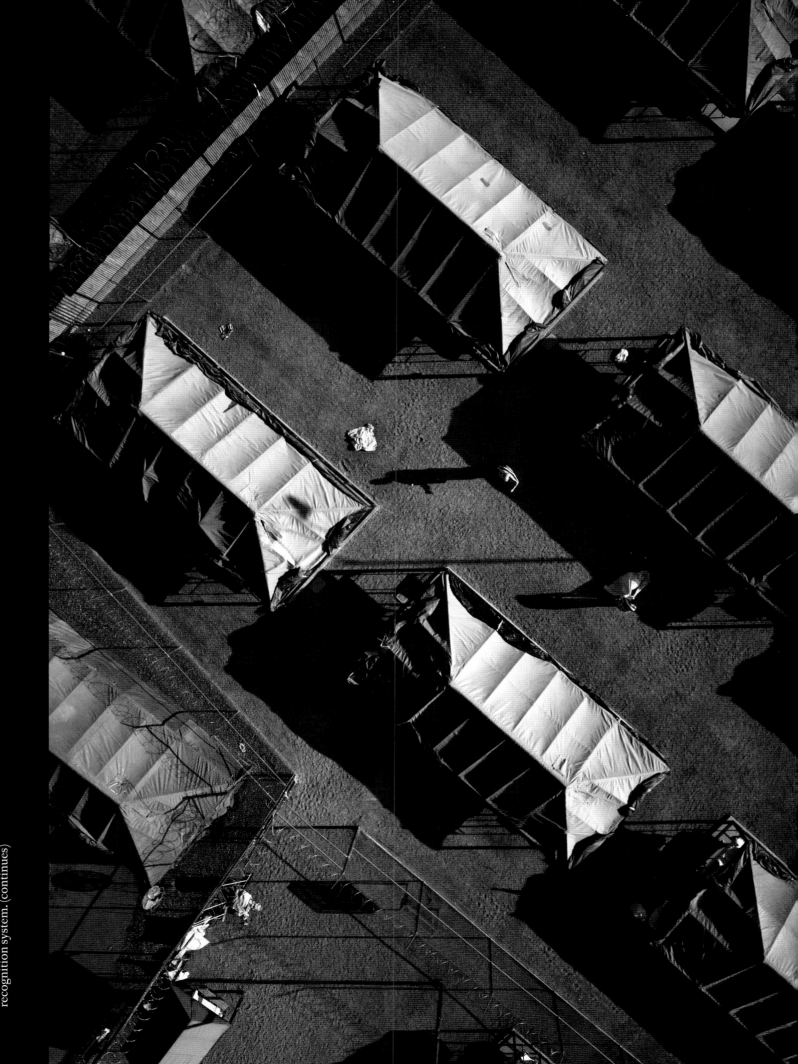

(continued) Tent City Jail in Maricopa County, Arizona. Sheriff Joe Arpaio announced plans to purchase two surveillance drones for a facility already equipped with perimeter stun fences, watchtowers, and a facial recognition system. (continues)

(continued) Students in a courtyard in El Dorado County, California, viewed from a drone. In 2006, a drone strike on a religious school in the village of Chenegai, Pakistan, reportedly killed up to 69 children. (continues)

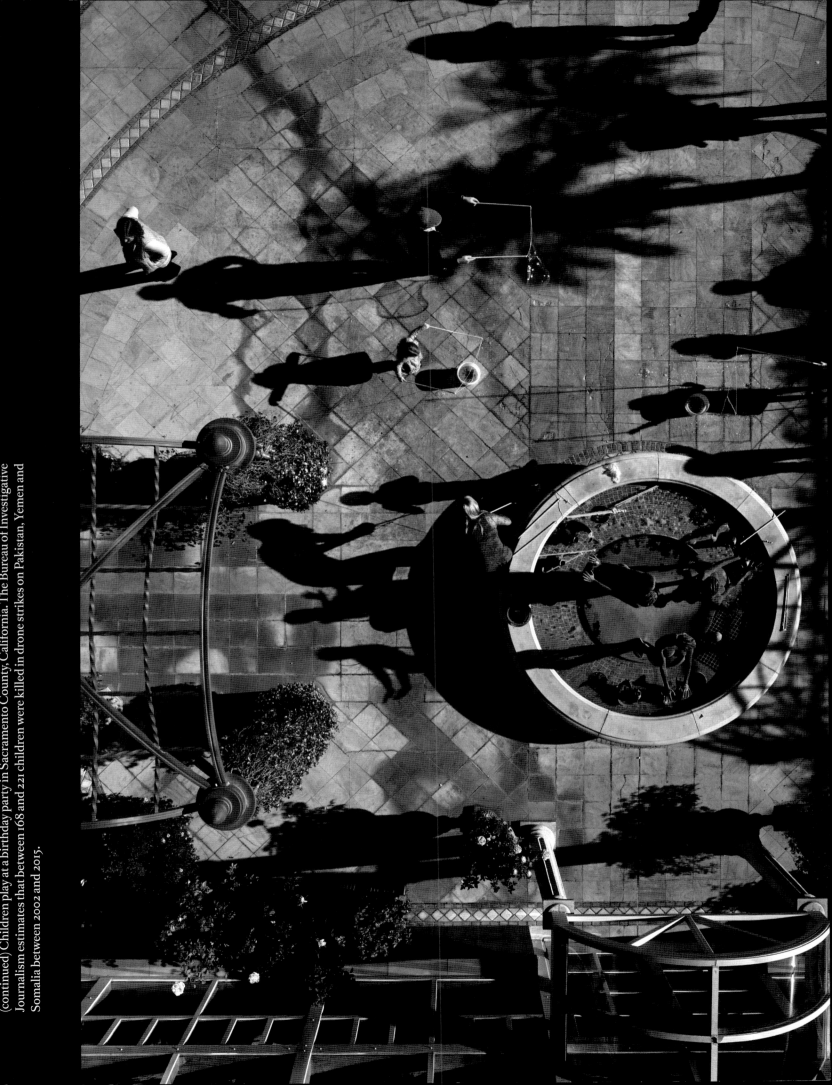

(continued) Children play at a birthday party in Sacramento County, California. The Bureau of Investigative Journalism estimates that between 168 and 221 children were killed in drone strikes on Pakistan, Yemen and Somalia between 2002 and 2015.

Shinta Ratri (center) sits among pupils at Pesantren Waria Al Fatah, a religious school for transgender people, in Kotagede, Yogyakarta, on the southern coast of Java, Indonesia. *Waria* is a combination of *wanita*, the Indonesian word for 'woman', and *pria*, the word for 'man', and is often used to describe transgender women. *Waria* in Indonesia generally live in isolated communities and suffer a degree of marginalization and discrimination.

The *pesantren* is located in Shinta Ratri's family home, and is the only school specifically for *waria* in the country. It offers students subjects such as Islamic and transgender studies, Koran reading, and lessons in prayer, and receives support from the University of Jepara, one of many educational establishments set up by a traditionalist Sunni Islam group that runs religious schools throughout the country.

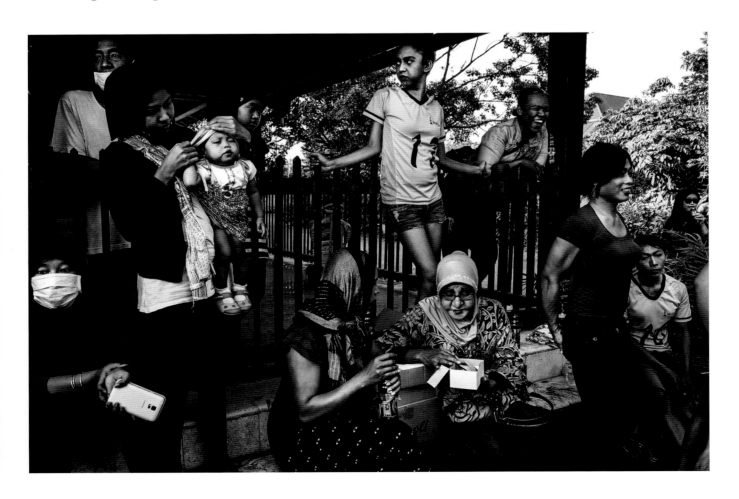

Fulvio Bugani / Italy

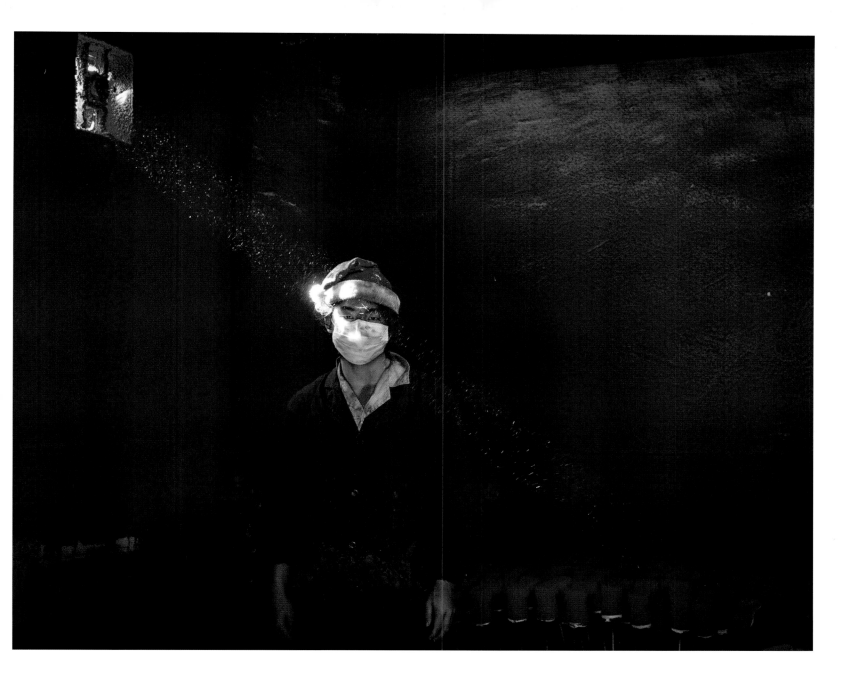

Wei (19) works in a factory in Yiwu, eastern China, coating polystyrene snow-flakes with red powder. He wears a Christmas hat to protect his hair, and goes through at least six face masks a day. According to the Chinese government press agency, 600 factories in Yiwu produce around 60 percent of the world's Christmas decorations. The factories are staffed largely by migrant laborers, who work 12-hour days for between 270 and 400 euros a month. Wei, who comes from rural Guizhou, 1,500 kilometers away, is not entirely sure what Christmas is, but thinks that it is a foreigners' form of Chinese New Year.

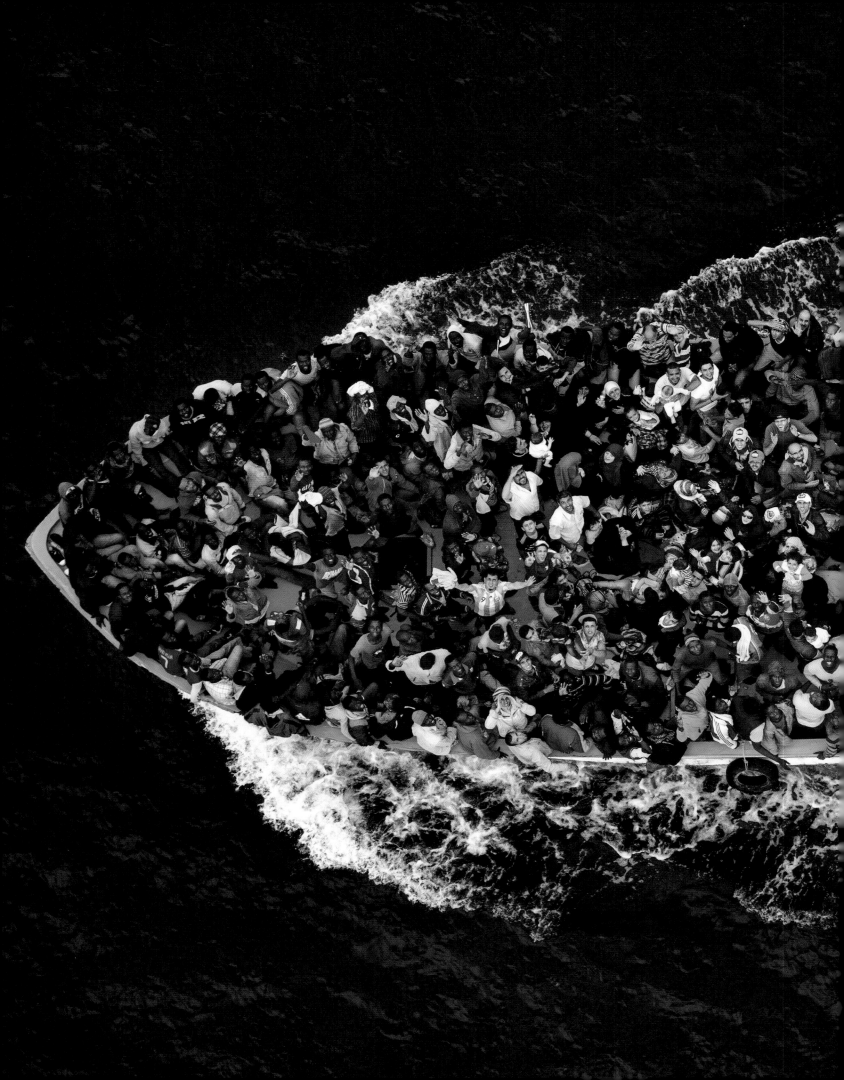

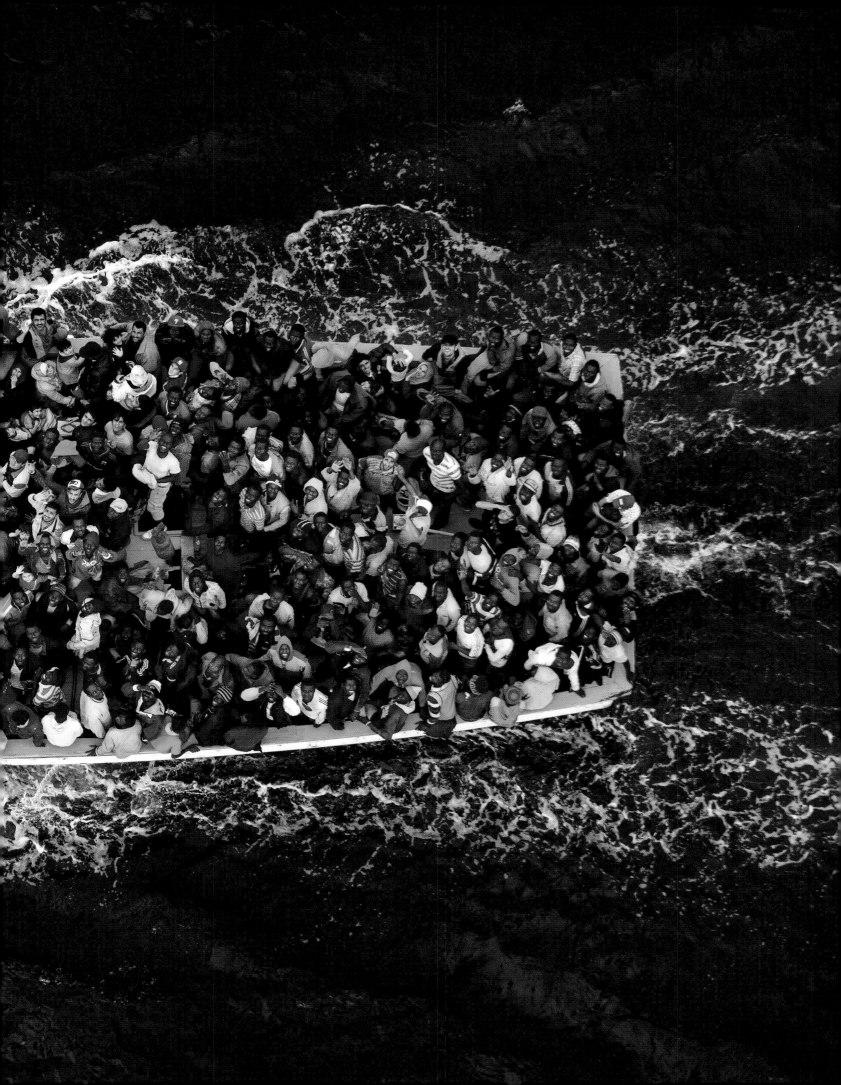

← Refugees crowd on board a boat some 25 kilometers from the Libyan coast, prior to being rescued by an Italian naval frigate working as part of Operation Mare Nostrum (OMN). The search-and-rescue operation was put in place by the Italian government, in response to the drowning of hundreds of migrants off the island of Lampedusa at the end of 2013. The numbers of people risking their lives to cross the Mediterranean Sea rose sharply in 2014, as a result of conflicts or persecution in Syria, the Horn of Africa, and other sub-Saharan countries. OMN involved the Italian Red Cross, Save the Children, and other NGOs in an effort not only to rescue lives, but to provide medical help, counseling, and cultural support. Naval officers were also empowered to arrest human traffickers and seize their ships. In its one year of operation, OMN brought 330 smugglers to justice, and saved more than 150,000 people, at least a quarter of which were refugees from Syria. The operation was disbanded in October, and replaced by Triton, an operation conducted by the EU border agency Frontex, focusing more on surveillance than rescue.

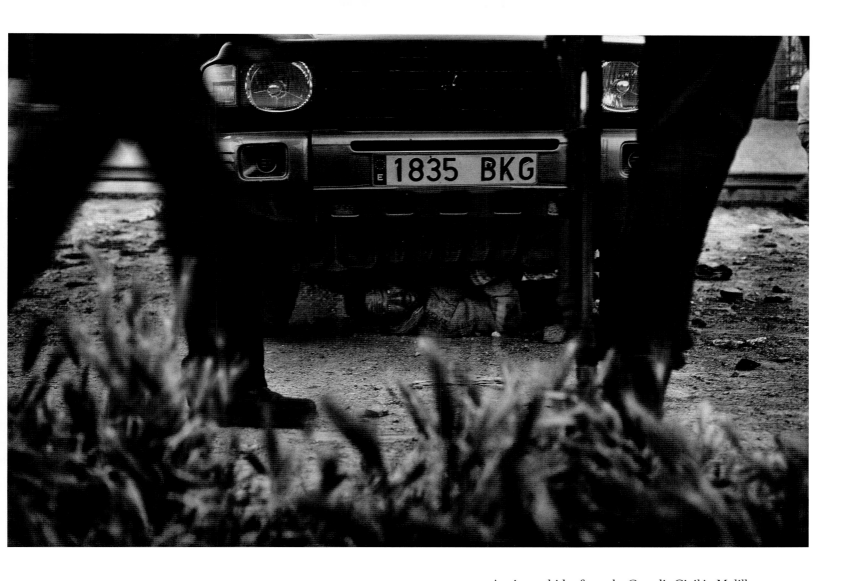

A migrant hides from the Guardia Civil in Melilla, an enclave of Spanish territory in North Africa. Three six-meter-high fences separate Melilla from Morocco, yet for decades people seeking a better life in Europe have attempted to scale the fences and reach Spanish soil. Some 6,000 such crossings were reported in Melilla and its sister enclave, Ceuta, in 2014. Very few migrants are granted political asylum; those who are not are taken to the mainland and handed an order to leave, but most cannot be deported as Spain does not have relevant treaties with their countries of origin. The man hiding beneath the vehicle managed in this instance to avoid capture.

Gianfranco Tripodo / Italy, Contrasto

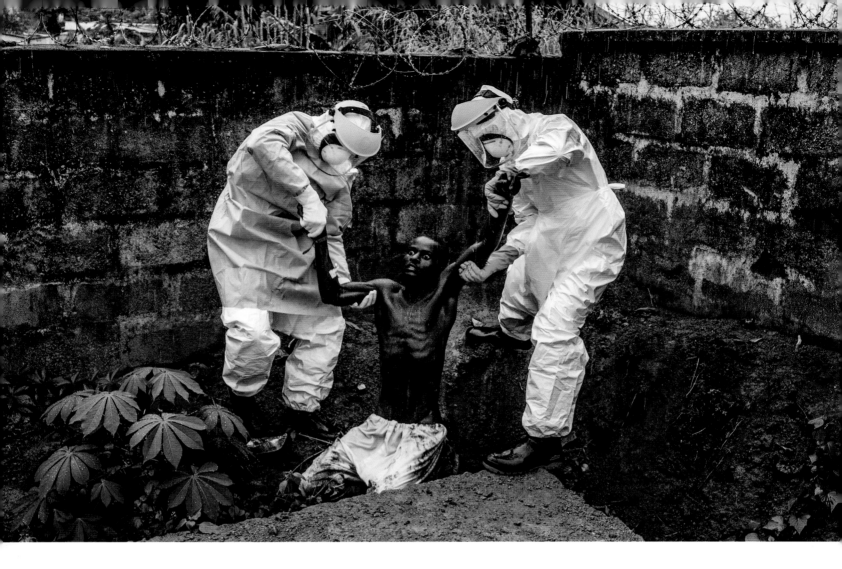

The first cases of a new outbreak of the deadly Ebola virus in Sierra Leone were reported in May. There is no cure for Ebola, and the fatality rate can be as high as 90 percent. The virus causes high fever, vomiting, and diarrhea, as well as internal and external bleeding. It is highly contagious, being passed on by sweat, blood and other bodily fluids. Extreme care has to be taken to avoid infection while treating patients, and in burying victims. The healthcare system in Sierra Leone, one of the world's poorest countries, was not equipped to cope with the disease, and assistance from foreign NGOs became crucial. By the end of the year, 2,758 people had died of Ebola in Sierra Leone.

The disease also ravaged neighboring Guinea and Liberia, with 7,880 deaths reported across the three countries overall in 2014. Above: Medical staff escort a man, delirious in the final stages of Ebola, back into the isolation ward from which he had escaped, in Hastings, near the capital Freetown. Facing page, top: People wait beside the road after being denied passage through a quarantine check-point in Kenema, eastern Sierra Leone. Below: A Red Cross burial team, wearing protective equipment, enters the home of a woman who is suspected of having died from Ebola. Following spread: Gravediggers rest after a day of burials, at the King Tom cemetery in Freetown.

Pete Muller / USA, Prime for *National Geographic*/*The Washington Post*

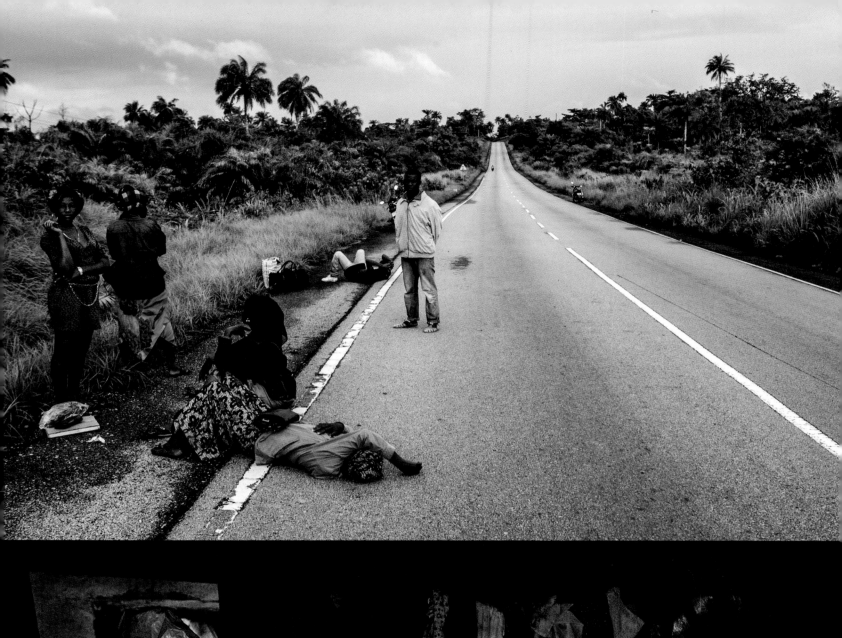
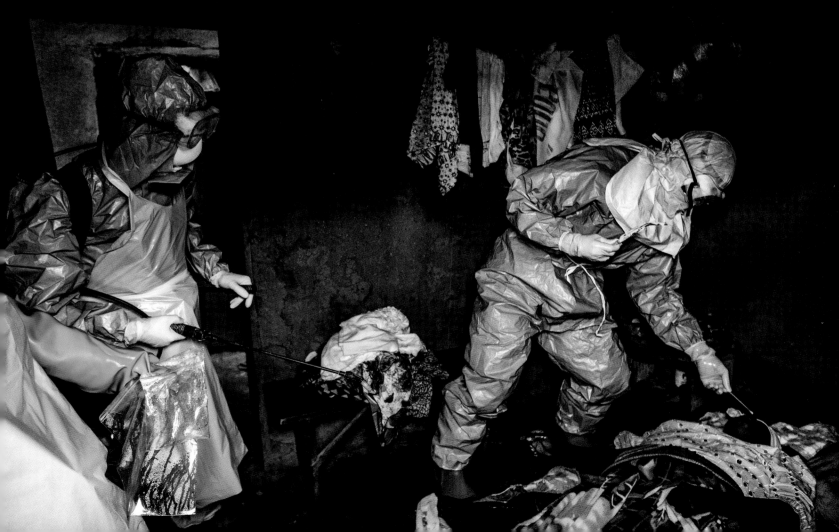

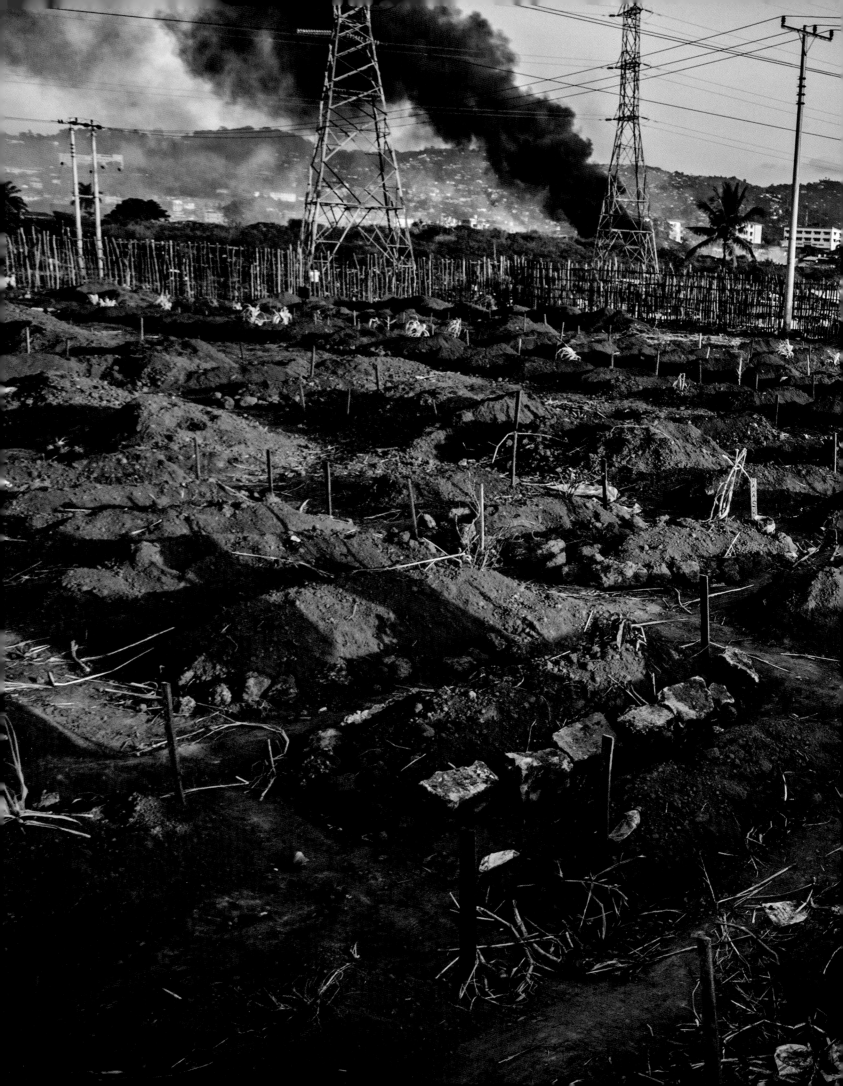

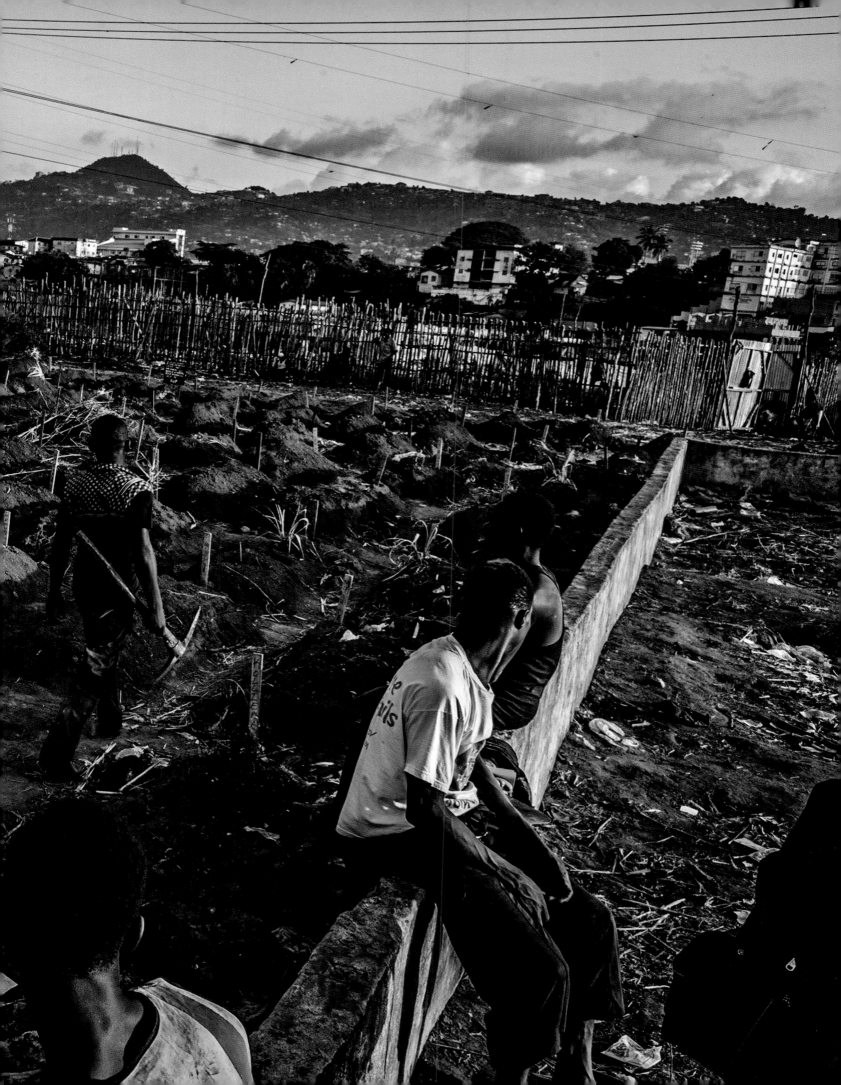

On 14 April, 276 girls were abducted from their school dormitory in Chibok, a remote town in Northern Nigeria, by the militant Islamist group Boko Haram. Schools in the area had been shut down due to Boko Haram attacks, but the girls had returned to sit their final exams. Boko Haram (whose name translates roughly as 'Western education is forbidden'), seeks the establishment of an Islamic state in Nigeria, and opposes the concentration of wealth among what it sees as a Christian elite in the south of the country. The group opposes secular education, especially for girls, and has for some years been attacking schools, killing civilians, kidnapping pupils, and conducting forced recruitment into its ranks. Around 50 of the Chibok girls managed to escape, but the fate of the remainder remains unclear. Efforts by the Nigerian government to rescue them or negotiate their release proved ineffective, although a hashtag campaign, #BringBackOurGirls, led to extensive media attention. Facing page, top: Dresses belonging to three of the kidnapped girls. Below: Hauwa Nkeki's notebook. Following spread, top left: A note from Rhoda Peters to her in-laws. Top right: Dorcas Yakubu, whose notebook bears a picture of the Eiffel Tower, is described by her parents as a shy girl, who loves the local dish *tuwo*. Below, left: Family photos of kidnapped girls. (Top row, left to right) Yana Pogu, Rhoda Peters, Saratu Ayuba, Comfort Bullus, Dorcas Yakubu. (Bottom row, left to right) Hauwa Mutah, Hajara Isa, Rivkatu Ngalang. Below, right: Shoes belonging to Margaret 'Maggie' Pogu, whose father is a teacher at Chibok.

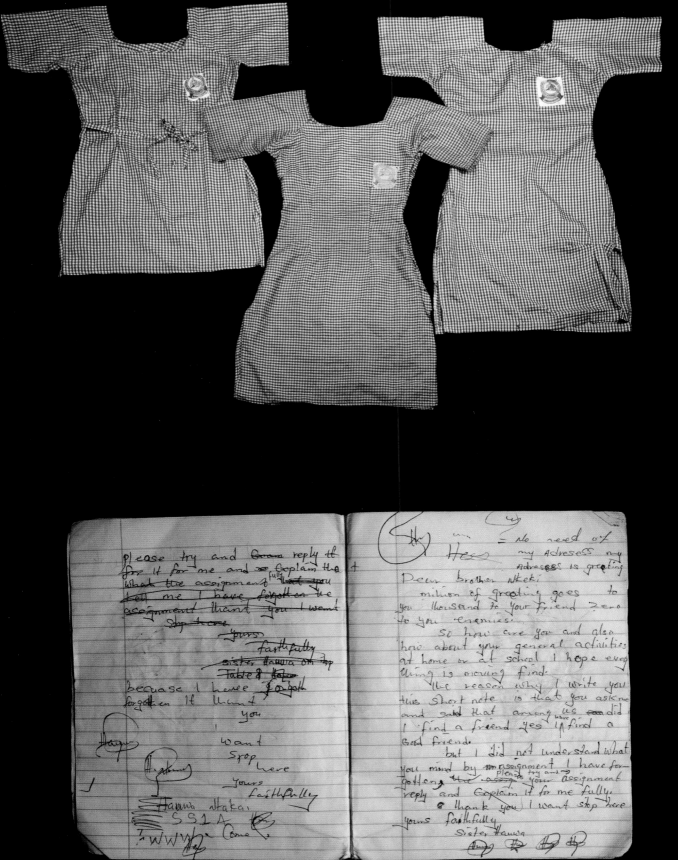

please try and ~~Soon~~ reply it
~~for~~ it for me and ~~so~~ Coplain the ~~t~~
what the assignment fully ~~that you~~
~~tell me~~ I have ~~forgotten~~ the
assignment thant you I want
~~Stop here~~
 Yours
 farthfully
 sister ~~Hauwa~~ ~~on top~~
 ~~Table d here~~
becuase I have ~~forgott~~
forgotten it Want
 you
 '
 Want
 Stop
 here
 Yours
 faithfully
 Hauwa Atakai
 S S 1 A
 ~~WWV~~ ~~Come~~

= No reed of
my Adresess my
Adresess is greeting
Dear brother Nkeki
 million of greeting goes to
you thousand to your friend Zero
to your enemies.
 So how are you and also
how about your general activities
at home or at school I hope evry
thing is moving find.
 the reason why I write you
this short note is that you ask me
and ~~said~~ that among us ~~so~~ did
I find a friend yes ~~if~~ find a
Good friend.
 but I did not understand what
you mind by ~~an~~ assignment I have for-
gotten ~~the assig~~ please try and
reply and Coplain it for me fully.
 ~~s~~ thank you I want stop here
yours faithfully
 sister Hauwa

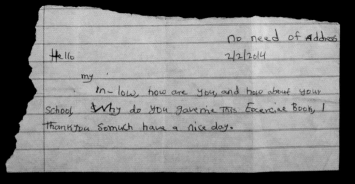

No need of Address
2/2/2014
Hello
my
in-low, how are you, and how about your
school Why do you gave me This Exercise Book, I
Thank you Somuch have a nice day.

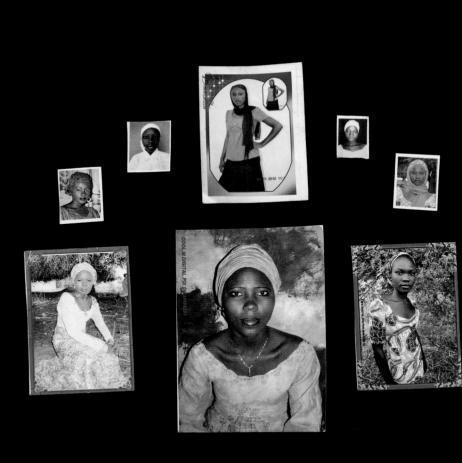

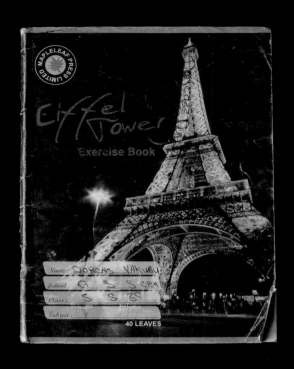

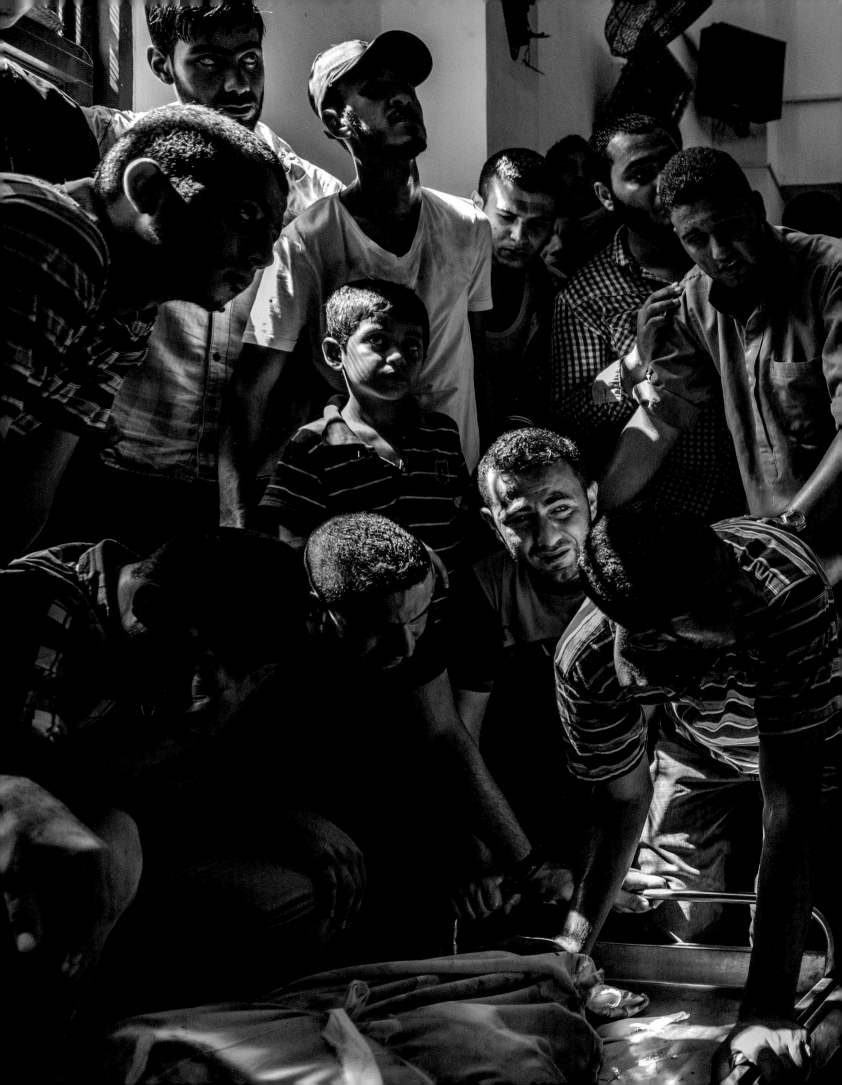

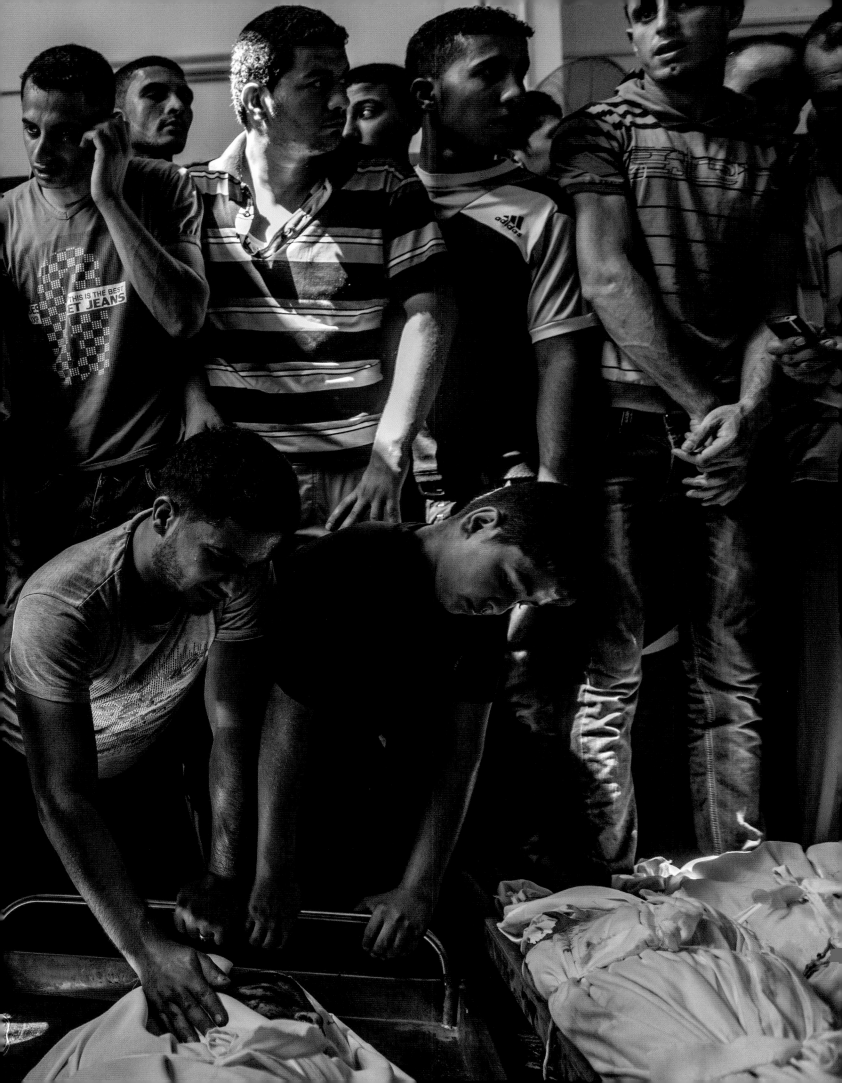

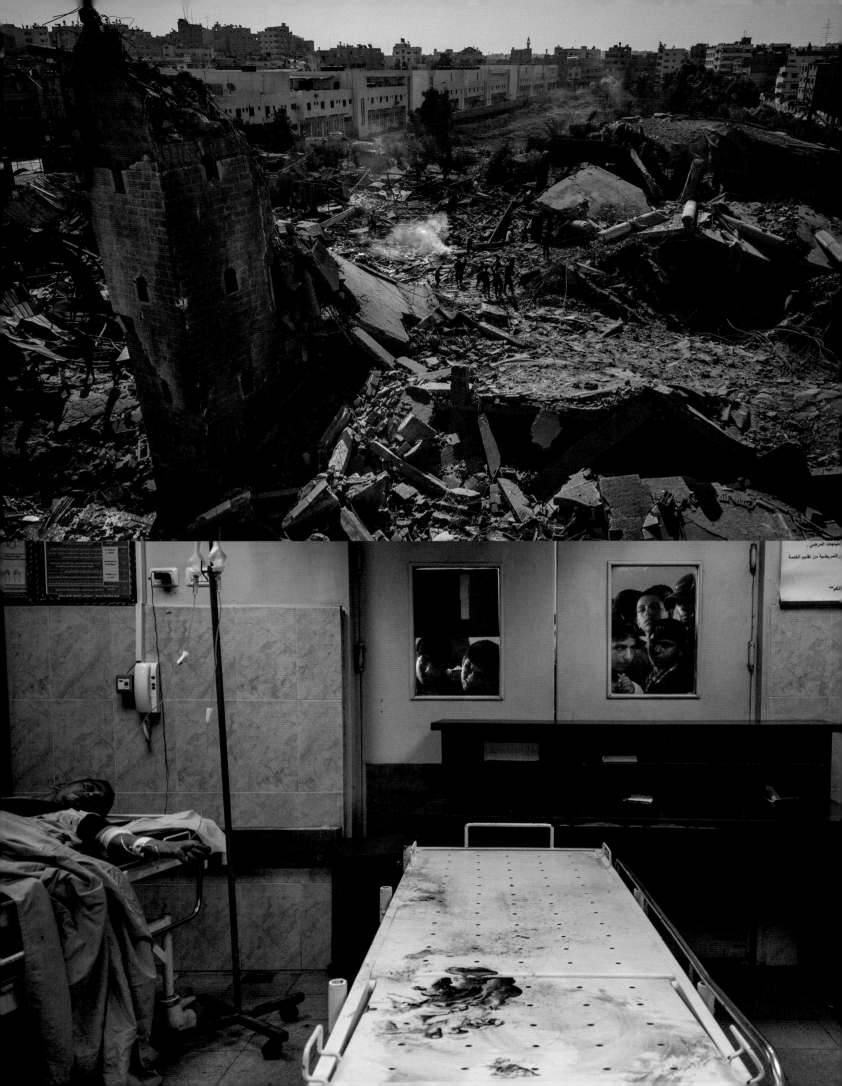

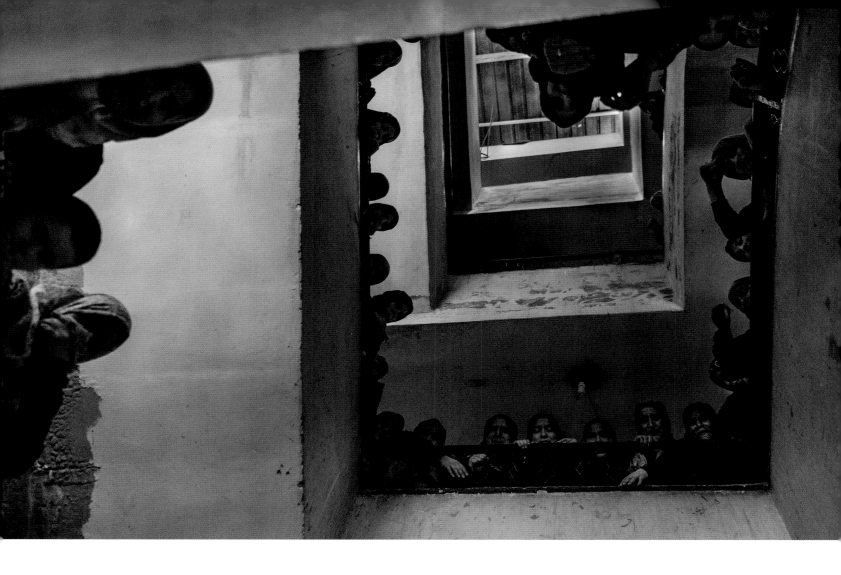

After weeks of rising tension following the killing of three Israeli teenagers, Israel launched a major offensive against Hamas in Gaza. Hamas had fired rockets into Israel on 7 July, after a series of Israeli air strikes in which several Hamas members had been killed. On 8 July, Israel launched Operation Protective Edge, aimed at stopping the rocket attacks, and destroying Hamas capabilities. The offensive lasted seven weeks, during which more than 2,100 people were killed in Gaza, 69 percent of which, according to the UN, were civilians. In Israel, six civilians and 67 soldiers were killed.

Amnesty International published a report that criticized Israel's 'grossly disproportionate' responses, but suggested violations of international law on both sides. Previous spread: People mourn for the Nigim family, killed during an air attack on Jabalia, Gaza, on 4 August. Facing page, top: A mosque, destroyed by an airstrike, in Gaza City. Below: People look through a window into an operating theater in Beit Lahiya, Gaza. Above: Women grieve on the stairs of an apartment block, during the funeral of a young Islamic fighter, Abdalla Ismail al Buheisi, on 22 July.

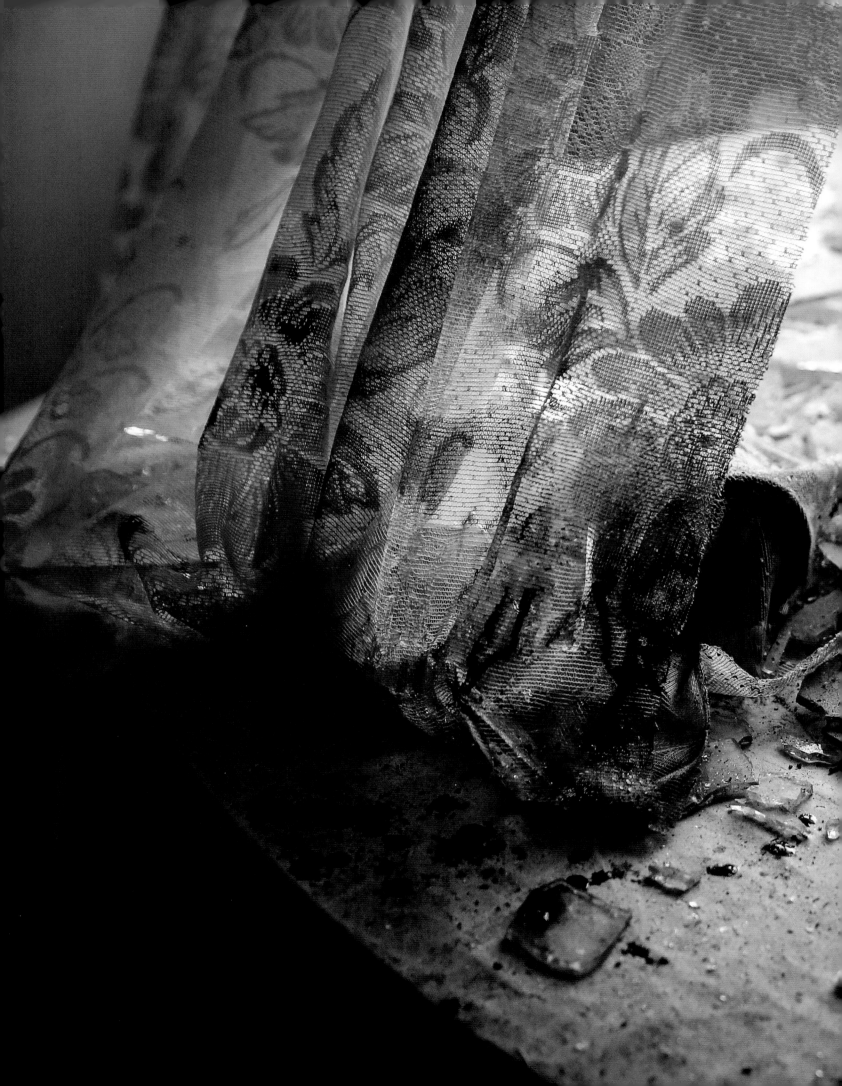

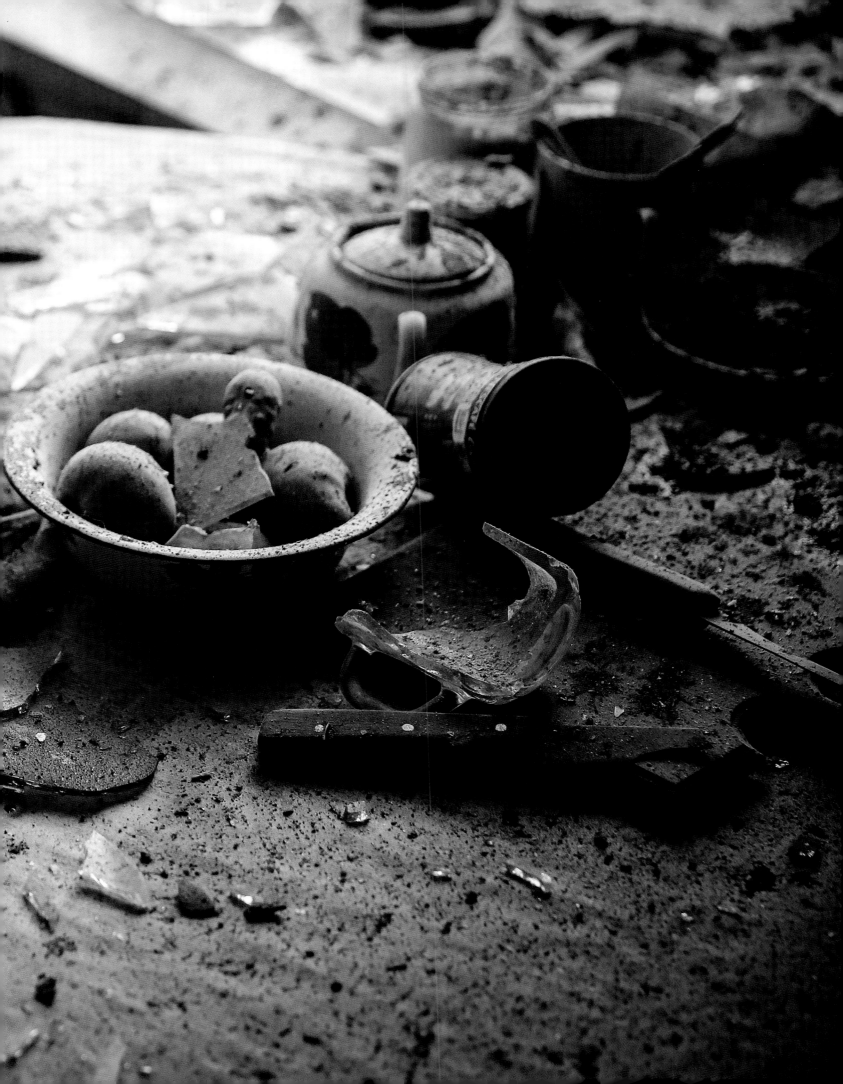

← A kitchen table in Donetsk, Ukraine, on 26 August, a day on which several districts of the city came under artillery fire from government troops. Protests in February had toppled Ukrainian leader Viktor Yanukovych from power, and installed the pro-European Petro Poroshenko as president. Separatists in the largely Russian-speaking east of the country demanded greater autonomy and stronger links with Russia. In April, rebels seized government buildings and established self-proclaimed people's republics in the eastern regions of Donetsk and Luhansk. Pro-Russian separatists in Donetsk later asked Moscow to deploy troops in the area and consider absorbing eastern Ukraine into Russia. Clashes between government and separatist forces over the ensuing weeks resulted in heavy casualties on both sides. Russia conducted a number of military exercises near the Ukrainian border, while Ukraine and NATO officials accused Russia of arming the rebels and invading Ukrainian territory with military units and personnel, a claim that Moscow denied.

Sergei Ilnitsky / Russia, European Pressphoto Agency

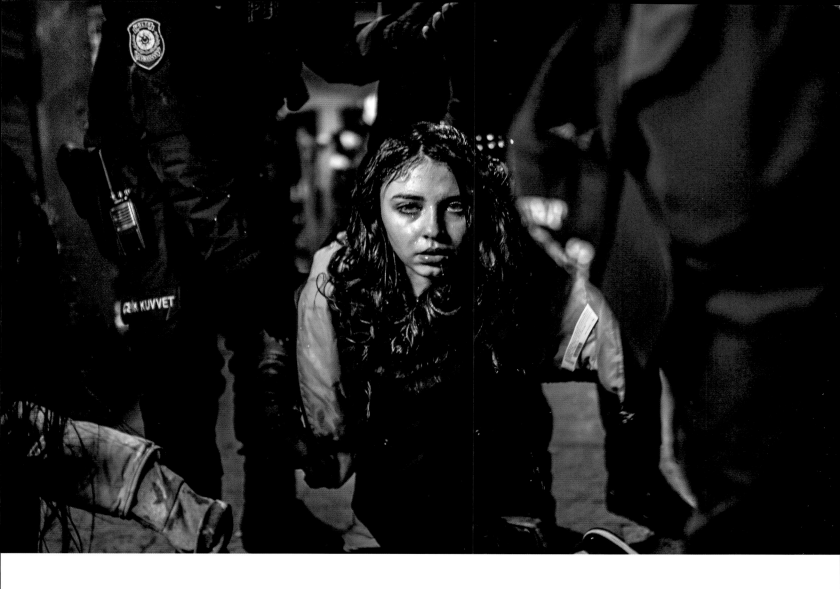

A young girl, wounded during clashes near Taksim Square in Istanbul, Turkey, on 12 March. Violence broke out between riot police and people attending the funeral procession of 15-year-old Berkin Elvan. He had been hit on the head by a teargas canister while out buying bread, during anti-government demonstrations the previous June, and died following a nine-month coma. The June protests had begun over plans to develop the city's Gezi Park into a mosque and shopping center, and had escalated into national expressions of opposition to what was seen as Prime Minister Recep Tayyip Erdogan's growing authoritarianism. Elvan's death triggered further anti-government protests across the country. Despite such opposition, Erdogan was elected as president of Turkey five months later.

Bulent Kilic / Turkey, Agence France-Presse

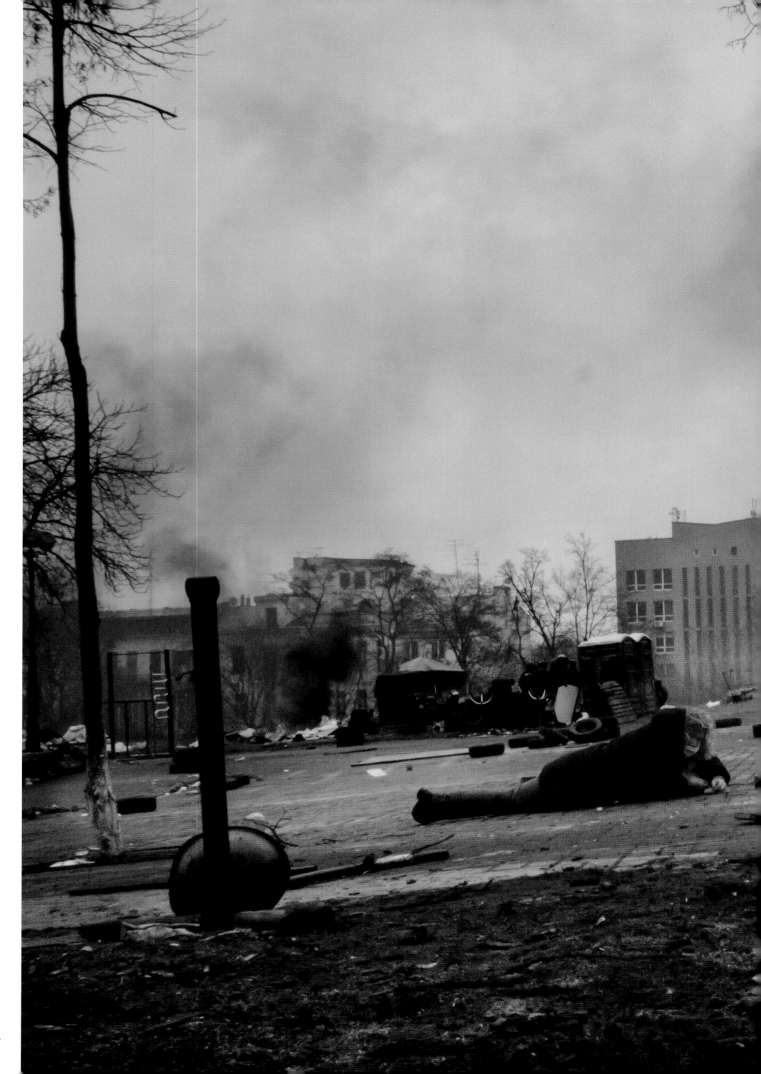

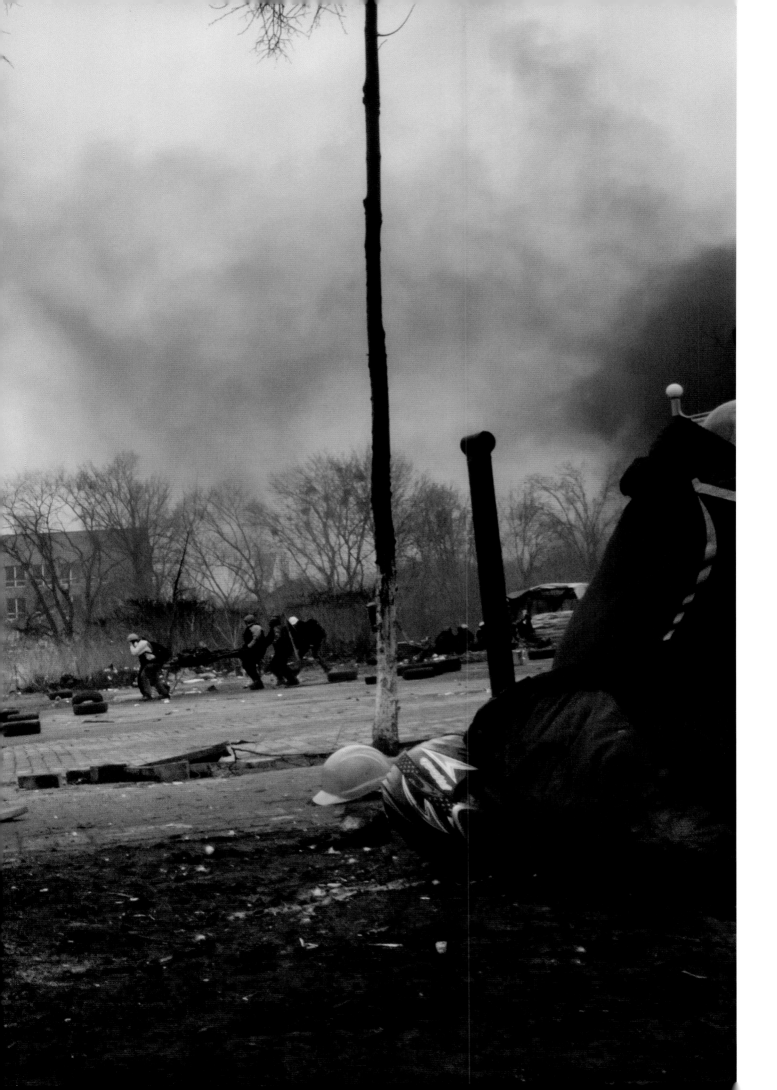

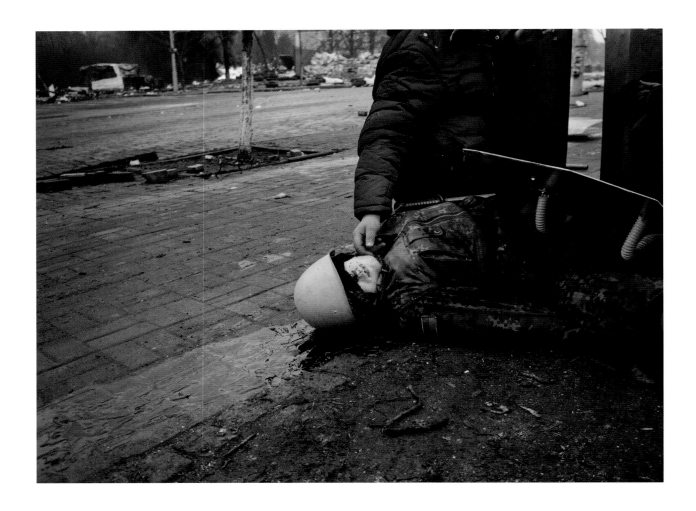

Protests broke out in the Ukrainian capital, Kiev, in November 2013, after President Viktor Yanukovych rejected a trade deal with the European Union in favor of closer ties with Russia. Thousands of pro-European supporters gathered on the city's Independence Square, known as Maidan, in an occupation that would last for months. Ongoing violence hit a peak on 18 February. Over the next three days, more than 70 people, both protestors and law enforcers, were killed by gunfire, with each side blaming the other for starting the shooting. President Yanukovych fled the country on 21 February, and the pro-European Petro Poroshenko was elected Ukraine's new president in May. Previous spread: Snipers opened fire on protestors on Institutskaya Street, leading to Maidan, on 20 February. Above: A man lies wounded after sniper fire. Facing page, top: An orthodox priest blesses protestors. Below: Demonstrators gather on Maidan, on 20 February.

Jérôme Sessini / France, Magnum Photos, for *De Standaard*

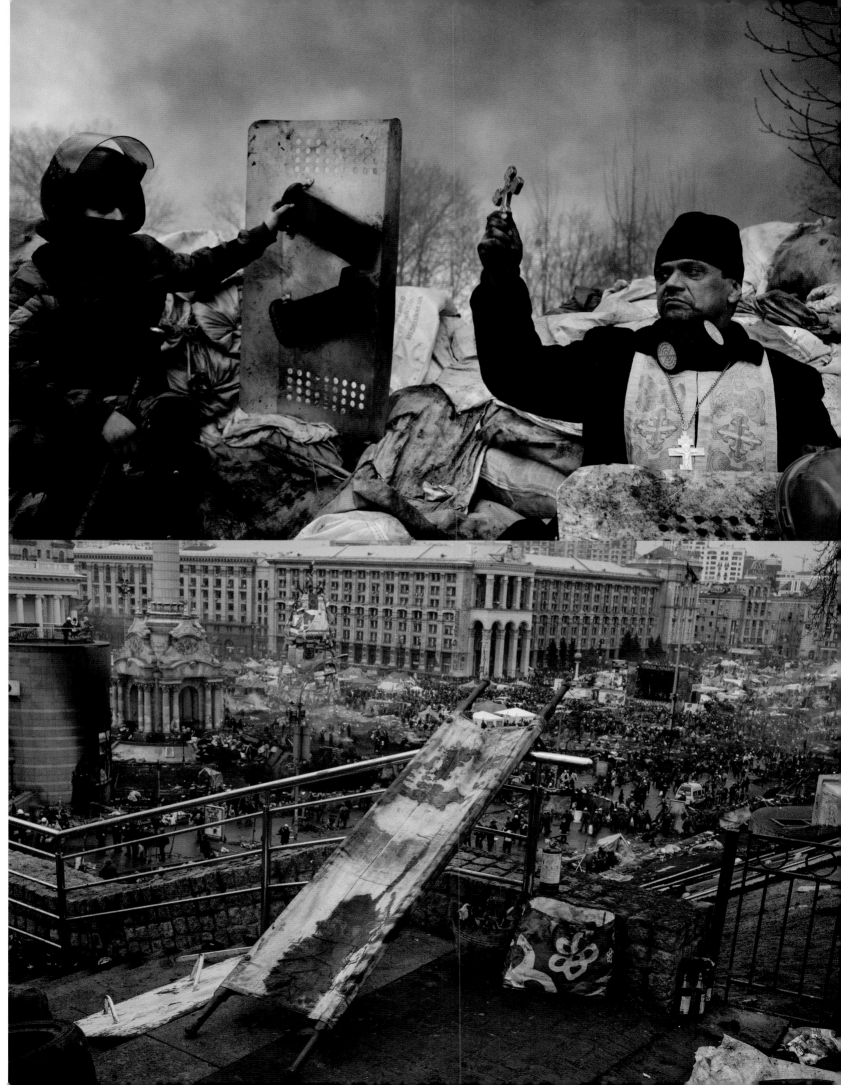

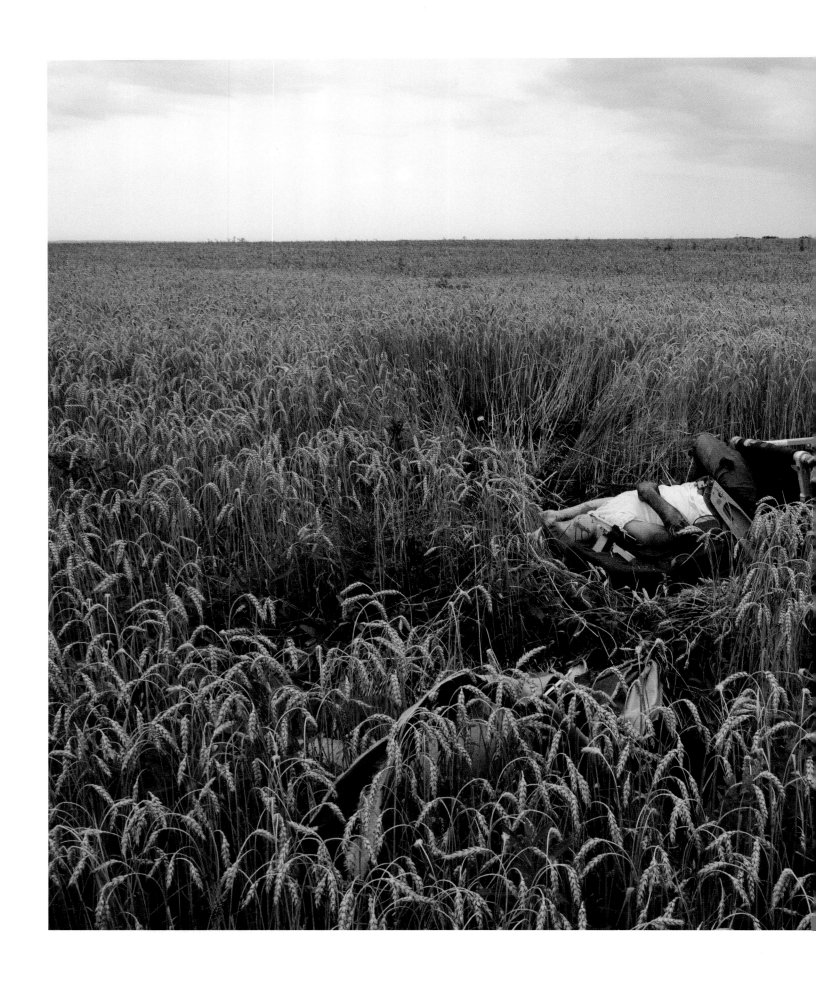

Jérôme Sessini / France, Magnum Photos, for *Time*/*De Standaard*

Malaysia Airlines flight MH17, traveling from Amsterdam to Kuala Lumpur at a height of 33,000 feet (10,058 meters), crashed into the countryside in eastern Ukraine, in rebel-held territory near the Russian border, on 17 July. All 298 people on board were killed. Wreckage was scattered over an area of several kilometers, near the villages of Rozsypne, Petropavlivka and Grabove. Evidence began to emerge that MH17 had been brought down by a missile. According to experts, an SA-11 surface-to-air missile of the sort allegedly supplied to the rebels by Russia, was the only weapon capable of such a range, although some suggested a Ukrainian military plane had been involved. Ongoing fighting in the area, and the presence of militiamen at the site, restricted initial investigations into the crash. Left: The body of a passenger lies still strapped in a seat, in a wheat field. Following pages, top left: A passenger's corpse lies in the bedroom of a house in the village of Rozsypne, having crashed through the roof. Top, right: Rescue workers search for remains. Below, left: Igor Tiponov stands at a window of his home, where a body had crashed through the bedroom roof. Below, right: Local people look out over the MH17 crash site.

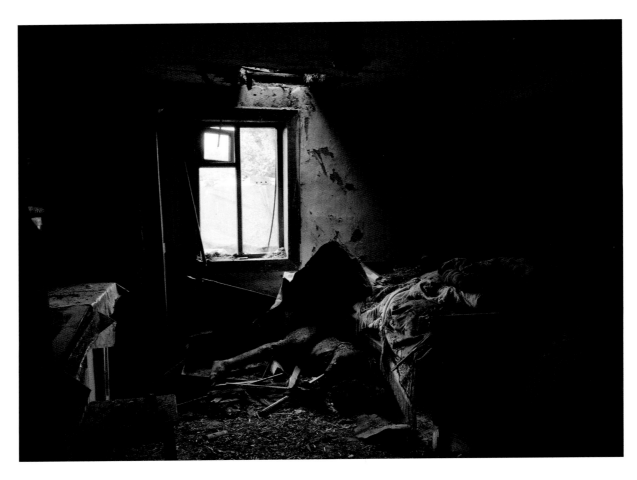

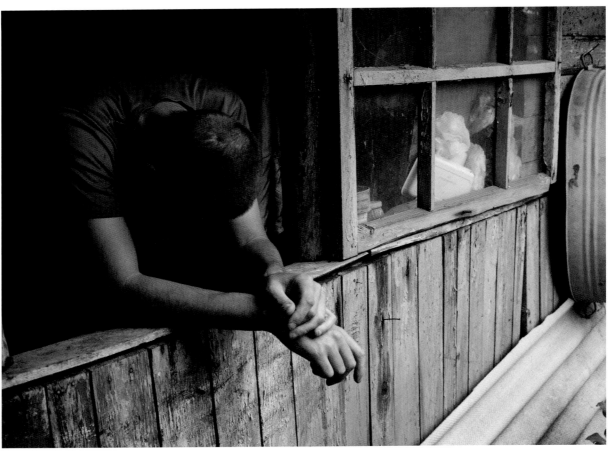

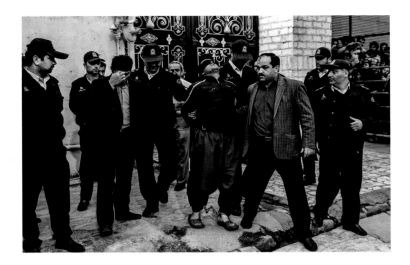
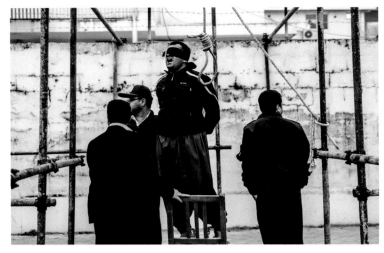
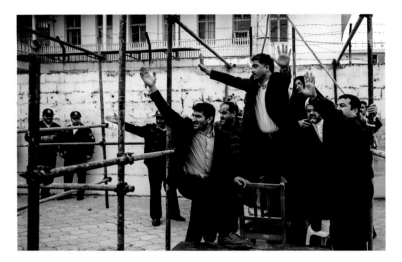
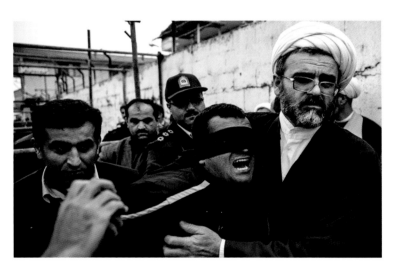

Although exact figures are not known, Iran is thought to execute more people than any country in the world, apart from China. Hangings are frequently held in public, and sometimes a murder victim's family may participate in the punishment by pushing the chair from under a condemned prisoner. On 15 April, in the northern Iranian city of Noor, a young man identified only as Balal was due to be hanged for stabbing a friend, Abdollah Hosseinzadeh, to death during a street brawl. Hosseinzadeh's mother was present at the hanging, but at the last minute, instead of pushing the chair, she slapped Balal's face in an act of symbolic forgiveness. Such an act puts a stop to the execution, though the victim's family does not have a say in any subsequent jail sentence. Top row, left to right: Prison authorities bring Balal to the scaffold. Balal stands on a chair, awaiting execution. The victim's mother slaps Balal. The victim's parents help in removing the noose. Bottom row, left to right: Officials ask cheering onlookers to remain calm. The supervising cleric takes an overwhelmed Balal back to prison. Hosseinzadeh's mother walks away, as the crowd and a police officer look on.

 Arash Khamooshi / Iran, ISNA

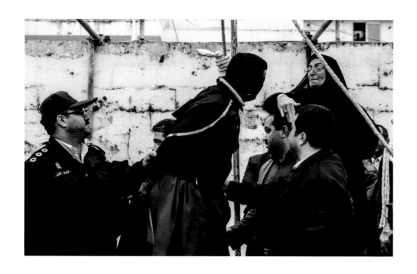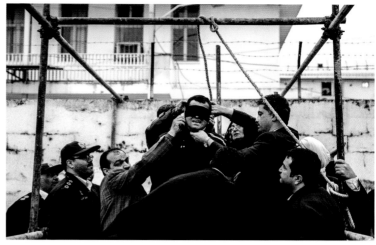
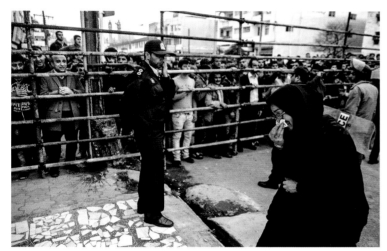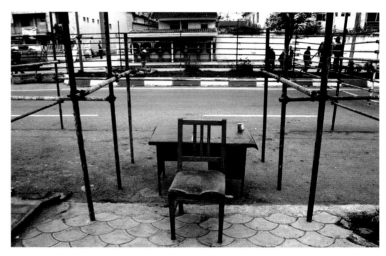

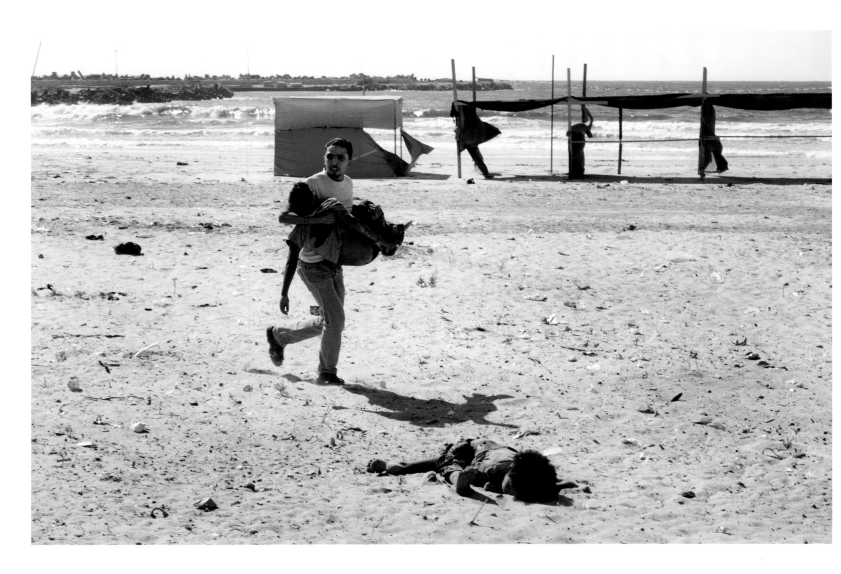

Israeli missiles struck a beach in Gaza City, on 16 July, killing four boys and injuring a young adult. Two explosions, separated by some 30 seconds, hit first a shack on the sea wall and then the open sand, where the children were fleeing. The boys were cousins, children of local fishermen. They had been told by their parents to remain indoors, but, having been cooped up for nine days of Israeli bombardment, had ignored their parents' caution and gone to play outside. The Israeli military later launched a criminal investigation into the attack; part of a 50-day war that saw more than 2,100 Palestinians and some 65 Israelis killed.

Tyler Hicks / USA, *The New York Times*

Smoke, dust and flames rise over a hill near the Syrian town of Kobani, after a US-led airstrike against the jihadist group that calls itself Islamic State (IS), on 23 October. IS was laying siege to Kobani, a Kurdish town within sight of the Turkish border, and militants had planted a black IS flag on the hill. Kobani was a strategic flashpoint, as the town's fall would put IS in a position to directly threaten a NATO ally, drawing the alliance into the conflict. The Turkish government has a difficult relationship with the country's own Kurdish population, and President Recep Tayyip Erdogan initially refused active help against IS, although he did later express willingness to allow a small group of Iraqi Kurdish fighters to cross Turkey into Kobani. →

Bulent Kilic / Turkey, Agence France-Presse

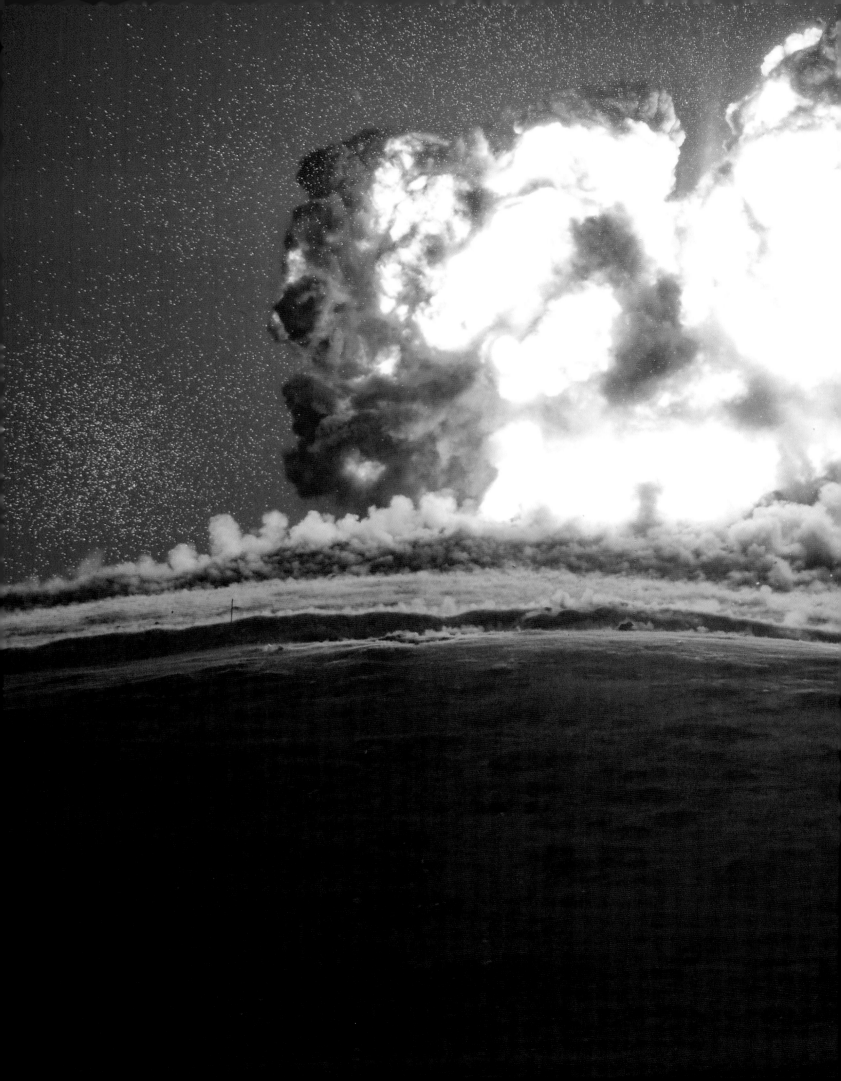

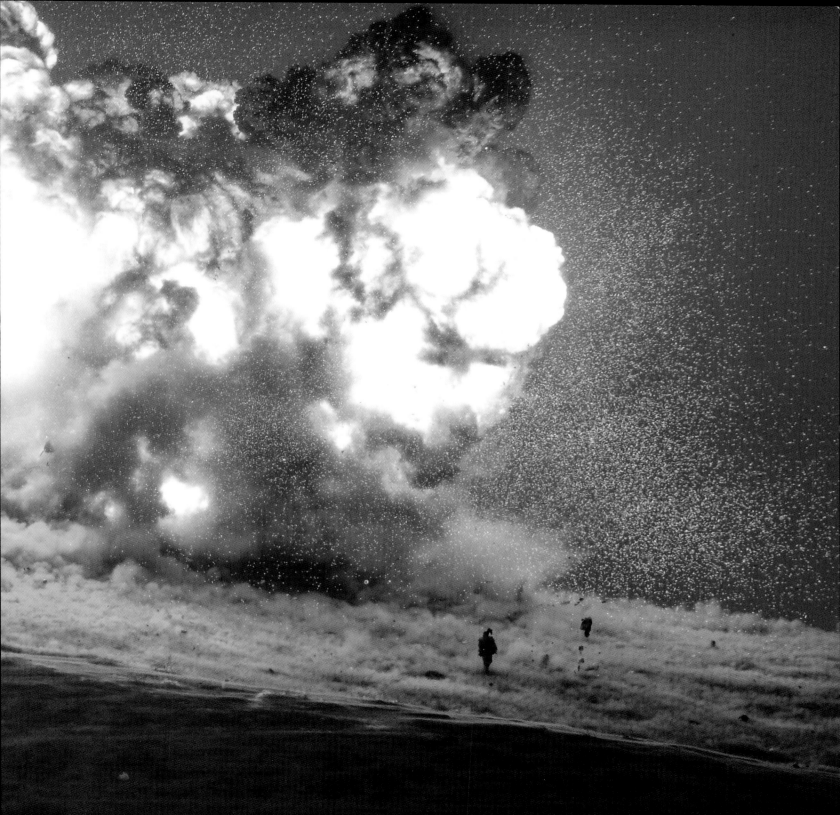

Development and Pollution in China

Lu Guang has been documenting pollution in China for the past decade. China, now the world's second largest economy, has undergone rapid industrial growth, which has consumed enormous energy and generated a large amount of toxic waste. In the ten years that Lu has been recording the environmental impact of this boom, pollution has not only been on the increase, but has spread in extent from the eastern regions of the country to the centre and west. Emissions of unprocessed sewage, exhaust gases, and industrial waste are polluting farmland, grasslands, drinking water, and the air.

Recent government efforts to curb pollution, through the auspices of the Environmental Protection Administration, have met with a degree of success. Some smaller enterprises with serious emissions records have been shut down, but many operations continue to discharge effluent illegally. Factories might emit polluting smoke or gas only at night; waste pipes are hidden deep in rivers or the ocean. Although some organizations have introduced evaporation ponds for liquid effluent, toxins still permeate the soil and affect the water table. Elsewhere, the quest for rapid profit has led to strip-mining—easy-access surface mining by removing the overlying layer of rock and soil—in place of underground mining, turning fertile country into wasteland.

Air pollution is a particular problem. In some areas, such as the Yangtze River Delta and the region around Beijing, the concentration in the air of particles of particulate matter (PM) smaller than the measurement known as PM2.5, is two to four times above World Health Organization guidelines. Particulate matter can comprise soot, acid, chemicals, metal, soil and dust. PM2.5 particles are about 1/30 the size of human hair, and can lodge deeply in the lungs. Millions of people in China breathe a toxic cocktail of such particles daily, caused by coal-fired power plants, factories and vehicles. The main culprit is the burning of coal, which provides 80 percent of the country's electricity.

Particulate and other air pollution has been shown to cause cancer, respiratory diseases, cardiovascular issues, birth defects, and premature death. In Beijing alone, some estimates hold that PM2.5 pollution in 2012 caused over 2,500 deaths and the loss to the economy of around 300 million euros. Everyday life is also affected, as smog causes delayed flights, shutdowns at schools, and closed highways.

Other forms of pollution, too, have a serious negative impact both on the environment and the population. In some heavily polluted areas, contaminated food and drinking water has led to the emergence of 'cancer villages'. In the countryside, farmland has been destroyed, herdsmen have lost their grasslands, and rural populations have been displaced.

Lu believes that the solution to the problem does not depend on the intervention of a few people from the Environmental Protection Administration, nor even on raising public awareness, but on passing stricter laws and enforcing criminal responsibility for pollution. He believes that fines currently imposed on transgressors are minimal compared to the costs of disposing of waste properly. Until fines increase, and polluters are held criminally liable for their acts, he says, the issue will not be resolved.

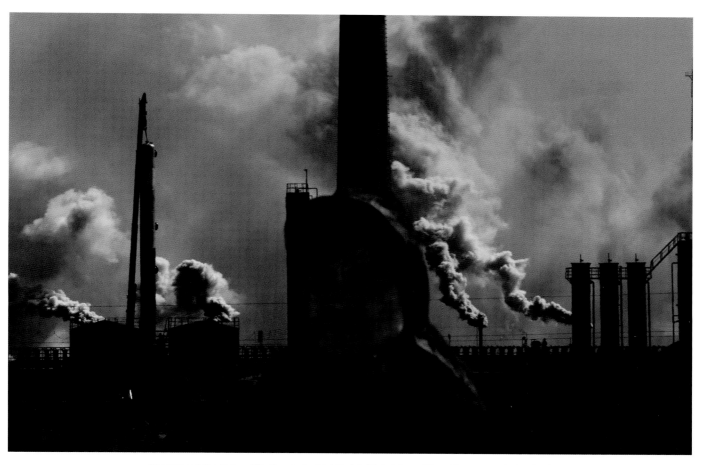

Factories at the Hainan Xilaifeng Industrial Park in Wuhai, Inner Mongolia, are mostly involved in metallurgical industries, and are high-energy consuming and highly polluting.

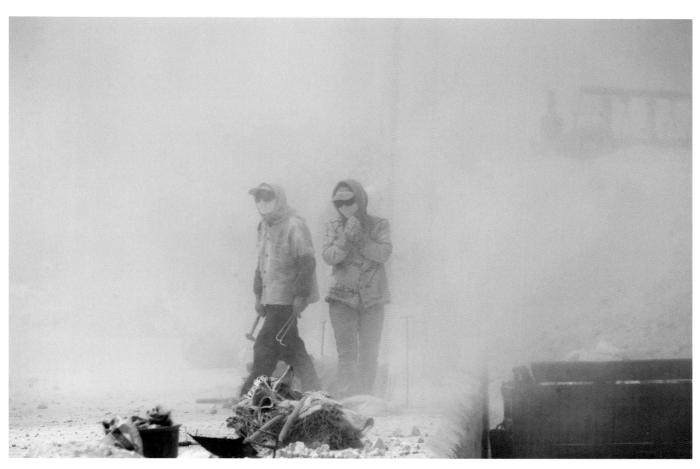

Above: Employees work in the midst of industrial dust.
Following spread: Coal mining and industry have destroyed the countryside around Holingol, Inner Mongolia.
Authorities have tried to improve the city's image by placing sculptures of cattle and sheep in former grassland.

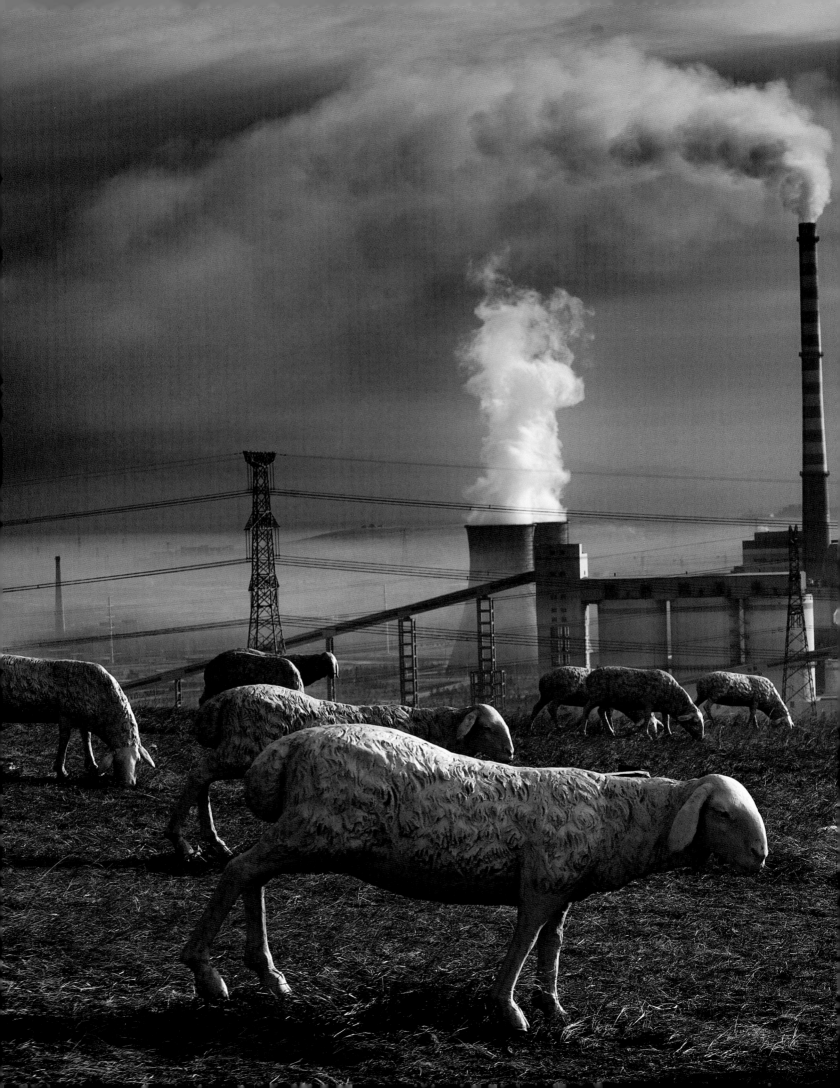

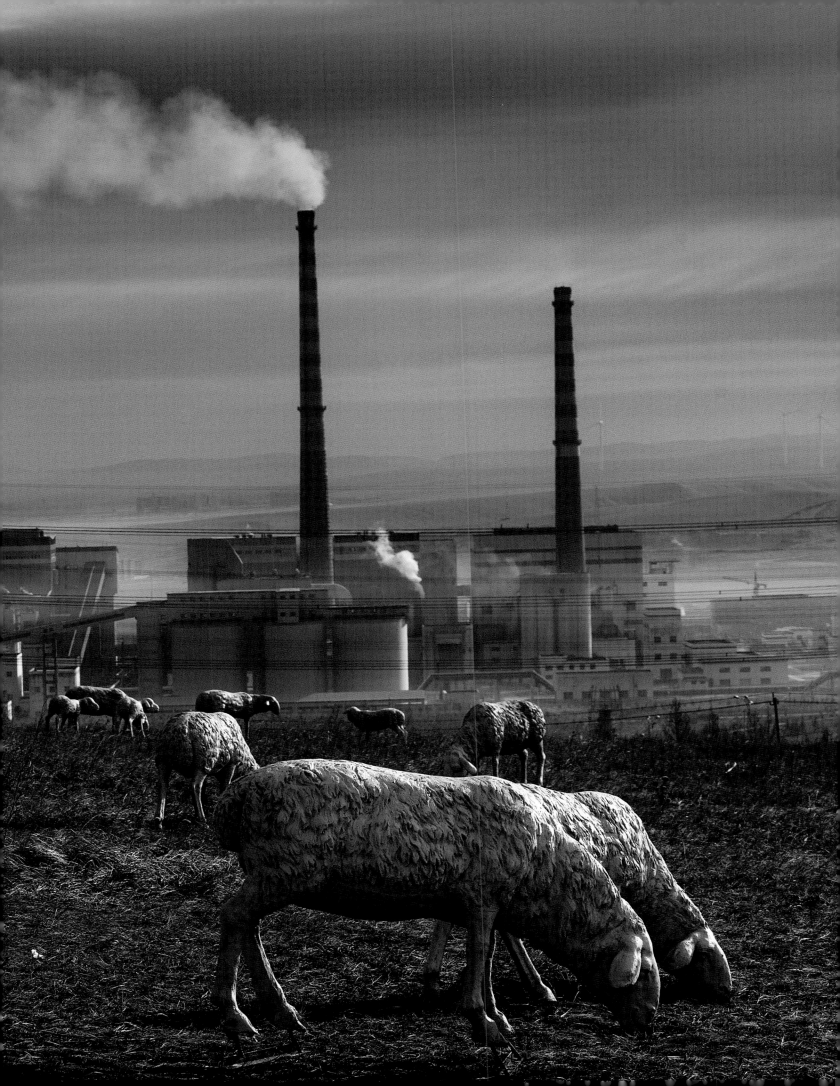

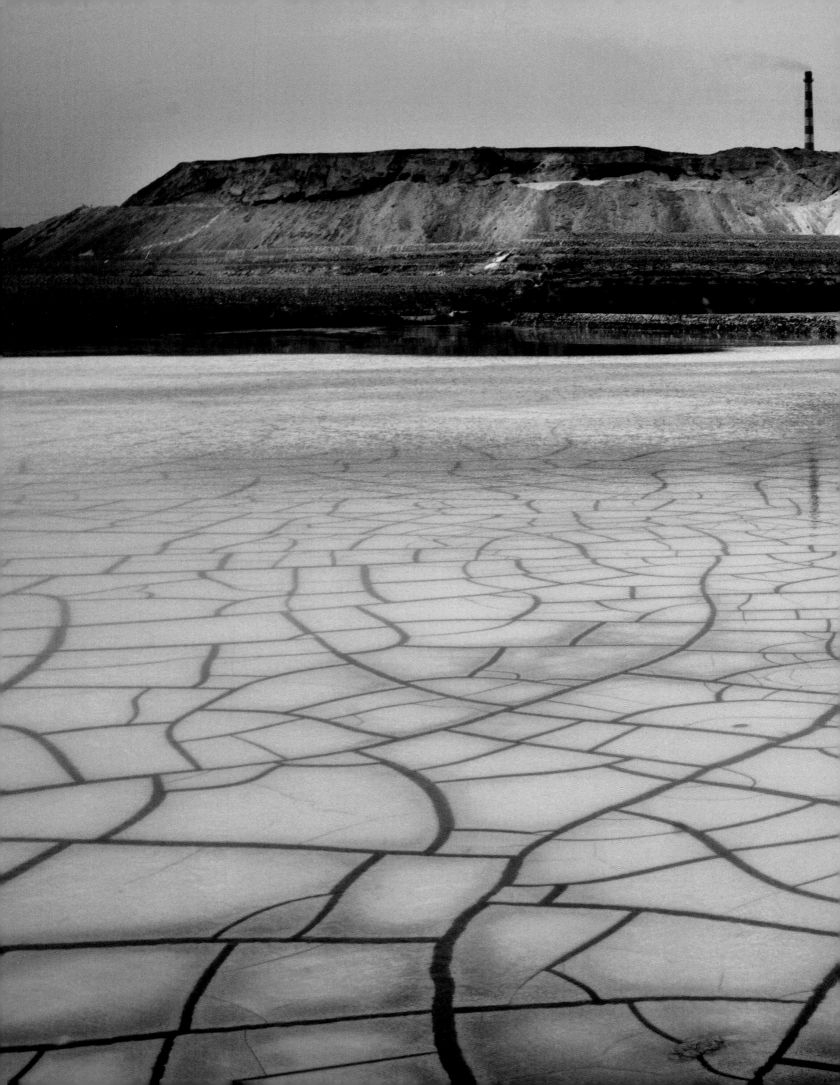

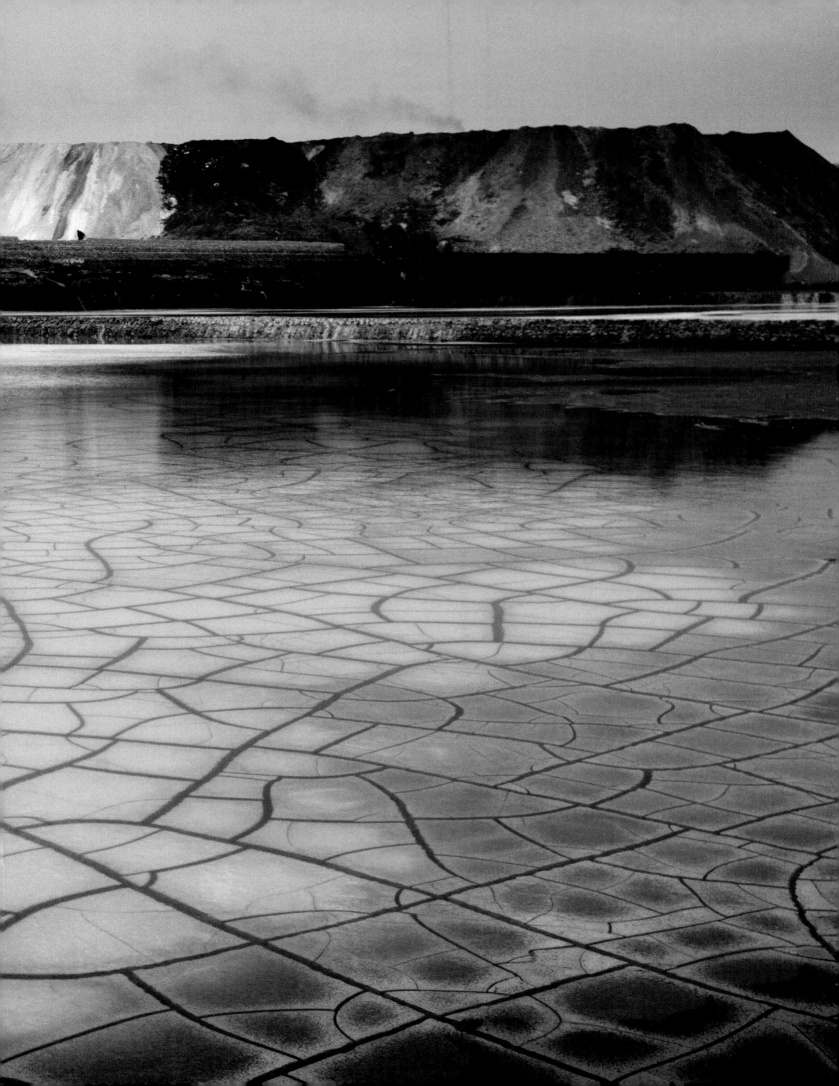

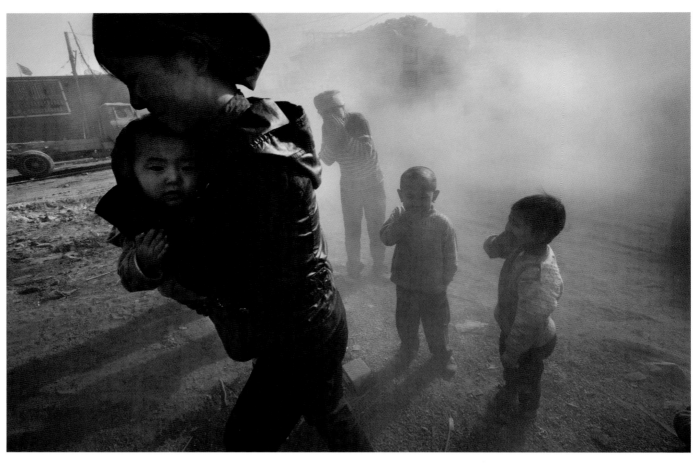

Previous spread: Toxic waste from the Wuhai Chemical Plant, which produces PVC products, is dumped in the Yellow River.
Above: A truck carrying coal and lime drives off, causing dust to fly, in Wuhai, Inner Mongolia.

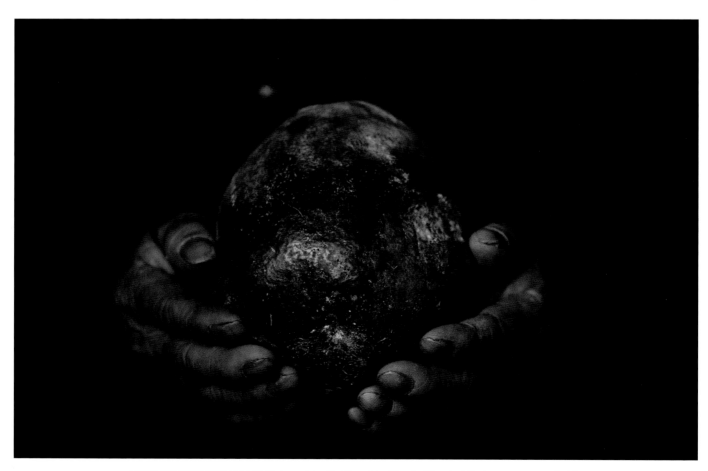

A toxic grapefruit, from Liuyang, Hunan, where the Changsha Xianghe Chemical Factory was prosecuted for
illegally dumping waste, leading to cadmium contamination of soil within 1,200 meters of the factory.

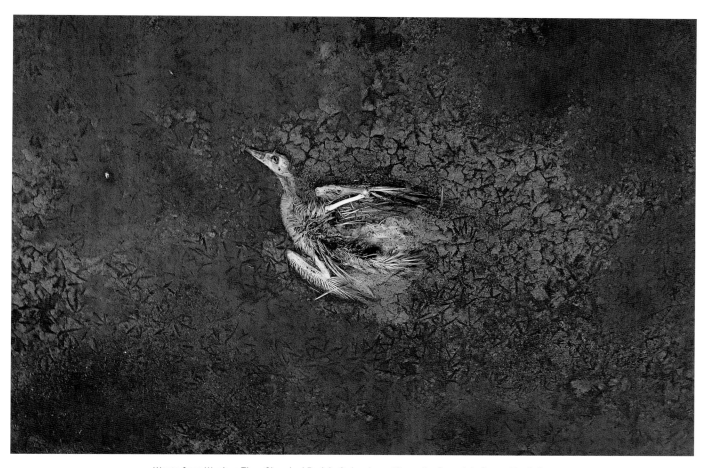

Waste from Wushen Zhao Chemical Park in Ordos, Inner Mongolia, flows into Qagan Nur Lake, causing the deaths of millions of birds every year.

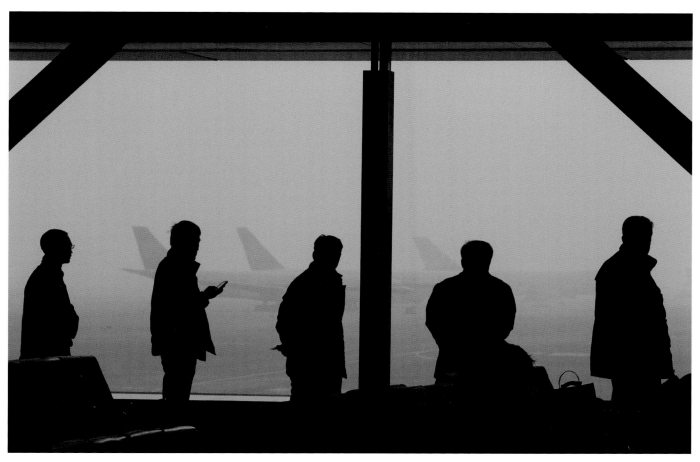

On a smoggy day, passengers wait in a lounge at Beijing Capital International Airport.

A man digs a grave for an infant found dead and abandoned. Environmental pollution is a cause of birth defects, and numbers of impoverished parents abandon children born with abnormalities, as they cannot afford to treat or support them.

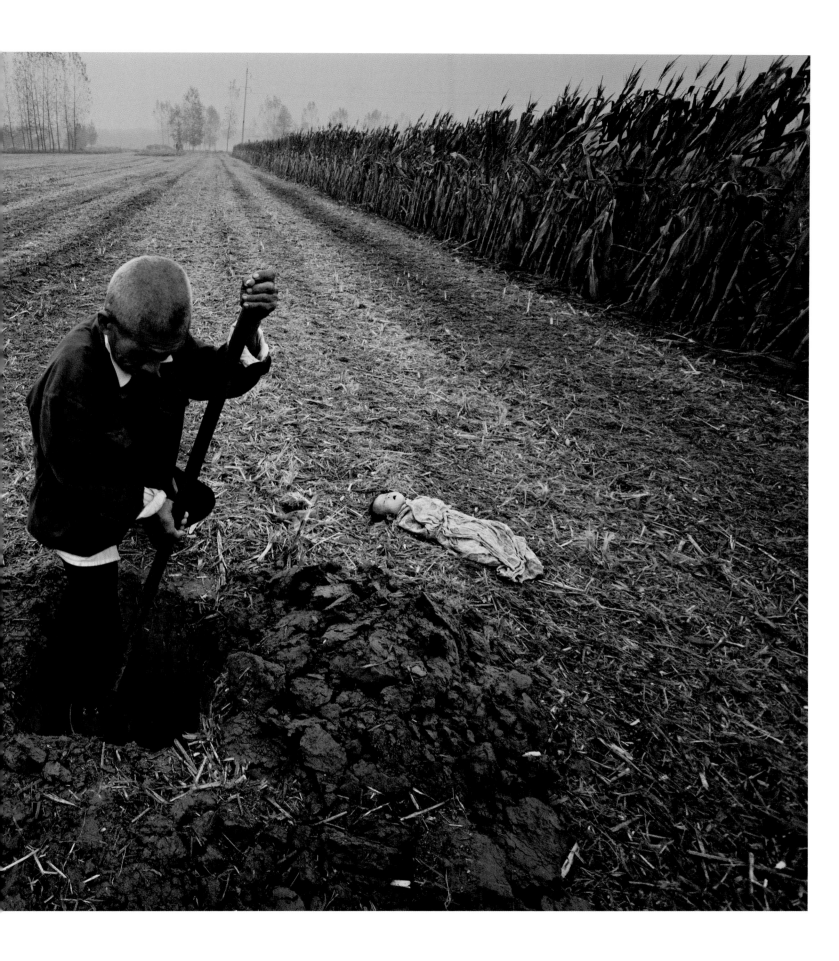

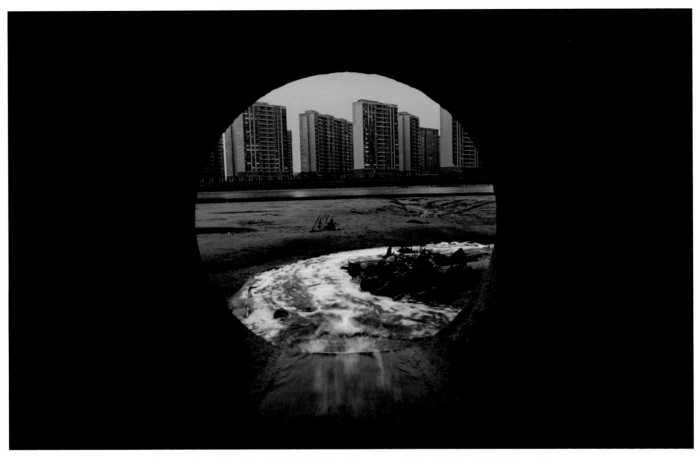

A waste pipe spills effluent into the Fenghua River, near a high-end residential development, in Ningbo, Zhejiang, northeastern China.

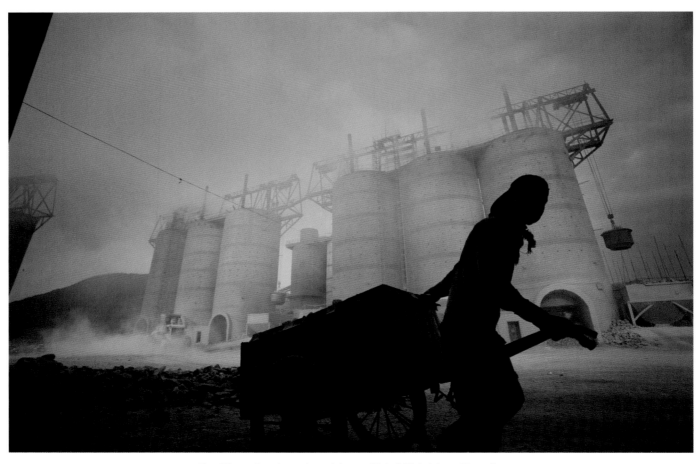

Limekilns emit toxic smoke and dust, at Maladi, Wuhai, Inner Mongolia.

"China has many problems, but that isn't to say you can easily photograph them. My photography is more of an investigation. You need to keep calm, and go into detail. You need to go into villages, and talk to ten, twenty, or more people living there. Only then will you get close to a deeper level of truth."

Lu Guang

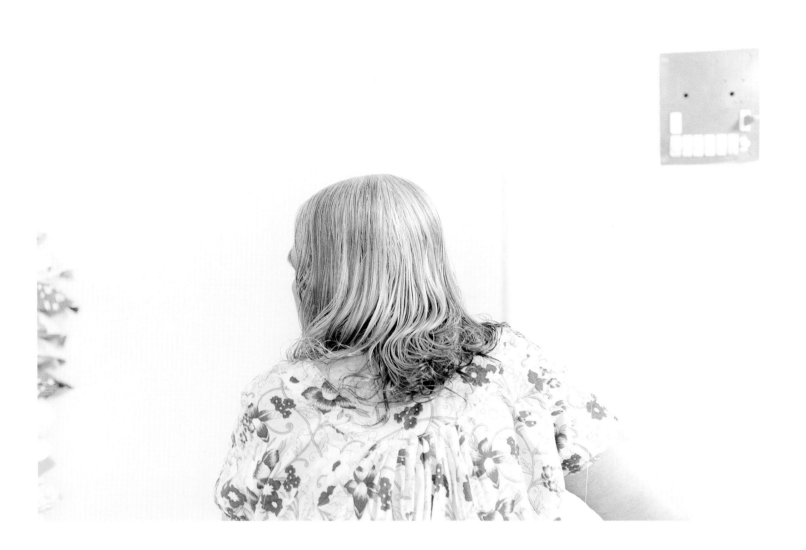

Failing health keeps the photographer's grand-
parents, John and Prova, housebound in their old
age, in Dhaka, Bangladesh. Life has become
contained in a single room. The photographer had
been very close to them as a child, but although he
could visit daily, he found he soon ran out of things
to say. One day he was struck by the way the light
coming into the room was washed out between the
white wall and the white doors. At that moment,
the photographer says, he could relate what he was
seeing to what he felt about John and Prova's silent,
suspended lives. Above: Prova sits on her bed after
a bath. (continues)

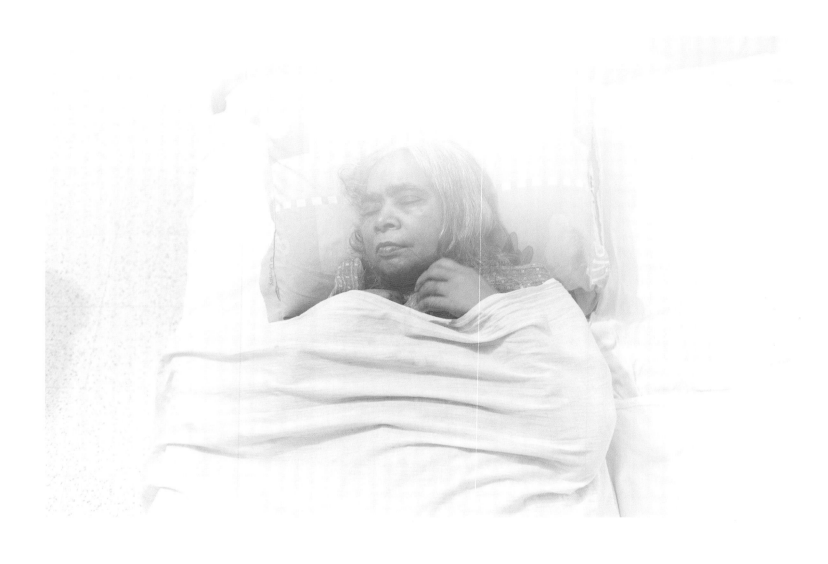

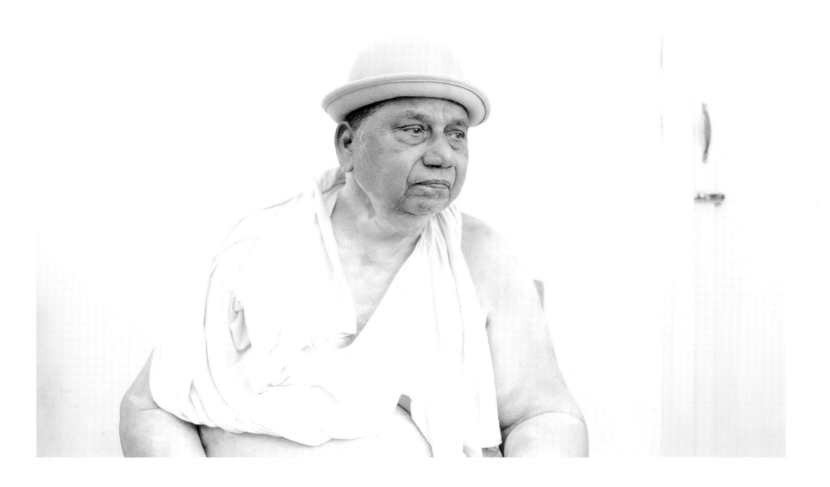

(continued) Hair turns gray, the paint on the walls begins to peel, all that remains are objects. In the white light, John and Prova's lives appear slow and bathed in an aura. Working on the project gave the photographer a new way of relating to the grandparents with whom he had lost touch. Facing page: Prova lies in bed, some days before her death. Above: John wears his grandson's bowler hat.

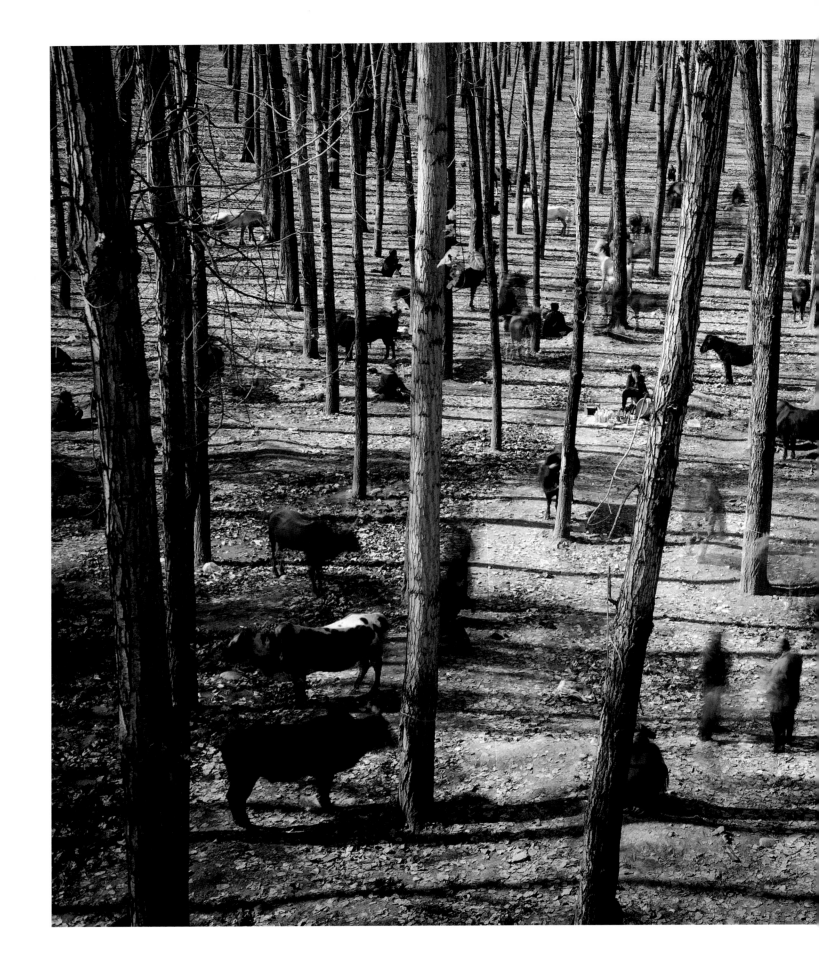

Cai Sheng Xiang / China, Fuzhou Ping Yi Environmental Art Design

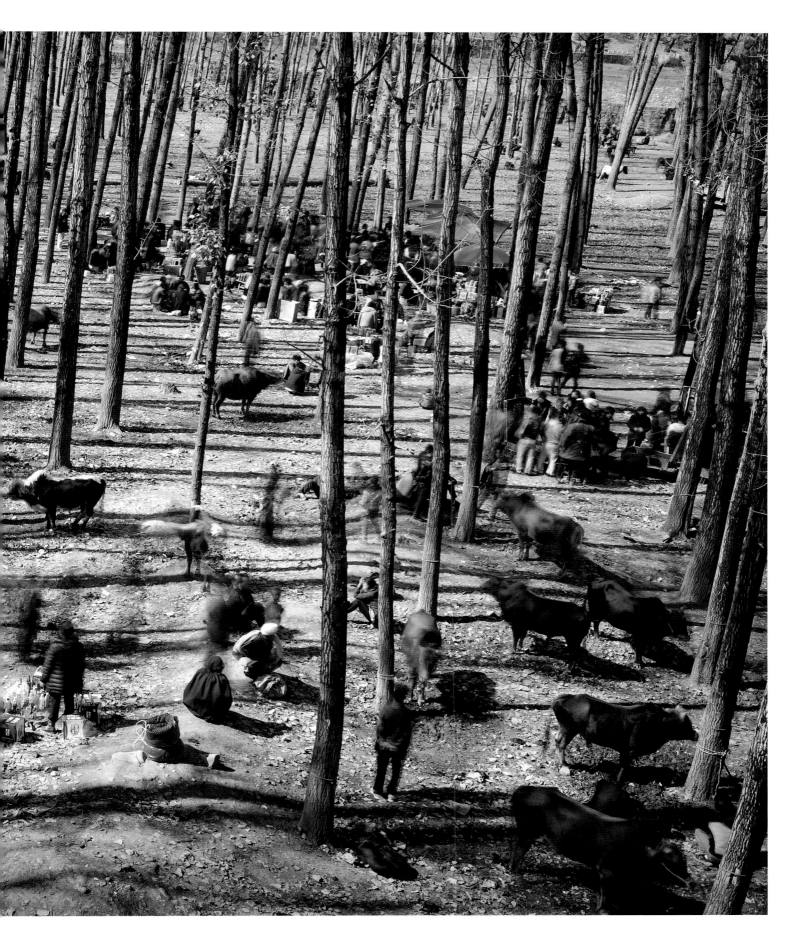

Yi villagers hold a cattle market in a forest outside the town of Niuniuba, near Liangshan, in Sichuan, China. The Yi ethnic minority live largely by agriculture, livestock herding and hunting. There are around 7.5 million Yi in China, concentrated principally in Sichuan and Yunnan provinces.

Mongolia's economy has been growing at an unprecedented rate, with an average annual increase in GDP between 2011 and 2013 of well above 10 percent. The new 'Mongolian Wolf' economy is based primarily on mining, and has attracted considerable foreign investment. The traditional way of life, which relies on ancestral nomadic herding, is undergoing a crisis as people leave to seek work in urban centers. Above: A cloud of coal dust rises over the road built by Energy Resources Mining, to facilitate coal delivery from Mongolia to China. The province of Ömnögovi, in the Gobi Desert, in southern Mongolia, is also rich in deposits of copper and gold. Facing page: A stripper gets ready for a show in a local club. (continues)

Michele Palazzi / Italy, Contrasto

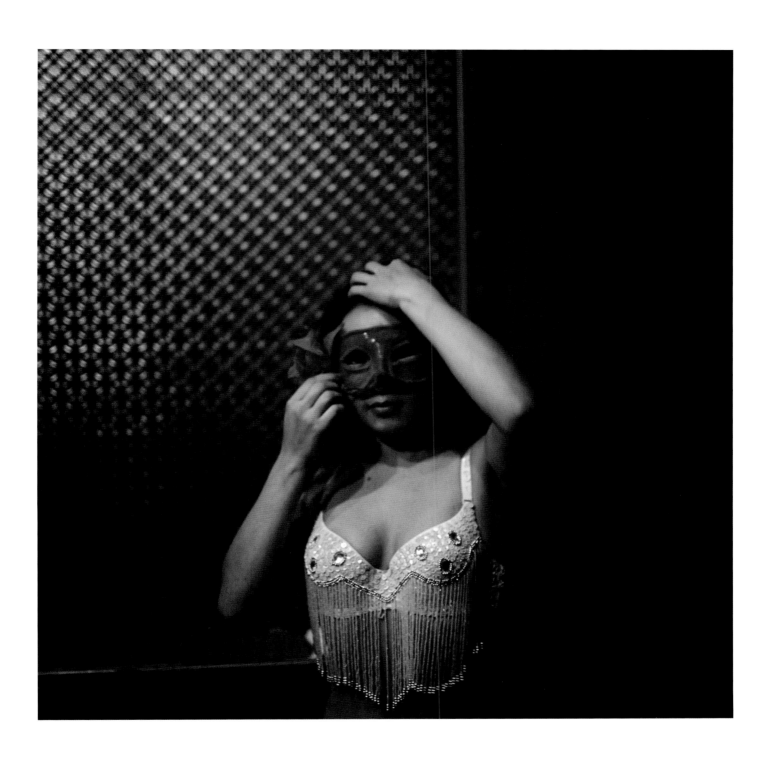

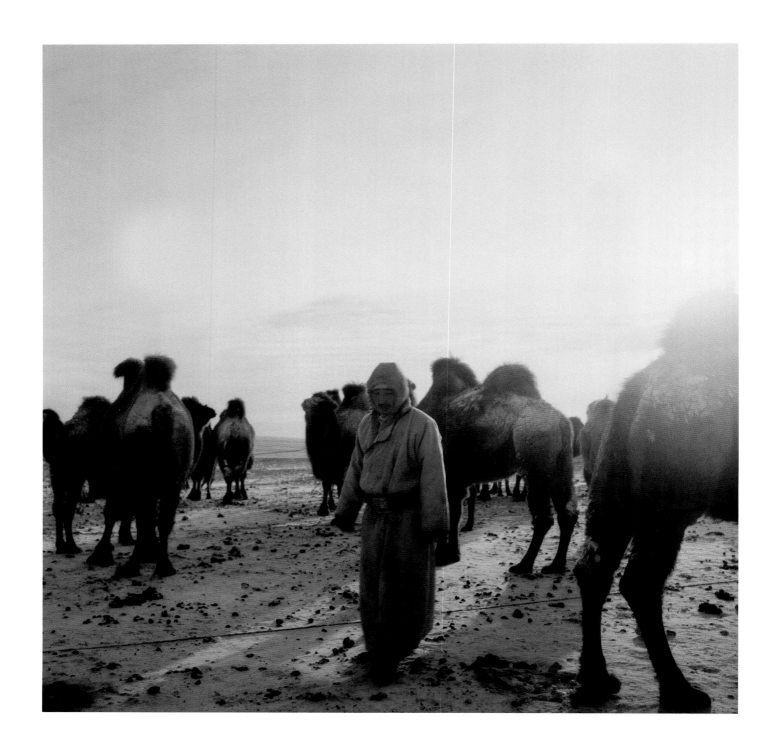

(continued) The new 'Mongolian Wolf' economy is based primarily on mining, and has attracted considerable foreign investment. Above: Tuvshinbayar tends to camels, in Ömnögovi. Facing page: Two new buildings go up, near a power station in the Mongolian capital Ulan Bator. (continues)

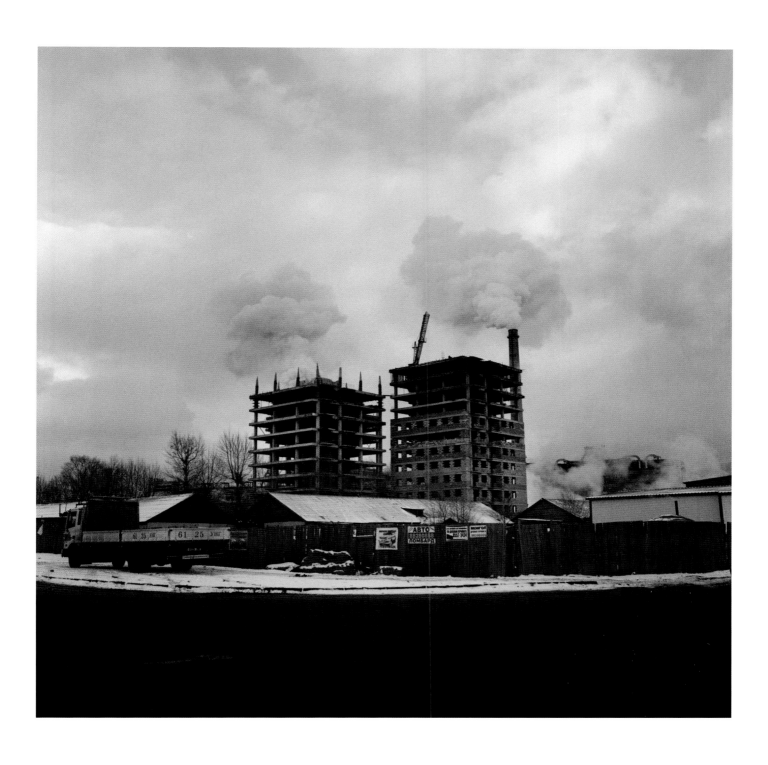

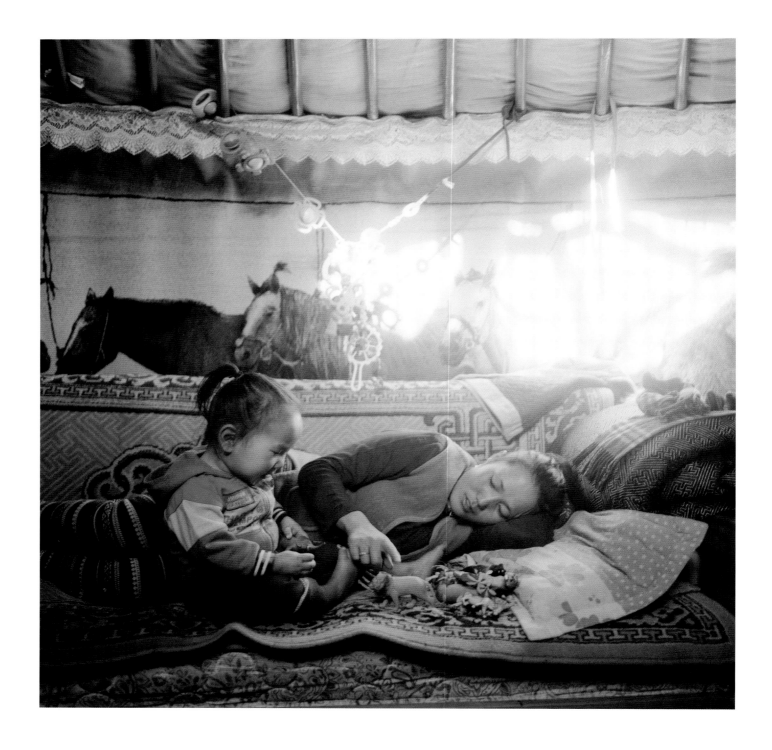

(continued) Development in Mongolia has been largely unregulated. People who still follow a traditional nomadic lifestyle have to cope with increasing levels of pollution, deforestation, and overgrazed pastures. Above: Members of Tuvshinbayar's family relax in their tent. Facing page: Young people watch a Mongolian metal band in concert.

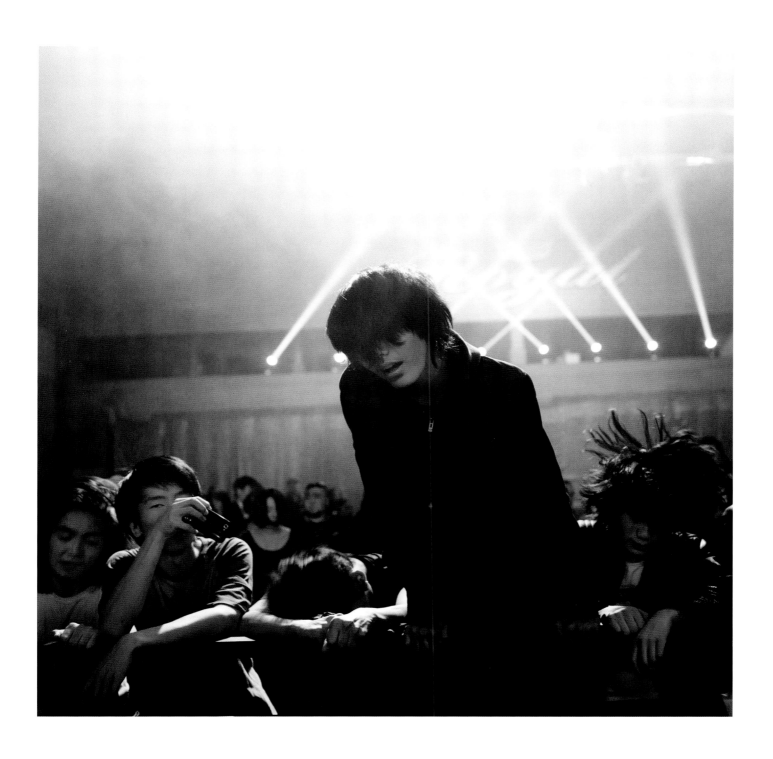

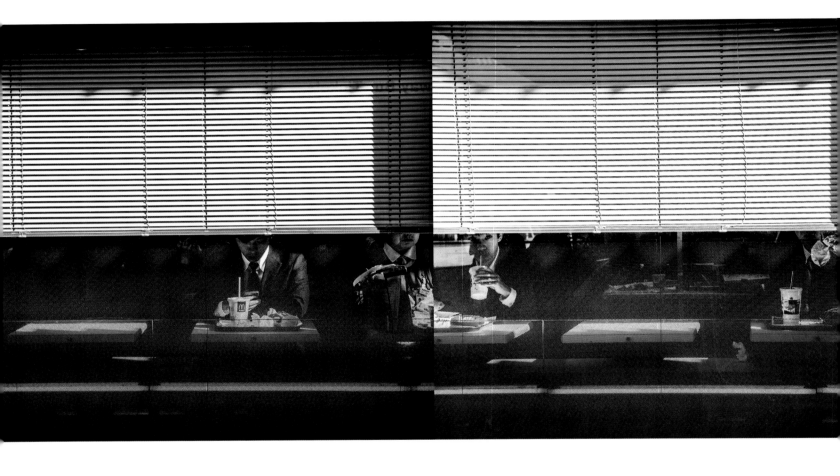

A fast-food restaurant in Nagoya, Japan. In some
modern cultures, the activity of eating is often a
solitary experience: in single seats at solo tables.

Turi Calafato / Italy

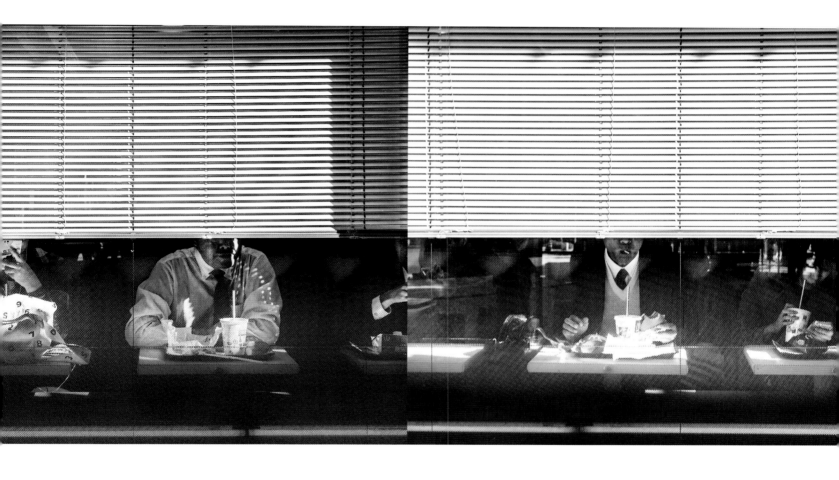

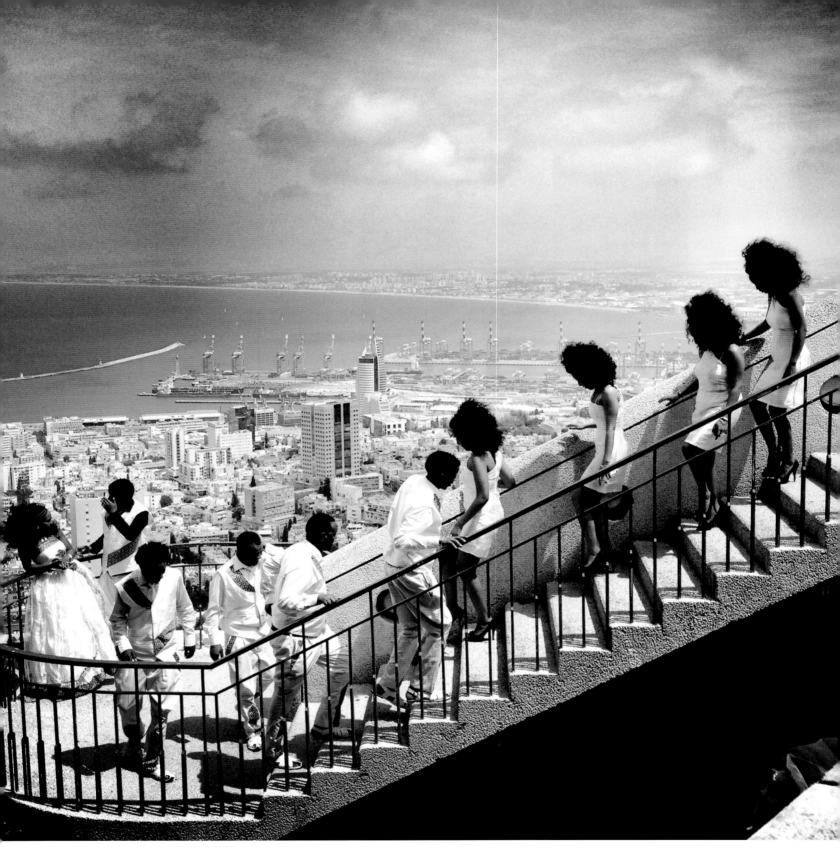

The wedding of an Eritrean couple, who came to Israel as refugees, is celebrated in Haifa. There are around 50,000 African asylum seekers in Israel, mostly from Eritrea and Sudan.

Malin Fezehai / Eritrea/Sweden, for *Time*

Igor whispers into his friend Renat's ear, at school in Baroncea, northern Moldova. It is Igor's birthday, and his grandmother has given him chocolate to hand out to his classmates. Moldova is Europe's poorest country. In the past ten years, one third of the working population has gone abroad in search of better-paying jobs. Children often find themselves looked after by elderly relatives, or left in orphanage boarding schools. Igor has a twin brother. They do not know their father and their mother died soon after leaving to work in Russia, when they were two years old.

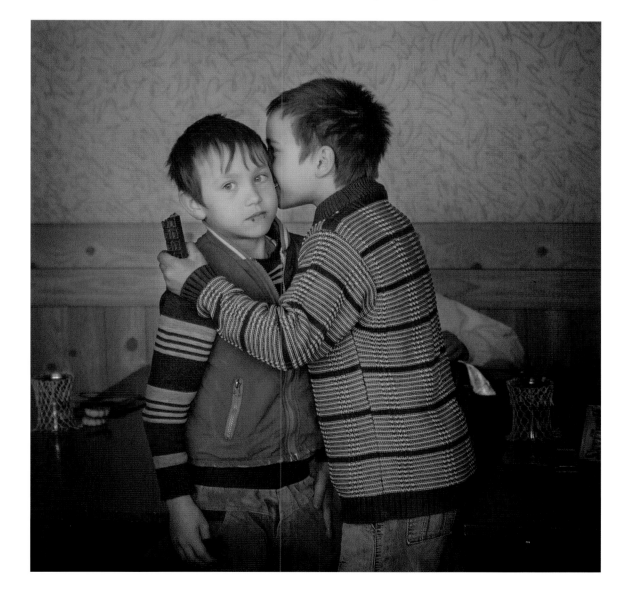

Åsa Sjöström / Sweden, Moment Agency/INSTITUTE for *Socionomen*/UNICEF

Family Love 1993-2014

The photographer, Darcy Padilla, first met Julie Baird on 28 January 1993. Julie was then 18, and was standing barefoot in the lobby of the Ambassador Hotel in San Francisco, with an eight-day-old child in her arms. She was HIV positive, and had a history of drug abuse. For the next 21 years, Padilla documented Julie's life, and that of her family.

Julie's earliest memory of her own childhood was of getting drunk with her mother at the age of six, then being sexually abused by her stepfather. She ran away from home when she was 14, and was a drug addict by the age of 15, living in alleys and crack dens. When Padilla met her, Julie was living with Jack, the father of her first child, Rachel. It was through Jack that Julie became infected with HIV. Julie left Jack in 1994, because he beat her. For a while, Julie lived alone with Rachel, mostly in hotel rooms, moving twelve times in one year. In 1996, she had another child, Tommy, but the father wanted nothing to do with Julie or the baby. After five months with Rachel and Tommy at a Salvation Army live-in program, Julie moved in with a man she had met there, Paul. He was later sentenced to jail for physically abusing Tommy. After losing custody of Rachel and Tommy, Julie entered a rehab program, hoping to be reunited with them.

While in rehab, Julie, now 24, met Jason Dunn, two years younger than she and also HIV positive. Jason, too, had gone through a troubled childhood, and had run away from his adoptive family at the age of 15, surviving for a while as a male prostitute. Over the next three years, Julie and Jason had three children together: Jordan, Ryan and Jason Jr. All three, like Rachel and Tommy, were eventually taken into care by the state. Julie and Jason served a nine-month jail sentence for abducting Jordan from hospital soon after the birth, so that he wouldn't be taken up for adoption.

In 2005, Padilla came across an internet posting by someone looking for Julie. It turned out to be from her biological father, who for three decades had been trying to track her down. Julie and Jason moved to Alaska to be with him, and they had a year together before he died of a heart attack. Later, Padilla also located Jason Jr (now known as Zach) living happily with his adoptive parents, and arranged a meeting with Julie.

In 2008, Julie gave birth to a daughter, Elyssa, but by 2010 life was difficult again. Jason, Julie and Elyssa were living in Alaska, in a house without electricity or running water, more than 30 kilometers from the nearest town, and Julie was very ill. She died, of AIDS-related illnesses, on 27 September 2010, at the age of 36.

After coming across Julie's story, Jason's adoptive parents offered to help. Jason moved with Elyssa to live near them, in a furnished apartment they provided in Portland, Oregon, but he could not cope with life as a single parent. Elyssa would often rage at him, blaming him for her mother's death. Later, Elyssa was taken into care, first by Jason's adoptive sister, and then by a foster family. Jason was jailed for 17 years in 2013, for sexual abuse of a minor, a charge he denies.

Elyssa continues to live with her new family, and is working on coming to terms with her relationship with Julie and with Jason. In 2014, Padilla received an email from a happily married Rachel, who had come across the publication 'The Julie Project', and said that knowing her mother's story had helped her to heal.

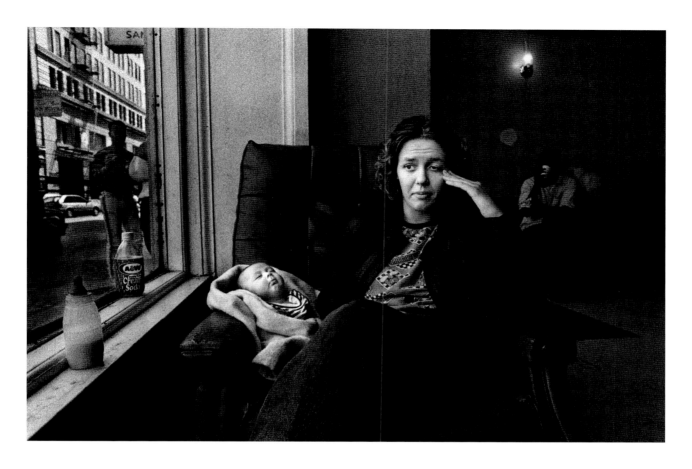

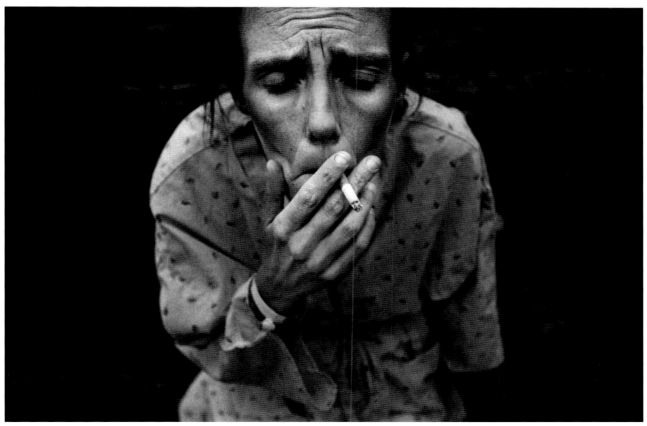

Top: Julie in 1993 with Rachel (aged three months), in the lobby of the Ambassador Hotel, San Francisco, where she lives with her partner, Jack. Below: Julie, in Alaska, in 2008. Following spread: Julie and Rachel in the lobby of the West Hotel in 1995, after breaking up with Jack.

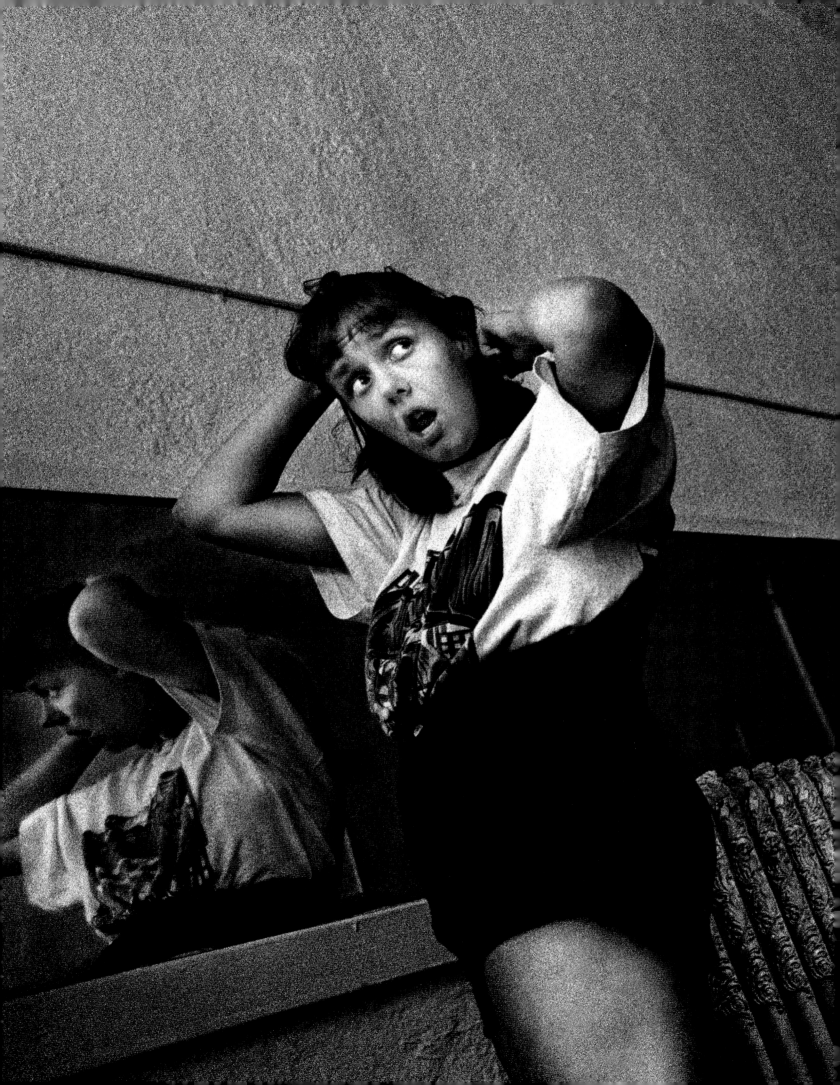

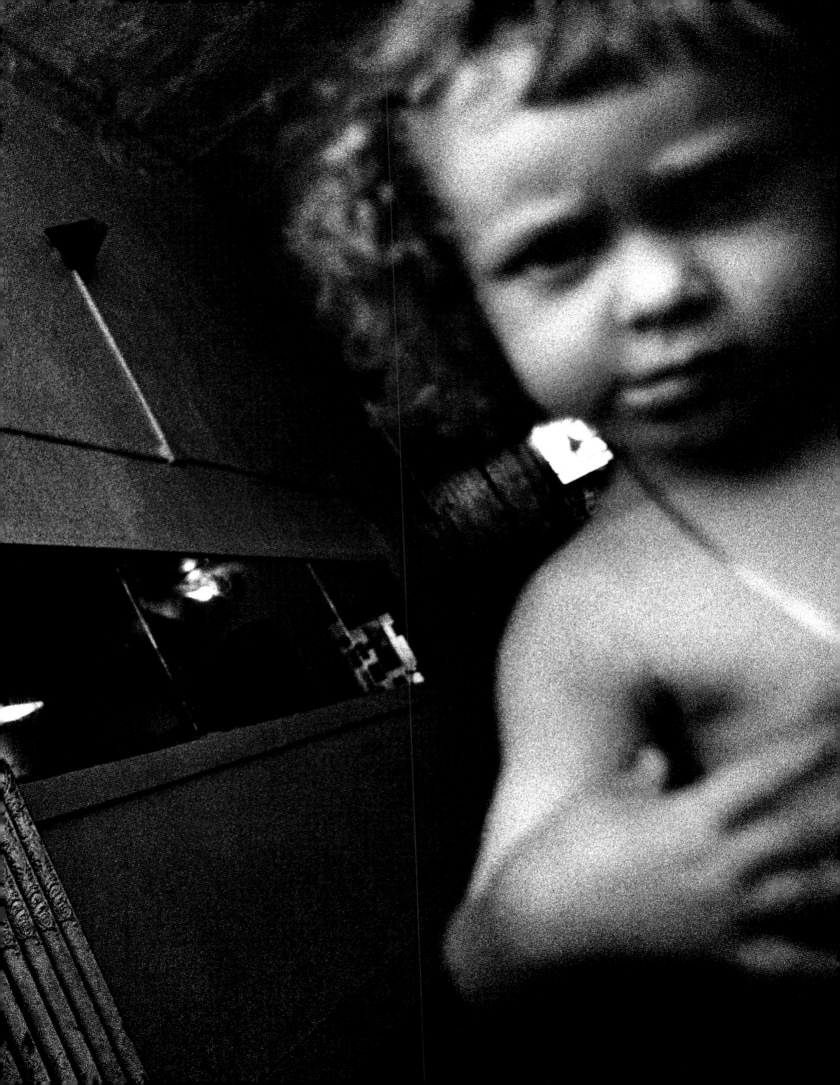

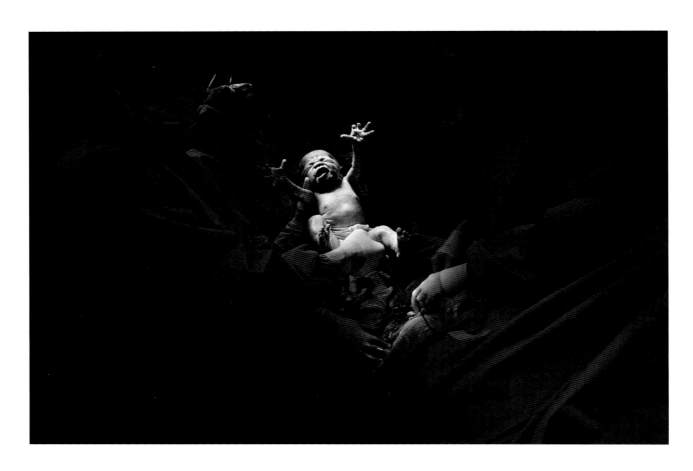

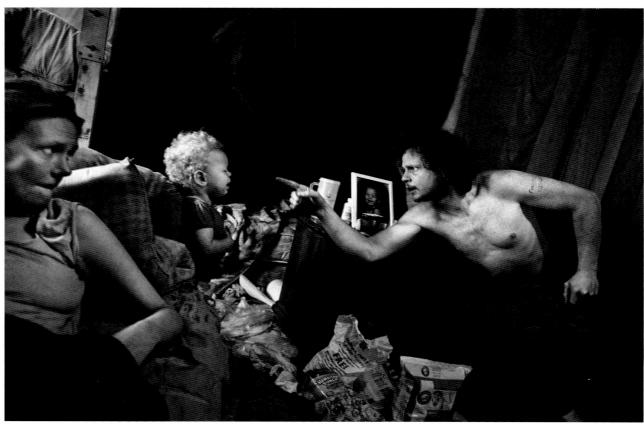

Top: A doctor holds Julie's newborn baby, Elyssa, in 2008. Julie did not want this baby, as she did not want a child to see her die. Below: Julie looks on as Jason scolds Elyssa. Julie takes 35 pills a day to combat her virus.

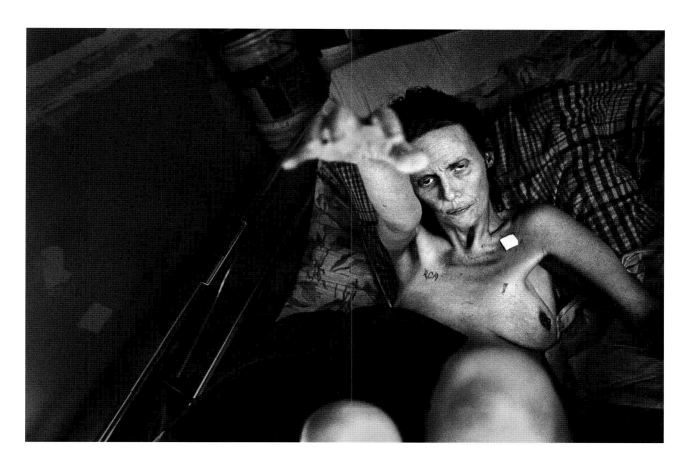

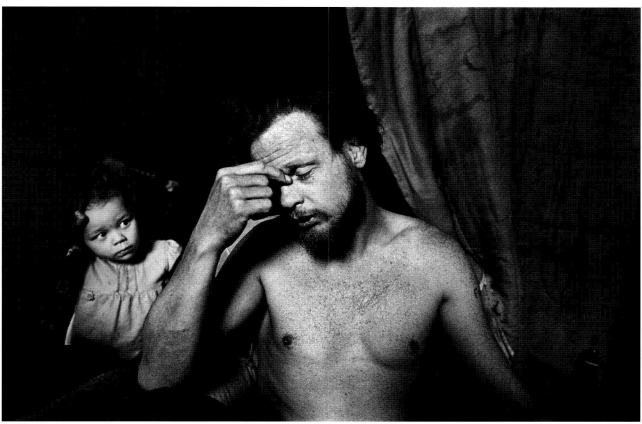

Top: Julie reaches out from bed for someone who is not there, while near to death in 2010. Below: Jason thinks of Julie, six months after her death. He wishes he could have a place of his own, which he could leave to Elyssa. Following spread: Jason and Elyssa in the front yard of their home in Alaska.

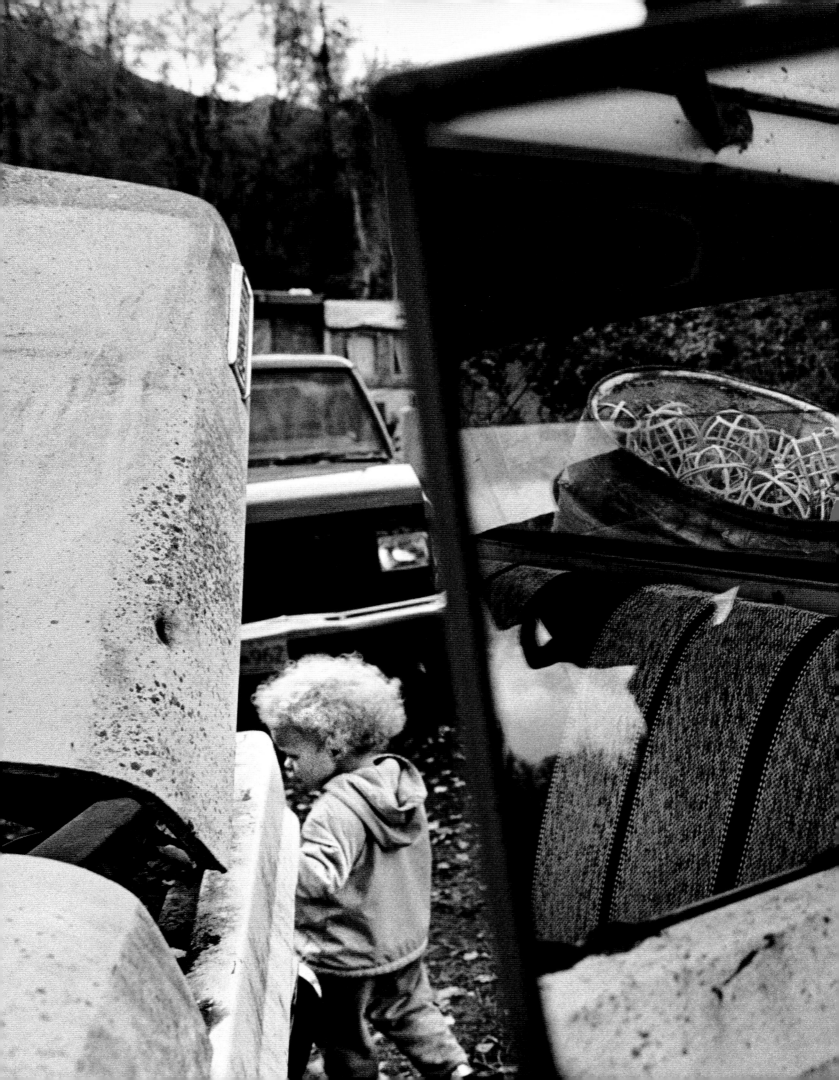

Previous spread: Elyssa plays with her cousin while living with Jason's adoptive sister in Oregon. For the first time, Elyssa has a bedtime routine: brush teeth, read book, pray, and go to bed. Top: Jason disciplines Elyssa, in their new apartment in Oregon. Below: Jason walks to receive his sentence, on a charge of sexual abuse of a minor.

"The story of Julie Baird and her family is a complex one: a story of poverty, AIDS, drugs, multiple homes, relationships, births, deaths and reunion. By focusing on one woman's struggle, I hoped to provide an in-depth look at social issues surrounding disadvantage and HIV, but I also wanted to create a record for Julie's children of their mother's story."

Darcy Padilla

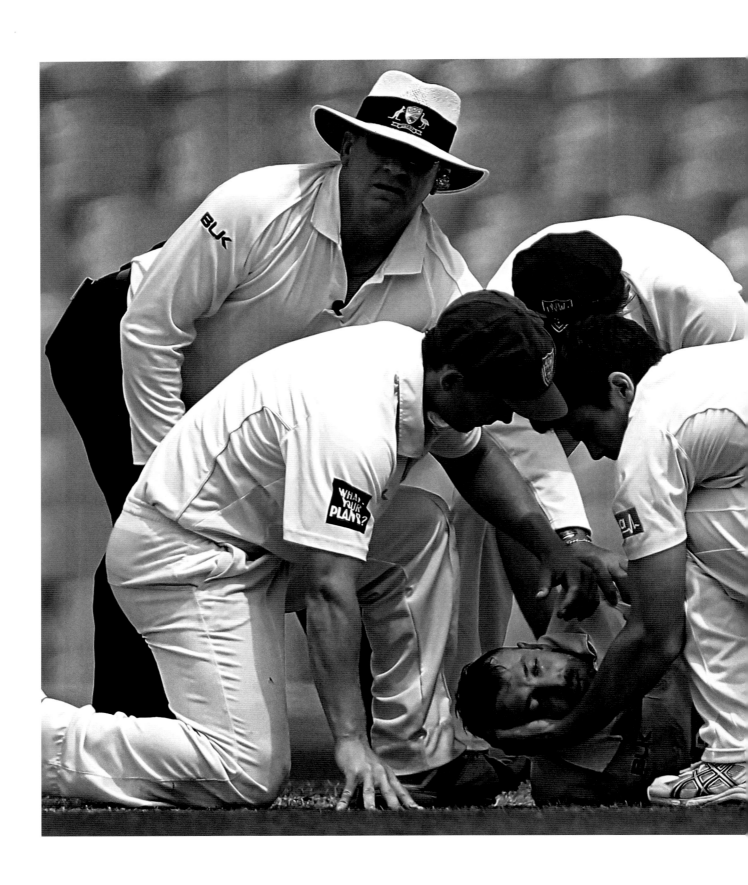

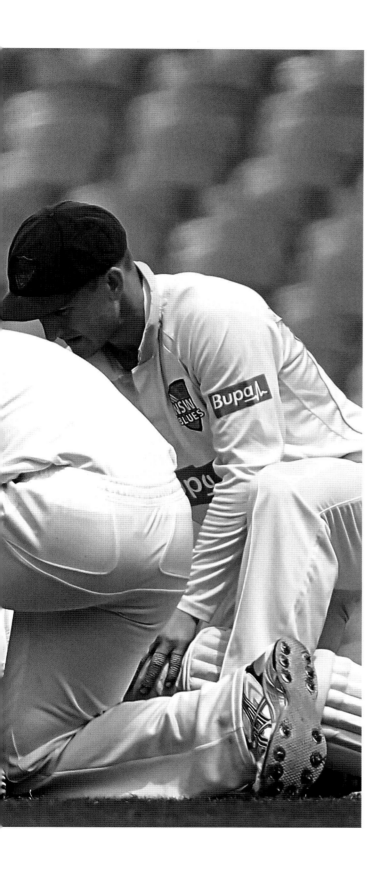

Members of the New South Wales team assist batsman Phillip Hughes of the opposing South Australia team, after he was struck by a ball during a cricket match in Sydney, on 25 November. Balls delivered by fast bowlers in cricket can surpass speeds of 150 kilometers per hour. Hughes was wearing a helmet, but was hit in an unprotected area just behind his left ear. After undergoing surgery in hospital, Hughes was placed in an induced coma. He died on 27 November, having never regained consciousness, three days before his 26th birthday. His death evoked an enormous reaction, internationally as well as nationally. In a symbolic gesture, the official scorecard for his final match was adjusted from 'retired hurt'—the usual wording for a player who has left the field after injury—to '63 not out', which would indicate that he was still batting when the match ended.

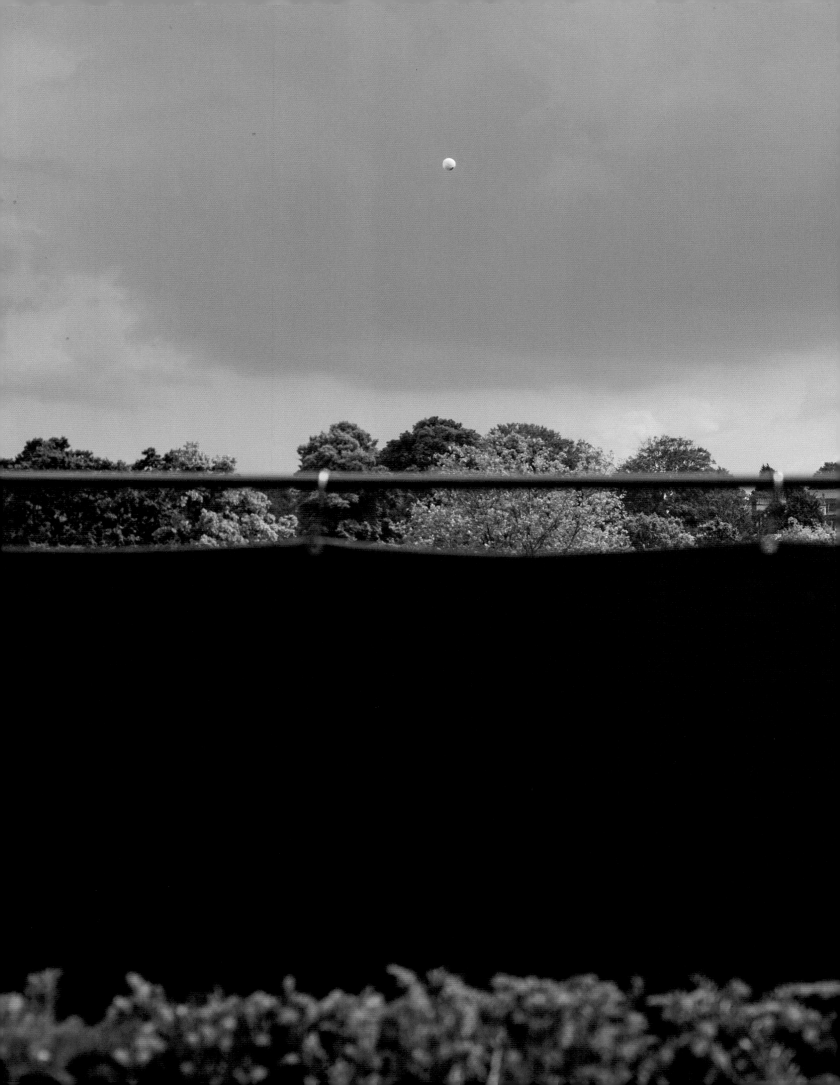

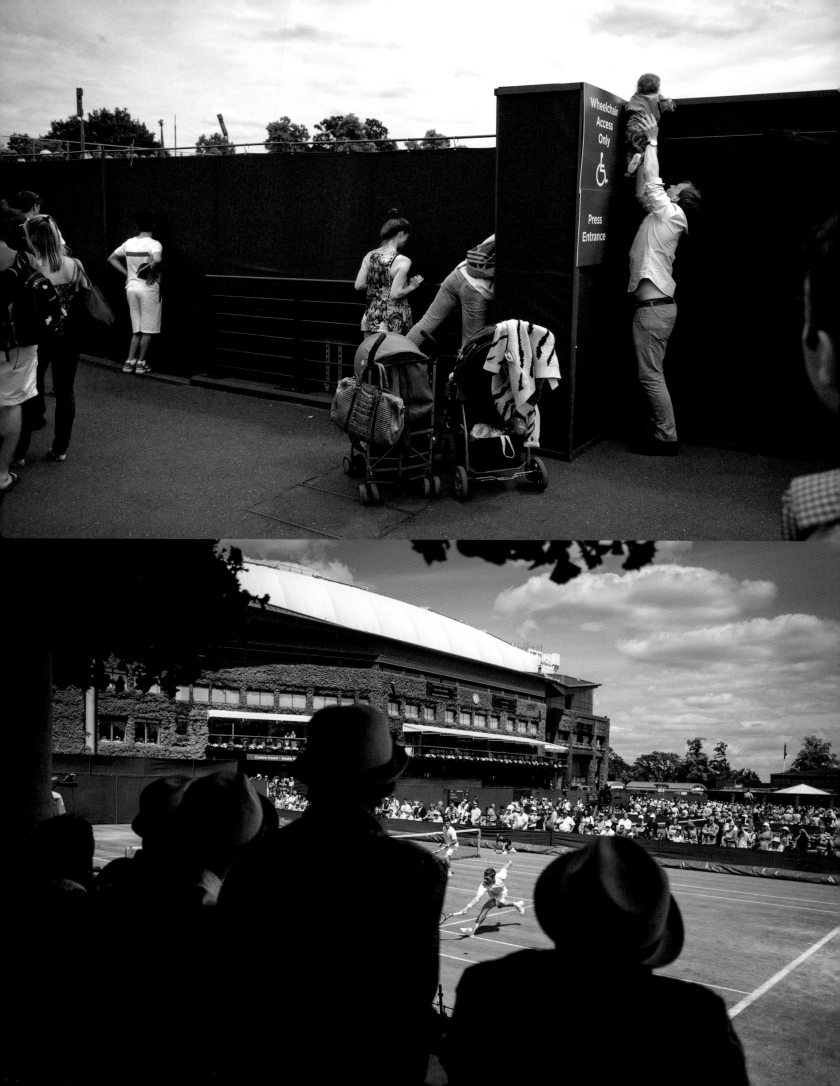

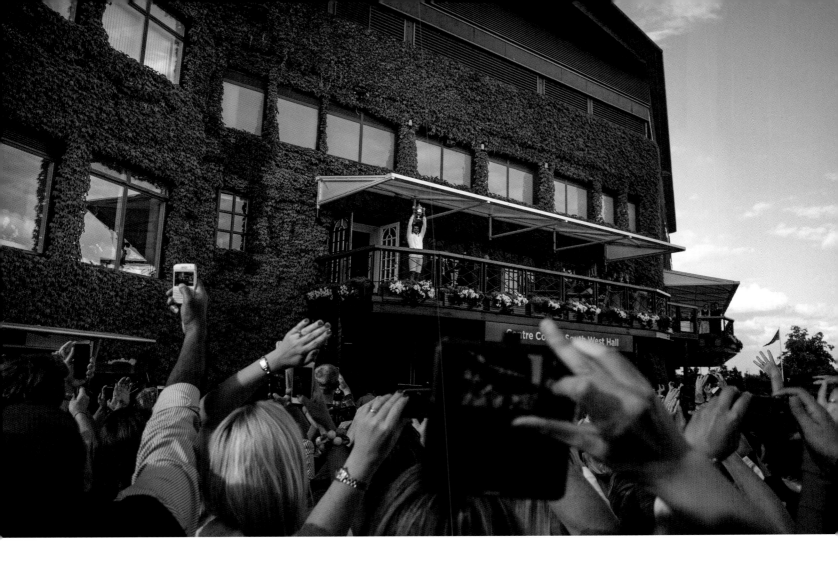

Spectators unable to secure tickets to any of the major show courts at the Wimbledon Championships, may make do with a Grounds Admission pass. This entitles them to wander around the outside tennis courts, where there are unreserved seats and standing is allowed. Even so, capacity is limited, and at times spectators may only be admitted as others leave. Most players, except the top seeds, can at some point during the Championships be seen playing on the outside courts. Previous spread: A ball flying above a fence is often the first glimpse a Ground Admissions pass-holder will have before setting eyes on a court. Facing page, top: Spectators with ground tickets find creative ways of watching play on Court 12. Above: Spectators photograph the 2014 Wimbledon champion, Novak Djokovic, as he holds up his trophy on the clubhouse balcony.

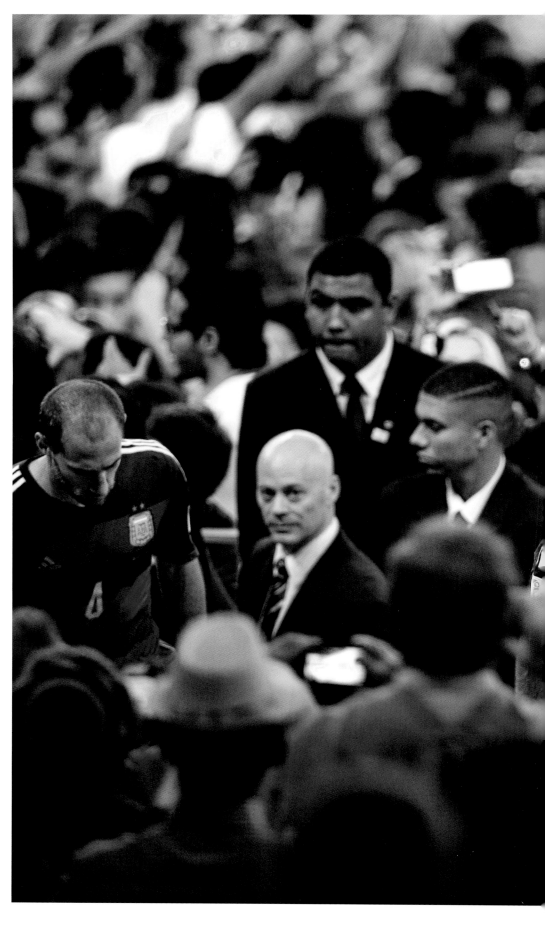

Argentina player Lionel Messi faces the World
Cup trophy during the final ceremony at Maracana
Stadium, in Rio de Janeiro, Brazil, on 13 July.

Bao Tailiang / China, *Chengdu Economic Daily*

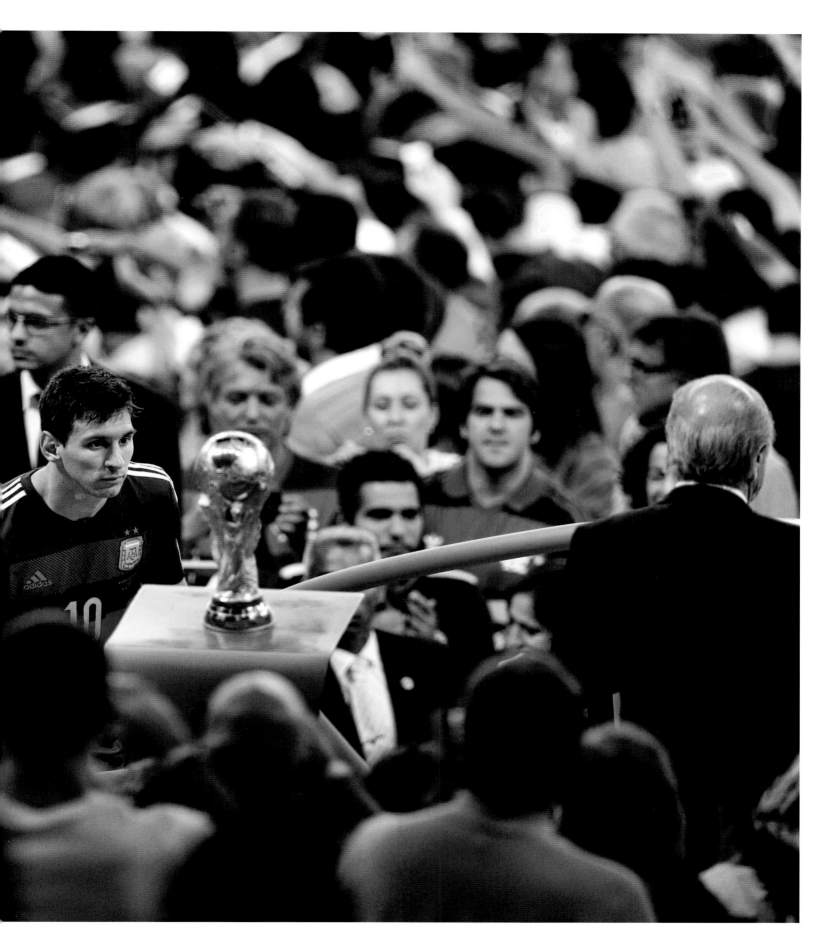

Argentina lost to Germany 1-0, after a goal by Mario Götze in extra time. Messi, who is ranked as one of the best footballers in the world, was awarded the Golden Ball, as the tournament's best player—a decision that sparked controversy, as he had scored no goals in the knock-out stage.

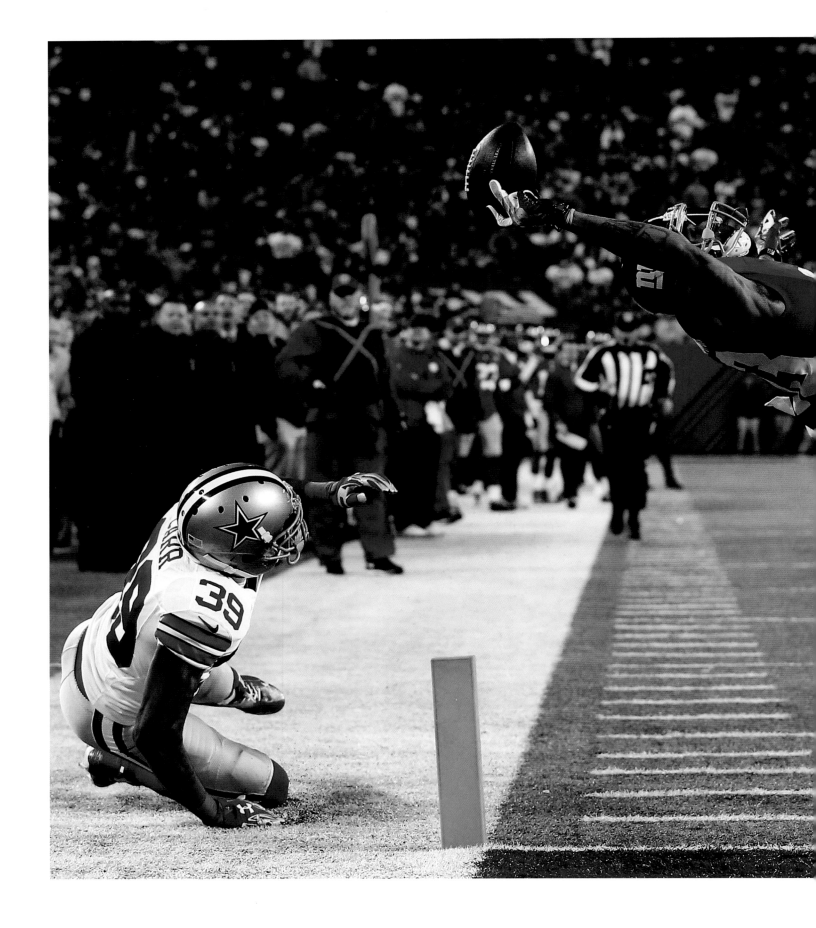

Al Bello / USA, Getty Images

Odell Beckham of the New York Giants makes a one-handed touchdown catch, in the second quarter against the Dallas Cowboys at the MetLife Stadium, in East Rutherford, New Jersey, USA, on 23 November. He made the catch, despite pass interference, while diving backwards with full extension of his right hand using only three fingers. Leading footballers dubbed it the 'catch of the year', and Beckham's jersey from the match was later put on display in the Pro Football Hall of Fame.

Ski-jumpers in the flight stage of their jump, during the HS134 night event at the FIS Ski Jumping World Cup, in Nizhny Tagil, Russia, in December. Aerodynamics is an important factor in the sport, and strict regulations govern the foil-like suits participants wear. Facing page: Jurij Tepes, of Slovenia. Following spread, top left: Anders Fannemel, of Norway, who won first place in the first competition, on 13 December. Right: Markus Eisenbichler, of Germany, in the qualification round. Bottom row, left: Matjaz Pungertar, of Slovenia, in the second competition, on 14 December. Right: Marinus Kraus, of Germany, in the qualification round.

Sergei Ilnitsky / Russia, European Pressphoto Agency

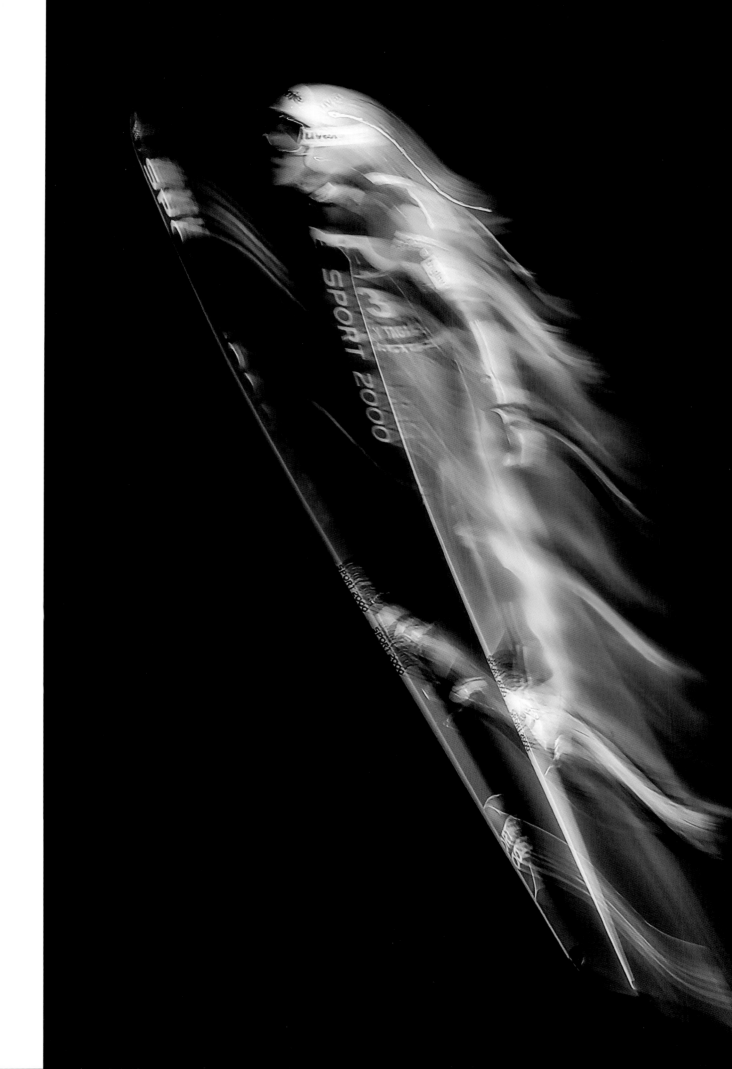

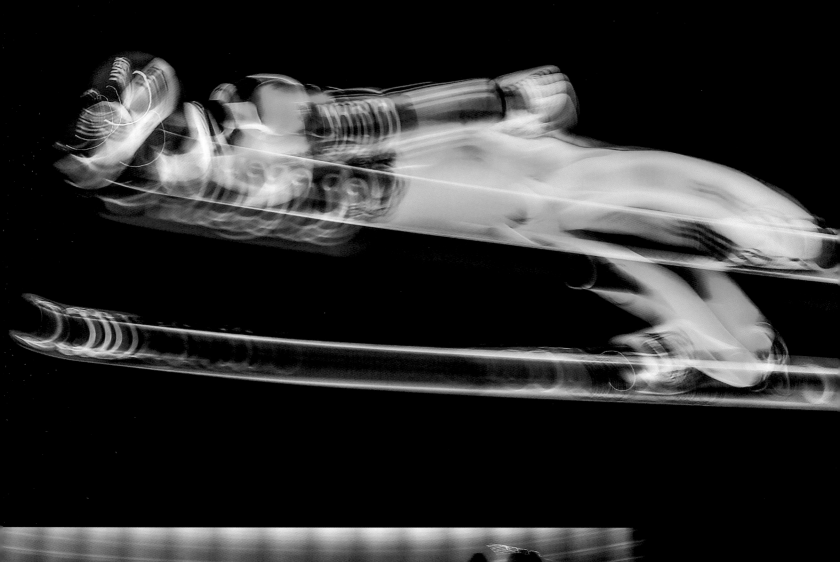

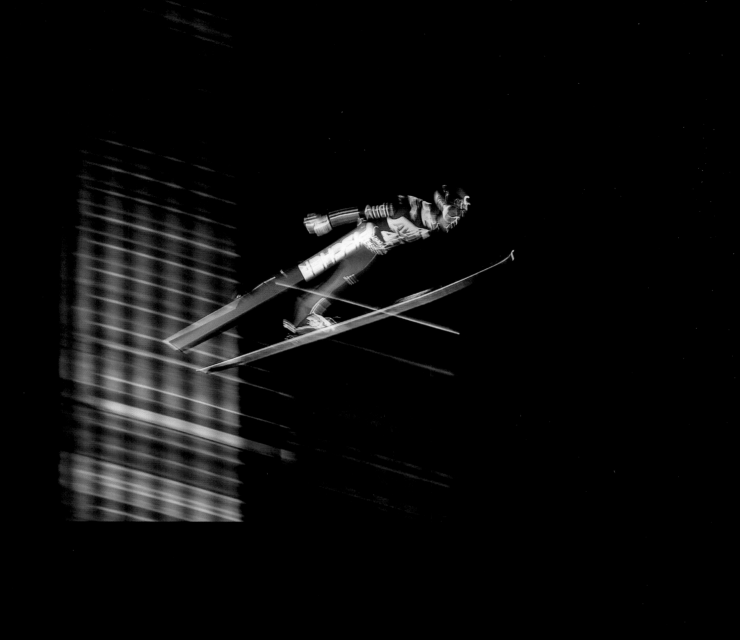
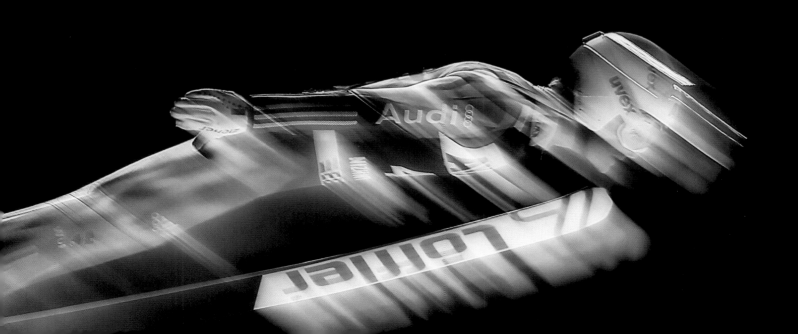

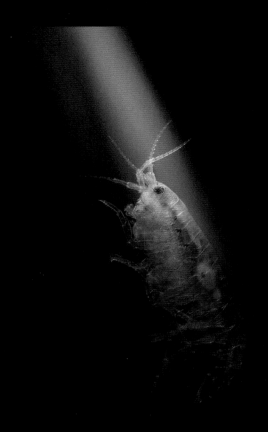

Many parasites not only feed off their hosts, but appear to manipulate the host's behavior in a way that is advantageous to the parasite's life cycle. Recent research indicates that this influence occurs at a genetic level—certain parasite genes seem to be able to take control of the host's brain. Above: *Hyalella azteca*, a tiny amphipod, lives at the bottom of lakes and ponds. Amphipods that have been invaded by the larva of a thorny-headed worm abandon the dark safety of the depths and swim to the surface. For the amphipod, this journey proves fatal, as it is a favored food of waterfowl, but for the larva (turned orange by pigments taken in from the host's tissue) it is essential. Thorny-headed worms can grow to maturity only in the gut of waterfowl.

Facing page, top: Larvae of horsehair worms infiltrate house crickets when they scavenge dead insects, and then grow inside them. The cricket is terrestrial, but the adult stage of the worm's lifecycle is aquatic. When the worm is mature, it alters the cricket's brain, causing it to leap into the nearest body of water. As the cricket drowns, the mature worm emerges. Below: The parasitic *Hymenoepimecis argyraphaga* wasp lays its egg on the abdomen of a *Leucauge argyra* spider. The larva feeds on the spider's body fluids. As the larva pupates, the spider begins to rip down its web and reconstruct one that is perfect for protecting the larva's cocoon from predators. The larva forms its cocoon after sucking the spider dry. (continues)

Anand Varma / USA, for *National Geographic* magazine

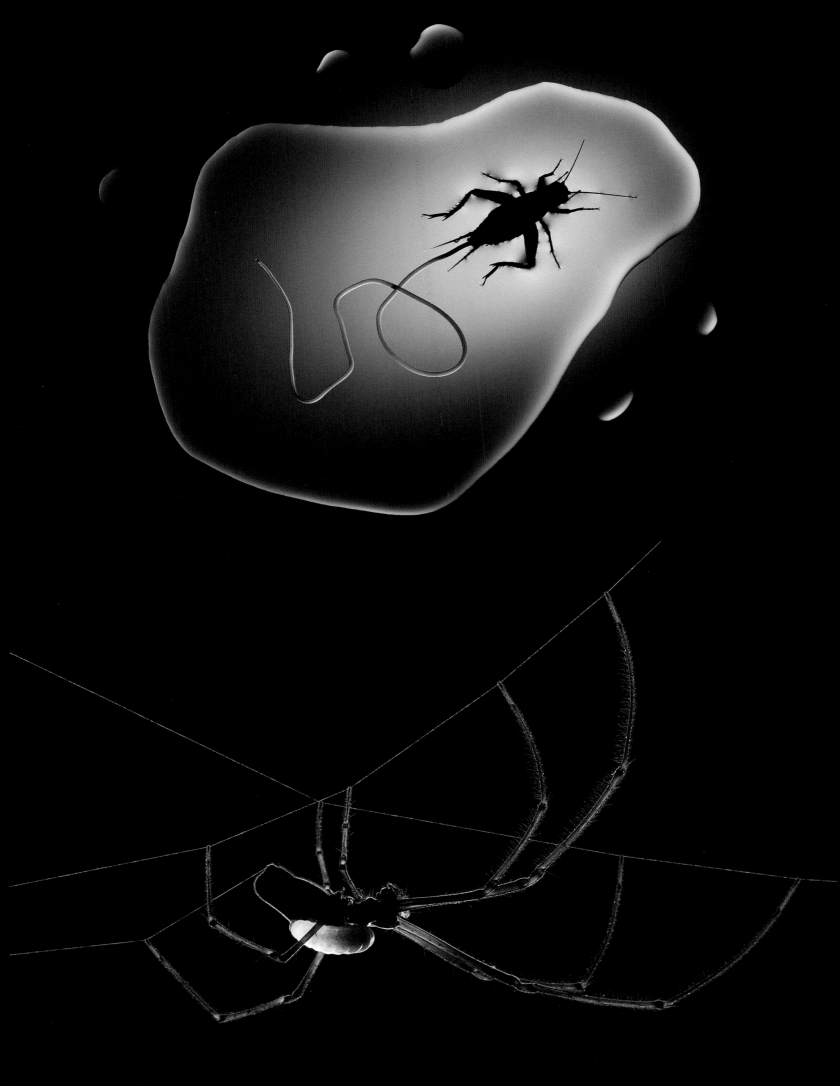

(continued) Research has shown that in some cases a single parasite gene is responsible for altering the host's behavior, though in most instances it is thought that the phenomenon is brought about by a combination of genes. Right: When spores of an *Ophiocordyceps* fungus land on an Amazonian ant, they penetrate its exoskeleton and enter its brain, compelling the host to leave its normal habitat on the forest floor and scale a nearby tree. Filled with the fungus, the dying ant fastens itself to a leaf or another surface. Fungal stalks burst from the ant's husk and scatter spores onto ants below, to begin the process again.

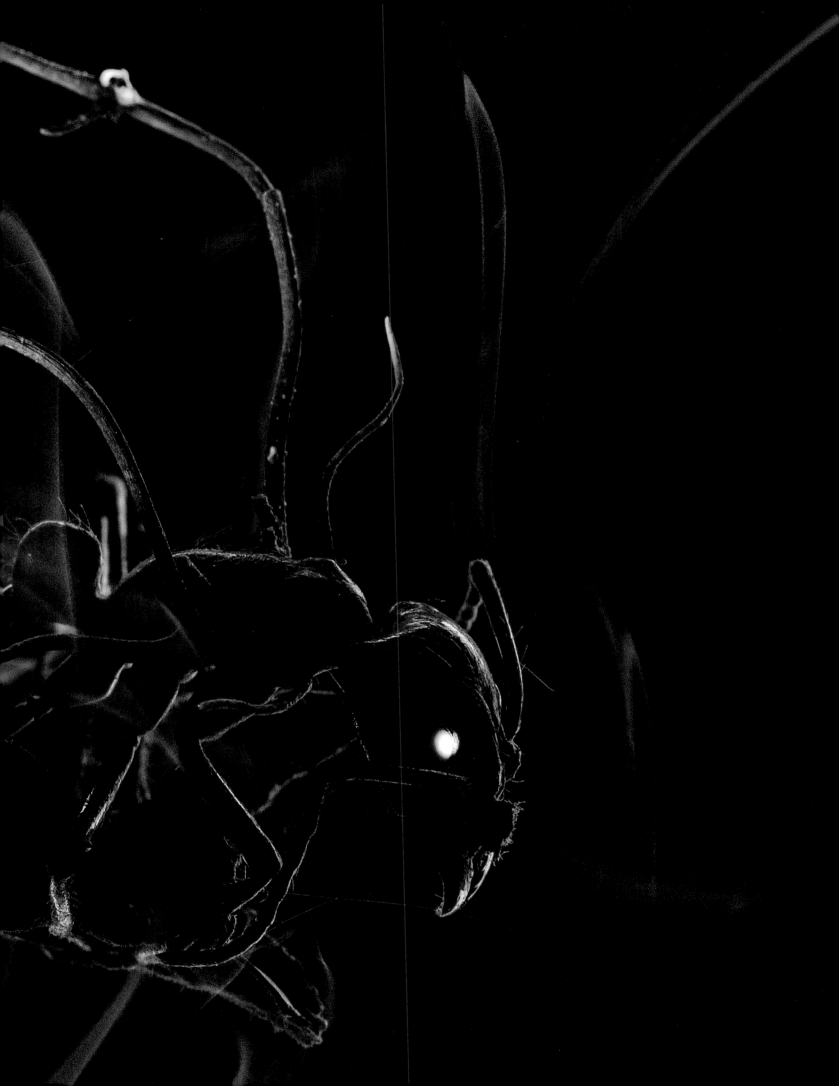

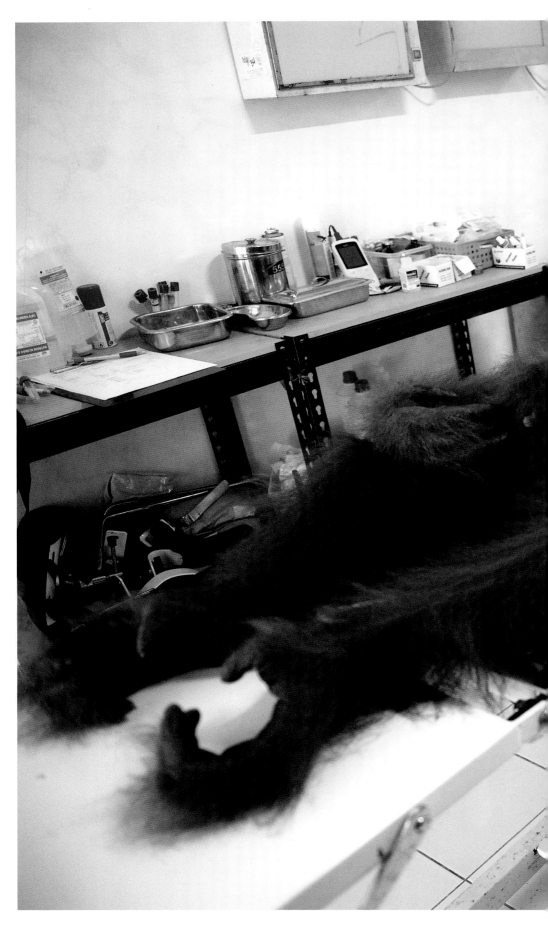

Angelo, a 14-year-old male orangutan, lies waiting for medical examination, in the Sumatran Orangutan Conservation Program (SOCP) care center in North Sumatra, Indonesia. He was found with air-gun pellets embedded in his body, in a palm-oil plantation. Globally, the demand for palm oil

Sandra Hoyn / Germany, Laif

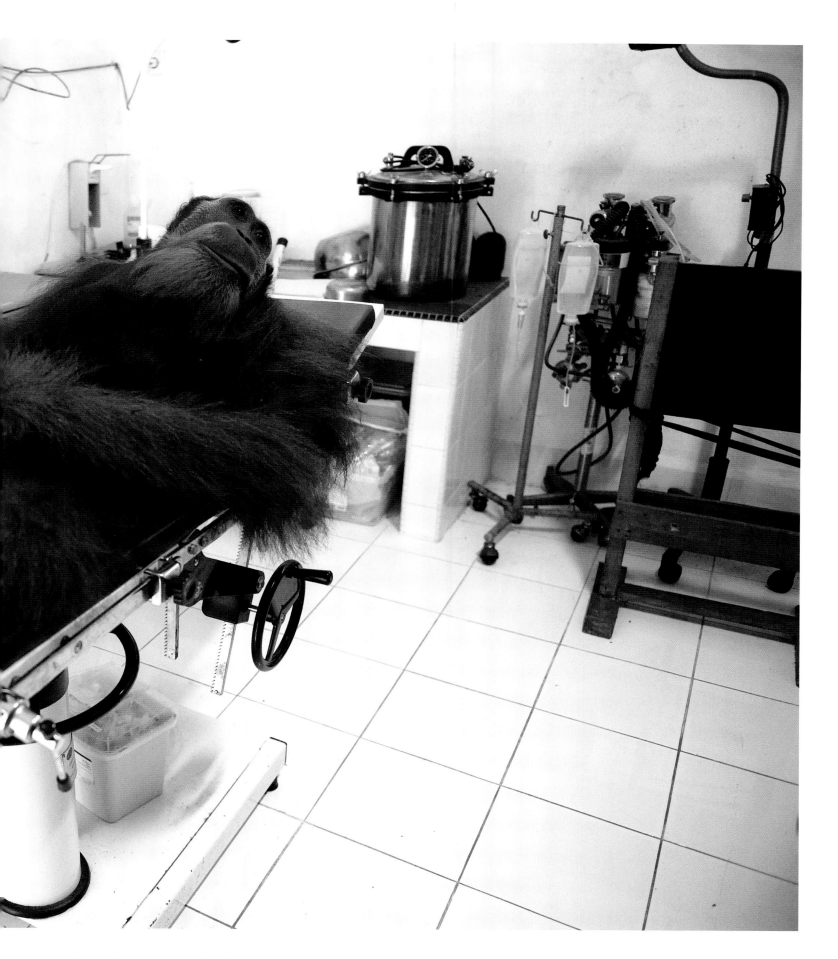

(used in food, cosmetics, and as bio-fuel) is growing rapidly, and Indonesia is a market leader. The loss of their rainforest habitat, largely to make way for palm plantations, has brought orangutans almost to extinction in Indonesia.

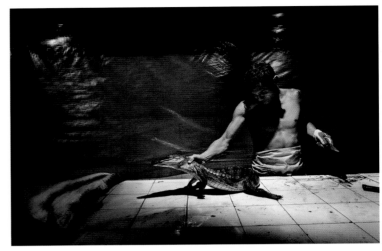

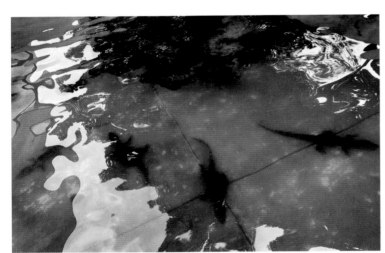

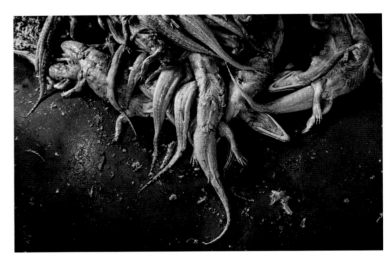

The skin of Colombian caimans, once considered inferior to alligator or crocodile, is now prized for its durability and quality. Production has soared since the 1990s. These days, most skins are obtained from farmed animals, rather than from the wild, and farmers are legally obliged to return a number of caiman to the wild to replenish natural stocks. Top row, left: One of two weekly meals for 250 adult caiman lies beside their tank. The animals are fed a mix of minced cattle offal with up to 20 percent caiman meat. Right: A specialist worker prepares to kill a caiman with a single cut to its throat. Below, left: Liquid antibiotics are added to a tank of baby caimans, to prevent disease. Right: Caiman carcasses lie in a pile after being skinned. The process is carried out by hand. Facing page, top row, left: Freshly slaughtered caimans lie in what workers call 'the hall of sacrifice'. Right: Caiman skins hang stretched out to dry, after initial cleaning. Below, left: Caimans are captured by hand by experienced handlers, who use a rubber band around the animal's mouth to avoid getting bitten. Right: Caiman skins go on display in Milan, Italy, during Lineapelle, an international leather trade-fair.

Paolo Marchetti / Italy

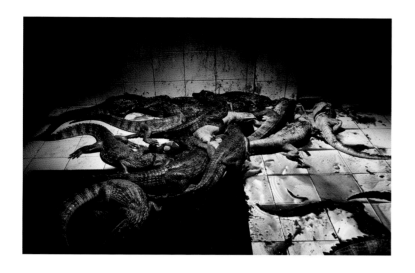

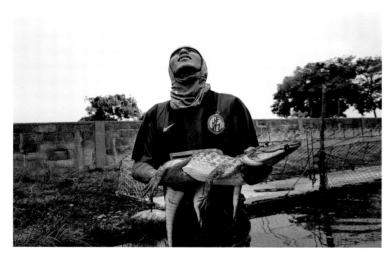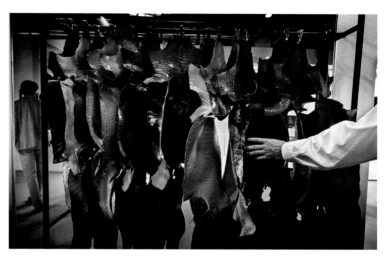

A rhesus macaque cowers as its trainer approaches, while training for a circus act, in Suzhou, eastern China. Performing animals in circuses and zoos are enormously popular in China. After years of pressure from animal-welfare groups, the Chinese government has banned animal circuses, and implemented regulations to stop abuse at state-owned zoos, but many trainers say they have not heard of the ban, nor have any intention of stopping. Authorities in Suzhou, which with its 300 troupes is known as the hometown of circus in China, have announced plans for developing alternative circus entertainment, without performing animals.

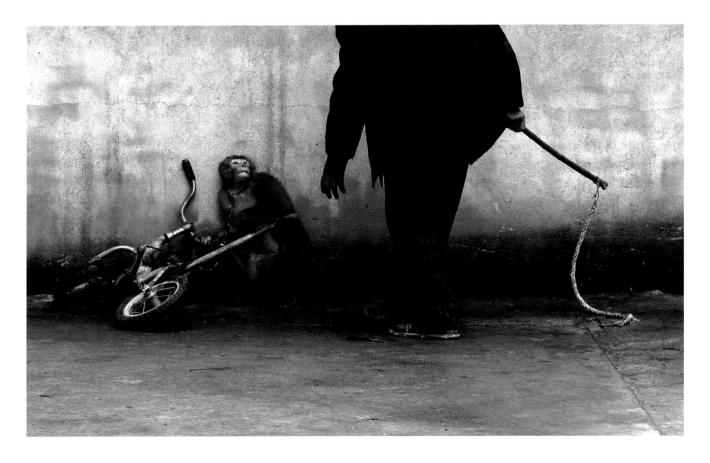

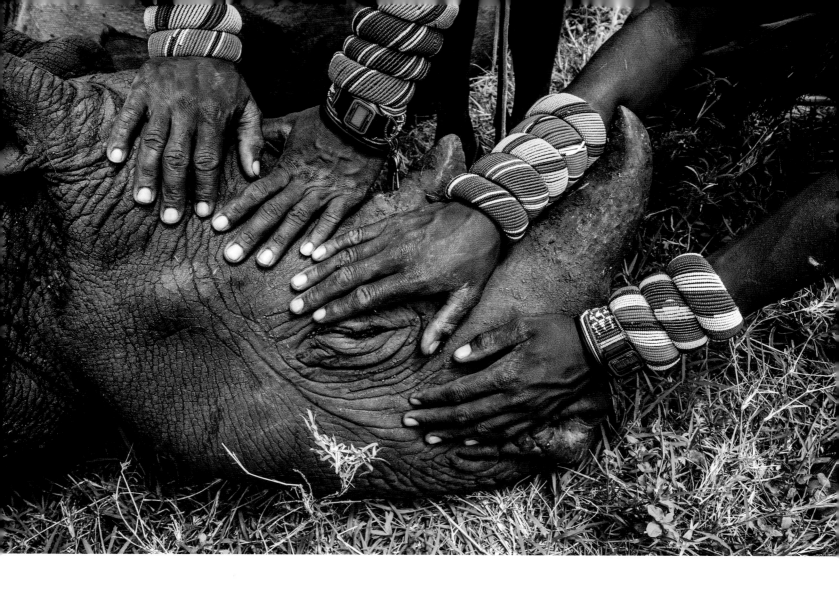

A group of young Samburu warriors touch a black rhino for the first time in their lives, at the Lewa Wildlife Conservancy, in northern Kenya. Black rhinos are almost extinct in Kenya. This young calf had been orphaned when poachers killed its mother, and was hand-raised at Lewa. Most people in Kenya never get the opportunity to see the wildlife living around them, especially at such close quarters. Attention is often given to the effect of poaching on wildlife, but there is little focus on indigenous communities, who are on the frontline in the clash between poachers and armed game wardens.

Ami Vitale / USA

Christian Ziegler / Germany, *Geo*

Carnivorous plants have evolved in a number of different parts of the world, generally in response to low-nutrient environments. While other plants are struggling to find nutrients such as phosphorus and nitrogen, carnivorous plants gather food in ingenious ways. Until recently, scientists thought all carnivorous plants operated in a similar way, catching insects and digesting them. But we are now discovering plant-animal interaction to be more complex, and to involve all manner of sophisticated symbiotic relationships. Facing page: A Villose pitcher plant (*Nepenthes villosa*) growing among orchids, 3,100 meters above sea level, on the slopes of Mount Kinabalu on the island of Borneo. Its pitcher-shaped leaves trap and digest small organisms. Snails often use the pitchers of this species to lay their eggs in—a reliably moist and safe environment that is hard to find on the steep slopes, in harsh sunlight. (continues)

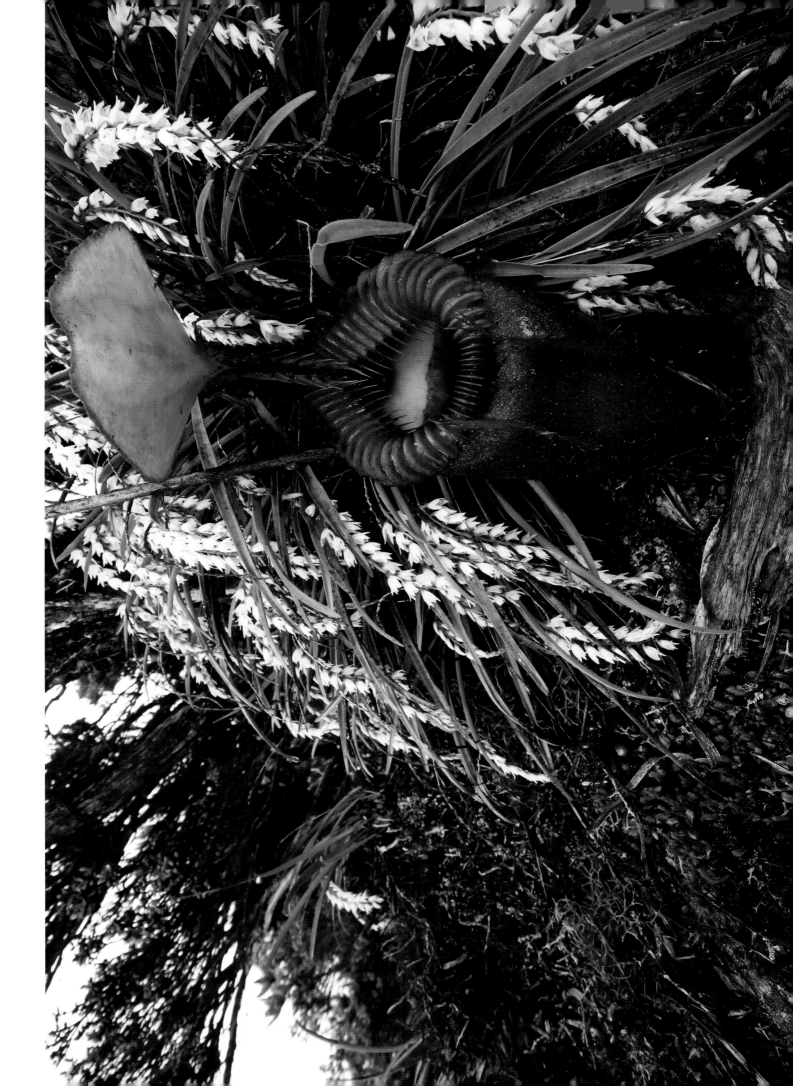

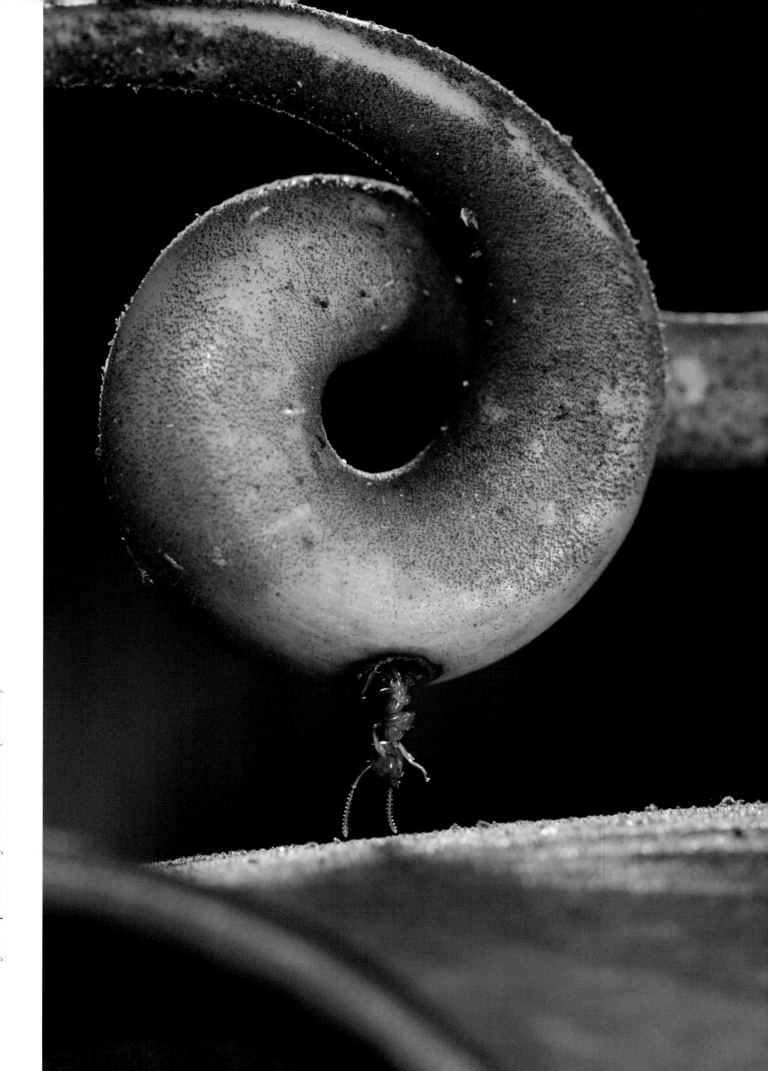

(continued) A complete colony of ants lives inside the stem of this plant, foraging inside the pitcher for insects. They are resistant to the plant's digestive juices, and can swim in the liquid without harm. The ants take only large insects, which would disrupt the digestive chemistry of the pitcher if they were not removed. (continues)

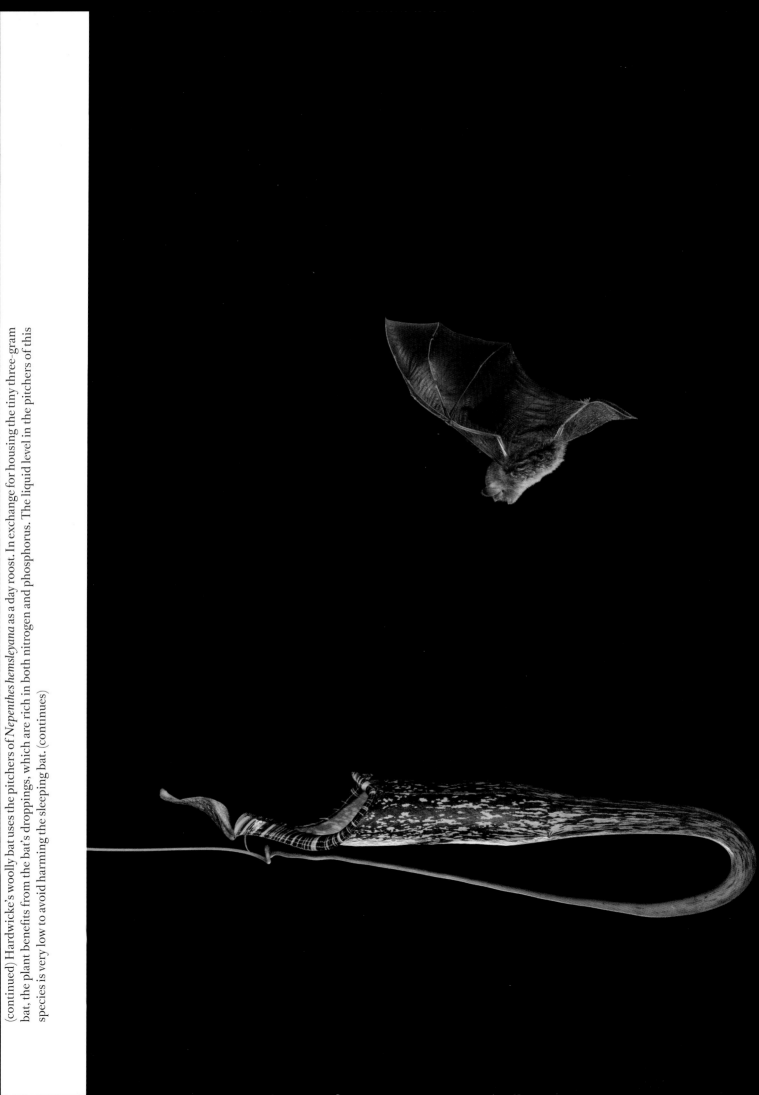

(continued) Hardwicke's woolly bat uses the pitchers of *Nepenthes hemsleyana* as a day roost. In exchange for housing the tiny three-gram bat, the plant benefits from the bat's droppings, which are rich in both nitrogen and phosphorus. The liquid level in the pitchers of this species is very low to avoid harming the sleeping bat. (continues)

(continued) The flask-shaped pitcher plant (*Nepenthes ampullaria*) is unusual in that the enzymes in its digestive liquid are best suited to breaking down plant matter. The pitchers collect and digest falling leaf litter. (continues)

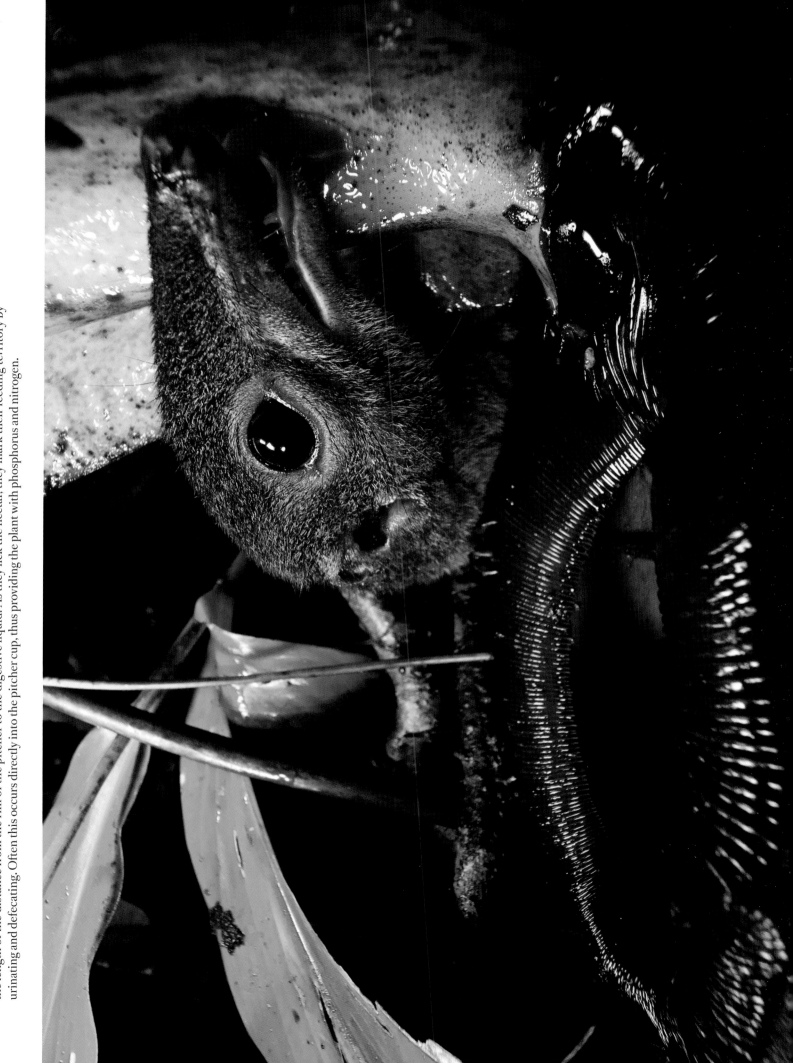

(continued) *Nepenthes rajah* has some of the largest pitchers of the genus, with a capacity of three liters. The plant has been known to capture lizards and small mammals, but tree shrews lick the nectar that gathers beneath the lid of the pitcher unscathed. Their bodies are precisely the length of the distance from the rim of the pitcher to the digestive liquid. As they lick the nectar, they mark their feeding territory by urinating and defecating. Often this occurs directly into the pitcher cup, thus providing the plant with phosphorus and nitrogen.

Side Effects

Kacper Kowalski is a pilot and a photographer. Side Effects is a documentary project about the complex relationship between humans and nature. The photos were shot either from a paraglider or a gyroplane, some 150 meters above the ground, mainly in the area around Gdynia, in Poland, where Kowalski lives. In this work, Kowalski explores answers to questions that deeply interest him: What is the natural environment for humans? Is it an untouched, virgin landscape? Or is it a landscape that has changed, adapted to human needs?

Kowalski sees his work as offering a graphic and sometimes abstract portrait of how civilization came into being. For Kowalski, the content of the photo is less important than the reactions, reflections, and ideas that arise when looking at it. He would like the project to be a starting point for discussion about what is good or bad, necessary or optional, in the relationship between humans and nature.

The camera is never connected to a remote control, and Kowalski never uses a drone. He wants to be up there, camera in hand. And he flies alone. That means he doesn't have to explain anything, or rely on another person's spatial imagination. It means he can fly precisely.

Side Effects is more a method of visual storytelling than a concrete set of pictures. It is an ongoing project that will continue to be modified.

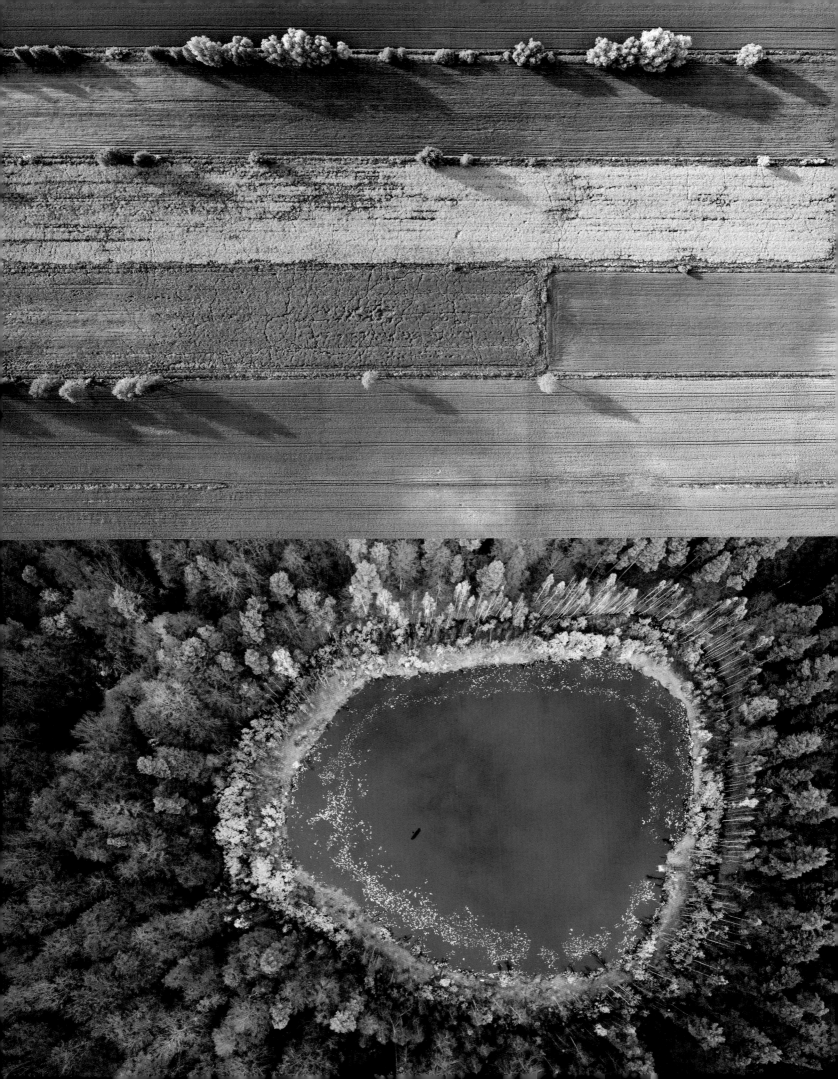

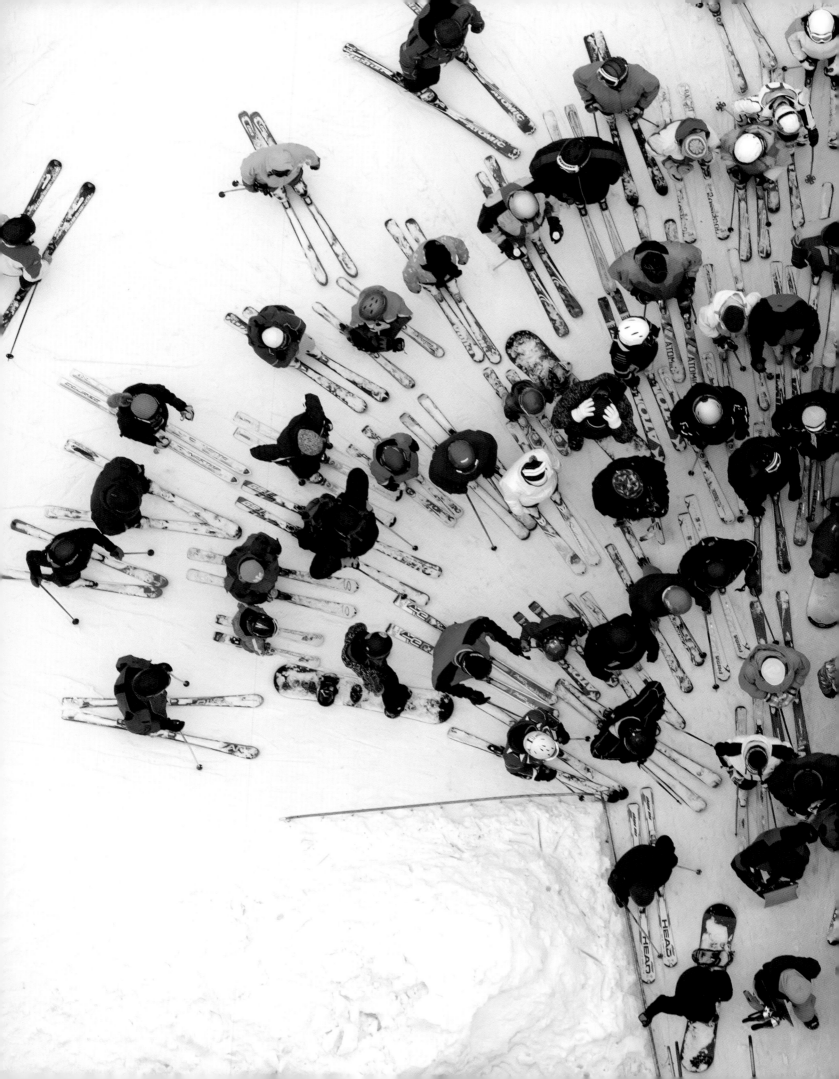

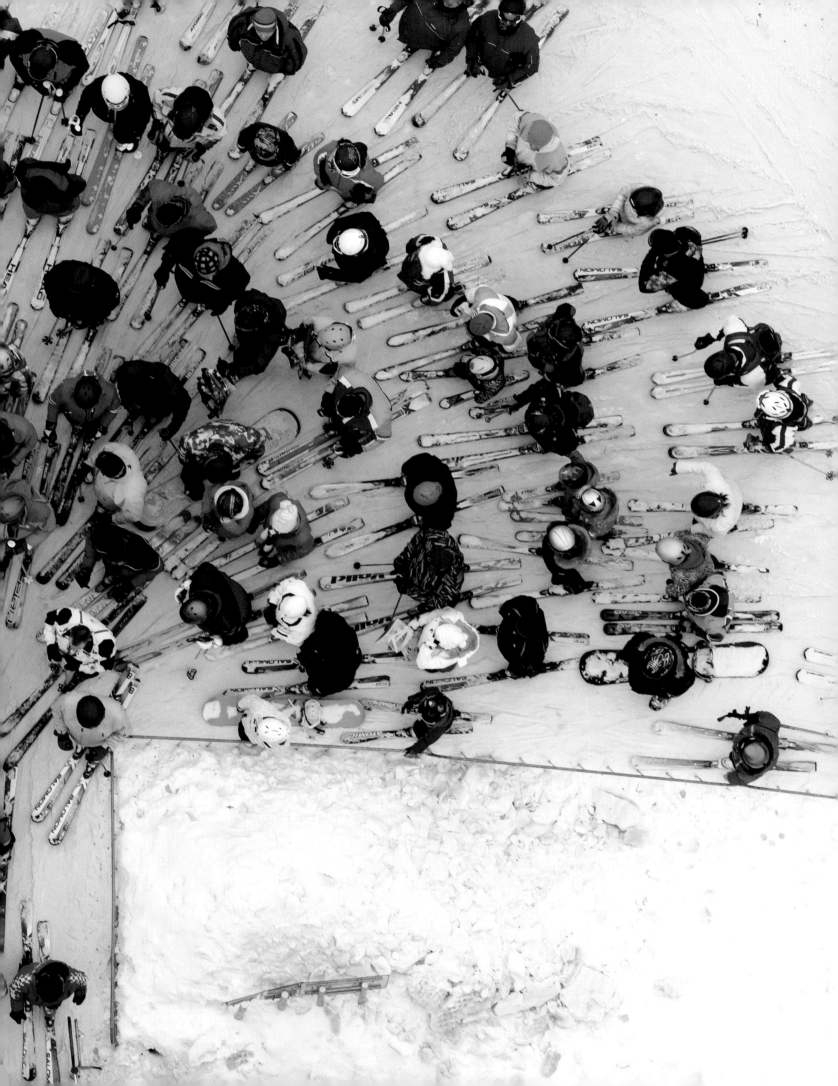

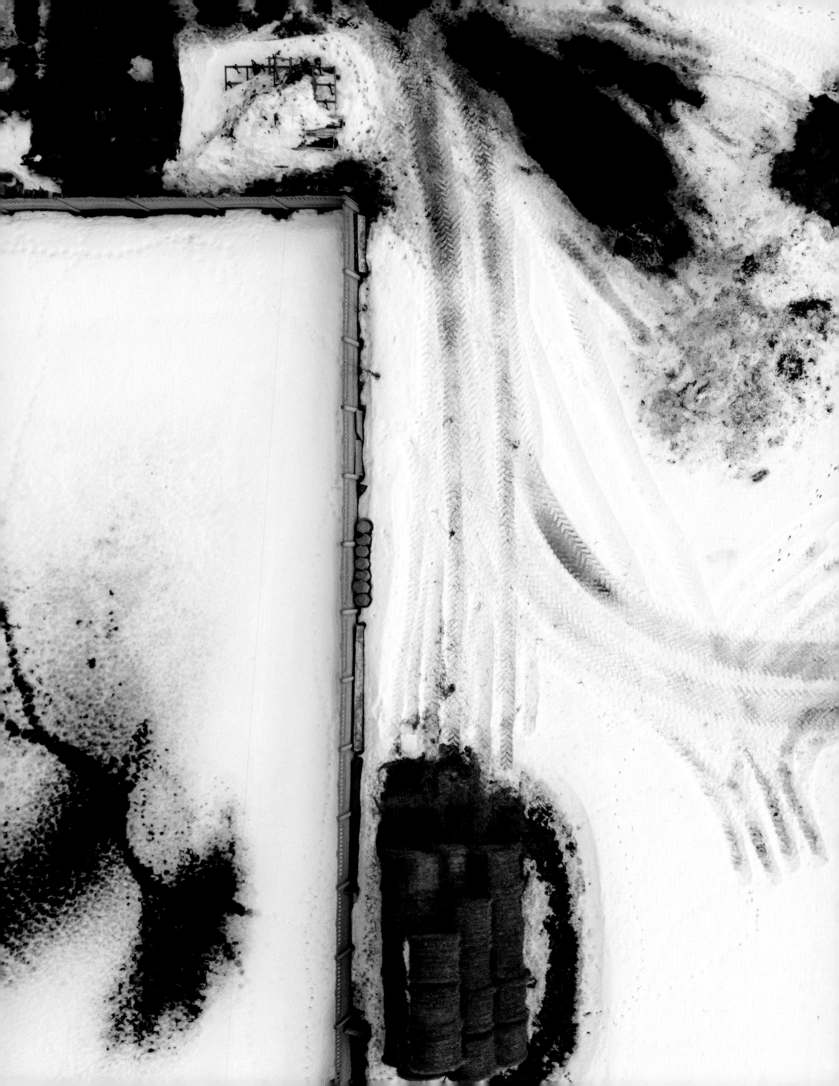

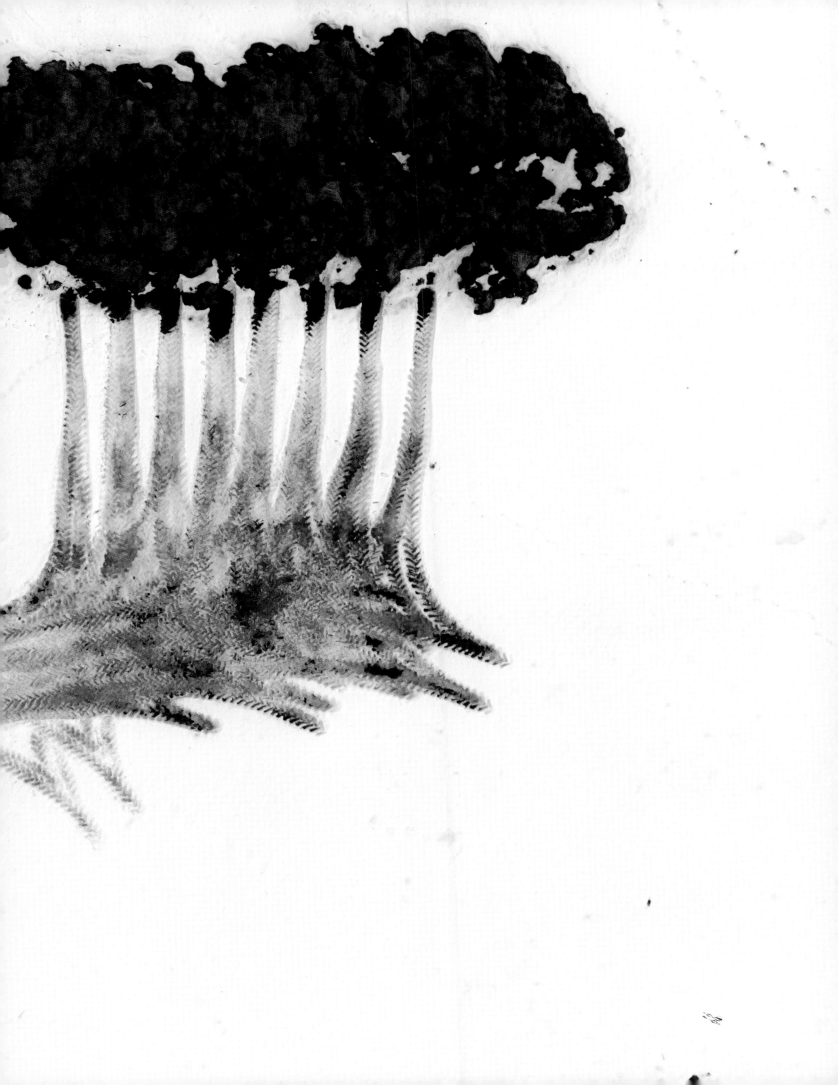

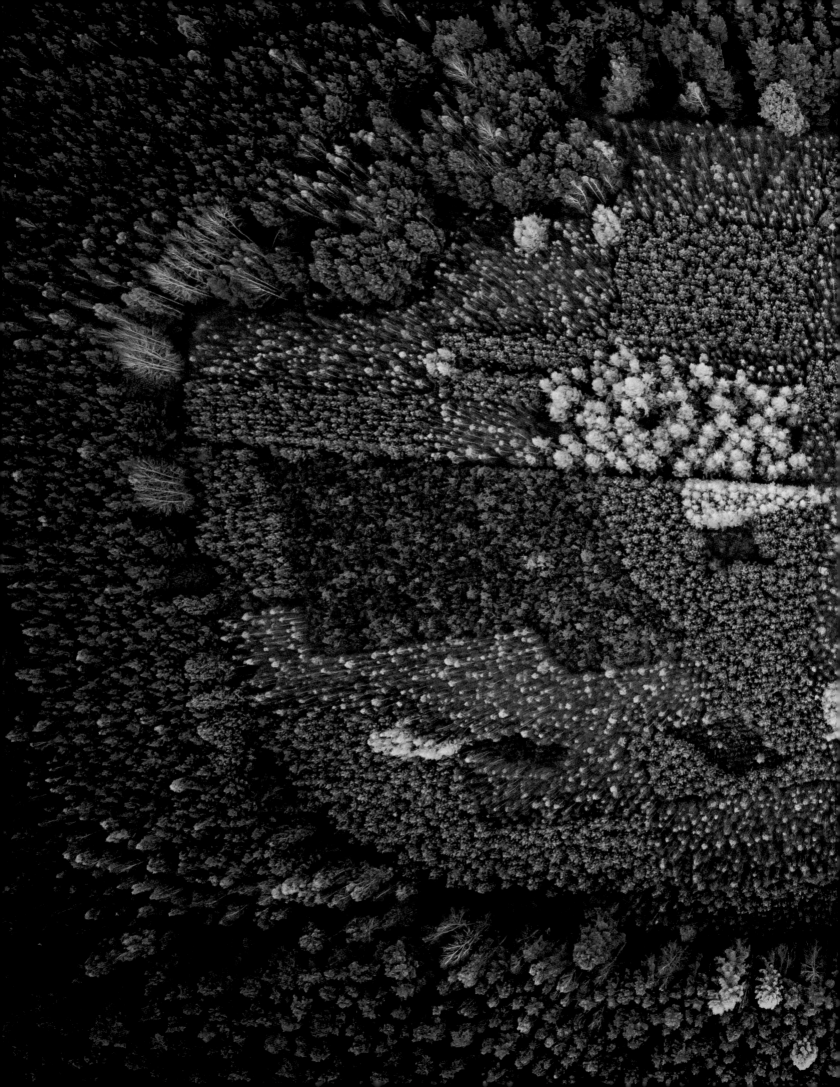

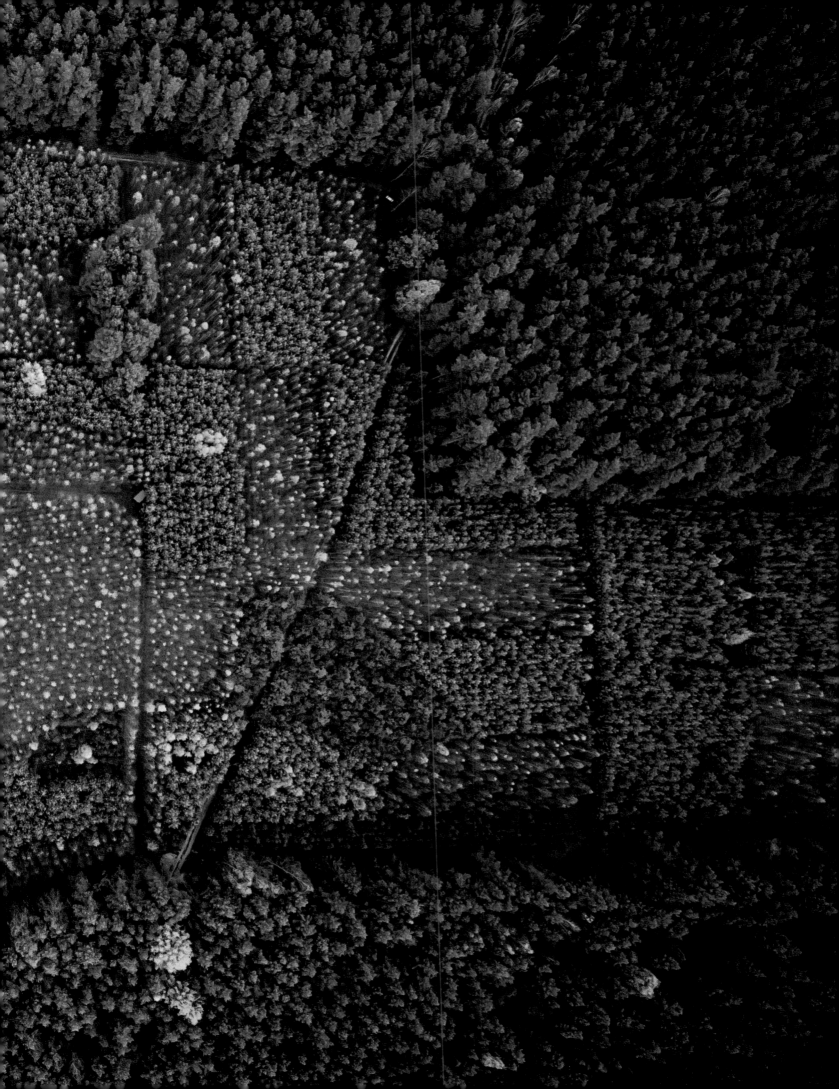

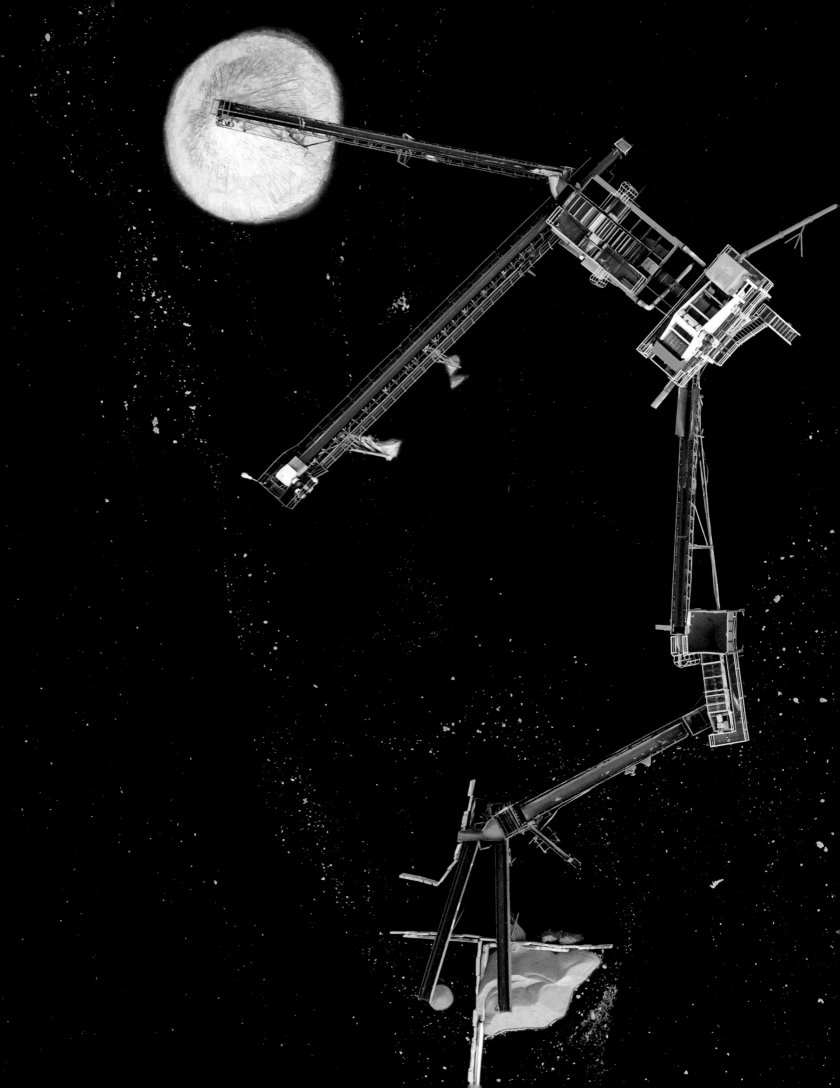

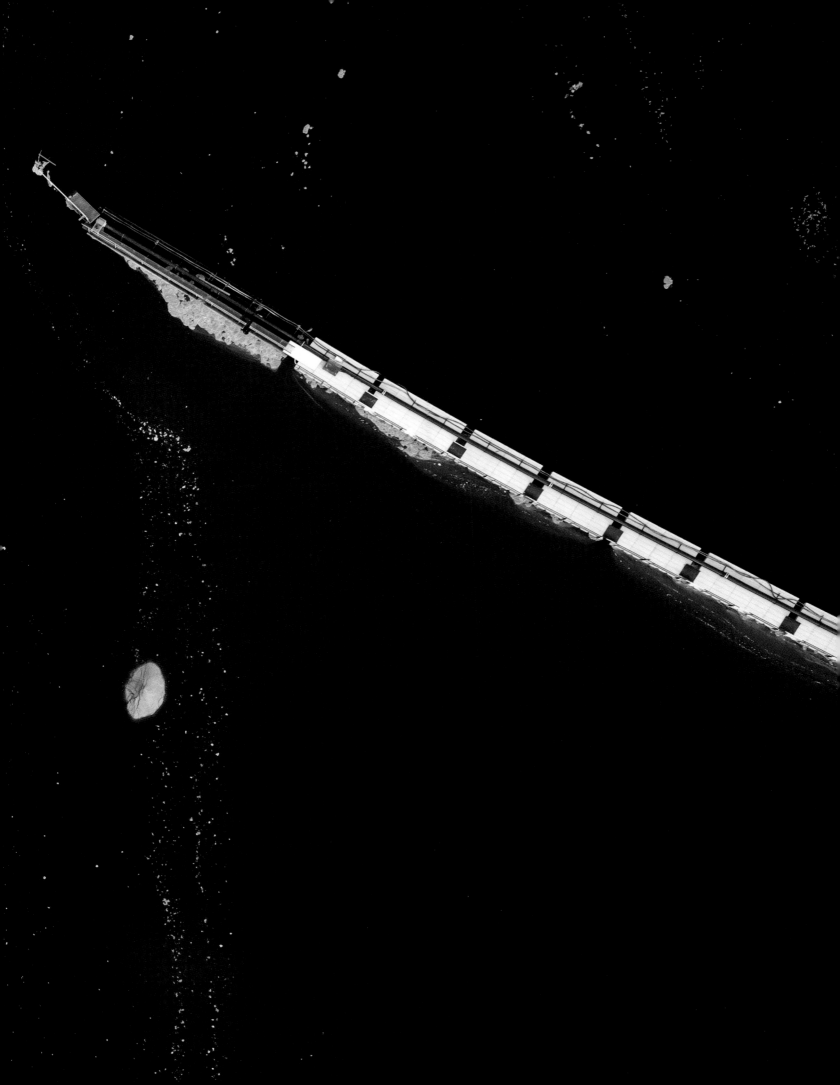

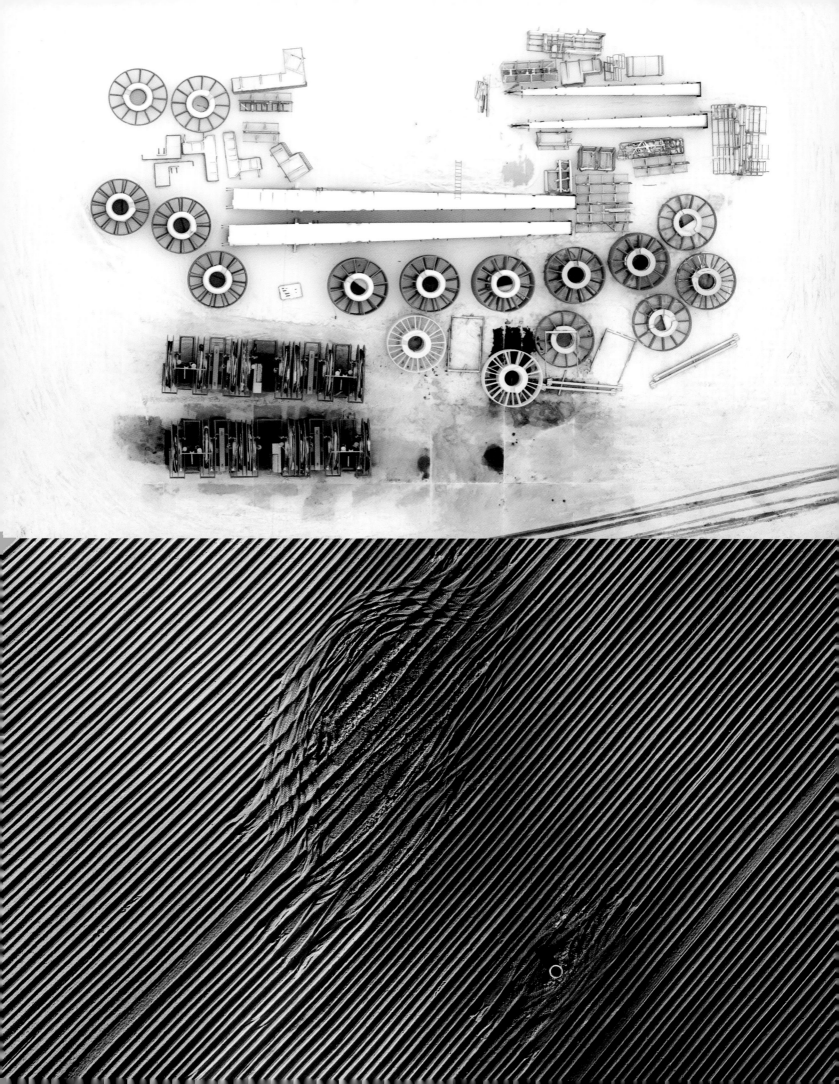

"It is a little as if the viewer is flying together with me, and—just like me during the flight—has no information about what they are looking at. An admiration of form comes before any under-standing of content."

Kacper Kowalski

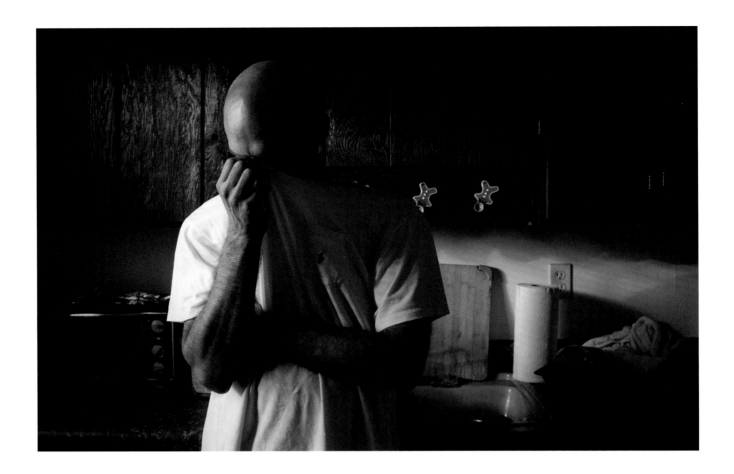

Miracle Village, on the southeast corner of Lake
Okeechobee in South Florida, in the midst of sugar-
cane fields and five miles from the nearest town,
houses a community of 100 sex offenders. It was
set up by an evangelical pastor, Dick Witherow, as a
sanctuary for people he terms 'modern-day lepers'—
subject to lifelong restrictions on their movements,
which often leave them few options of where to live.
Above: Until he was 18, Richard had a bad stutter,
which was worse when he talked to women. He
says that when he discovered internet chat-rooms,
which meant he could communicate without
talking, he felt it was the greatest thing ever.
Facing page, top: Rose is the only female offender
in the community, but says the stigma of being a
sex offender no longer bothers her, and that the men
look to her as a sister. Below: Paul stands outside
on his porch. (continues)

Sofia Valiente / USA, for Fabrica/*The Clewiston News*

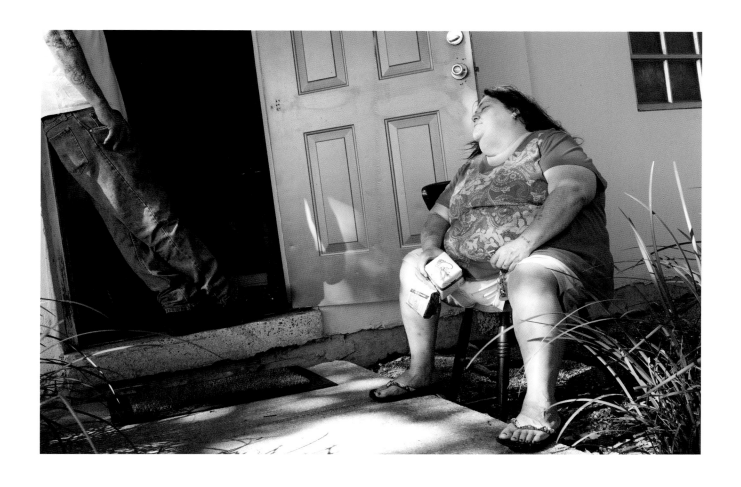

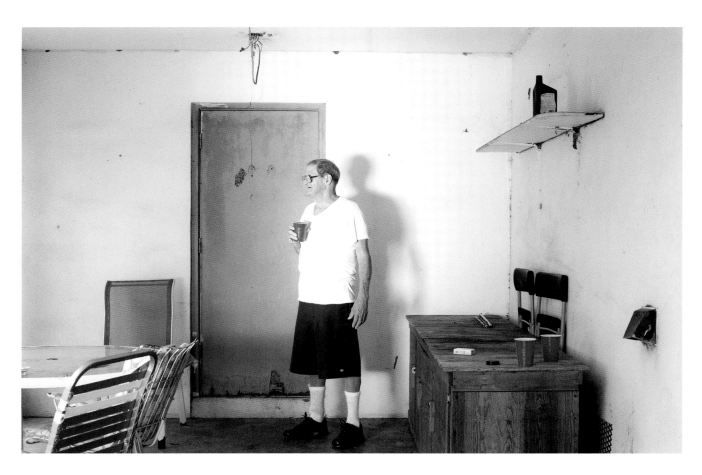

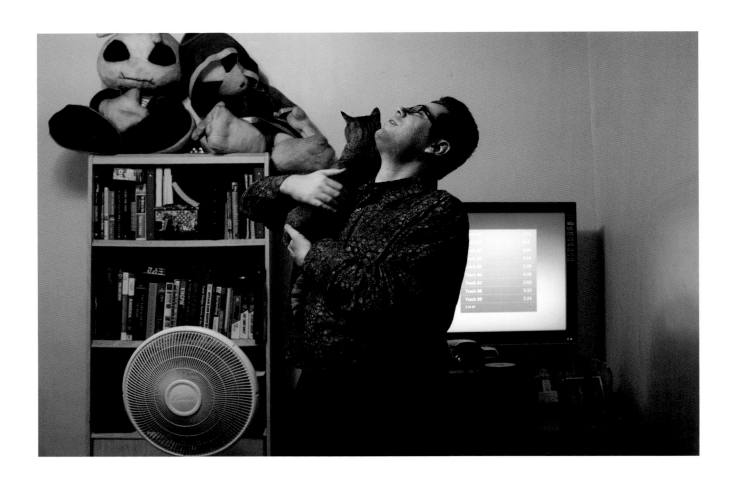

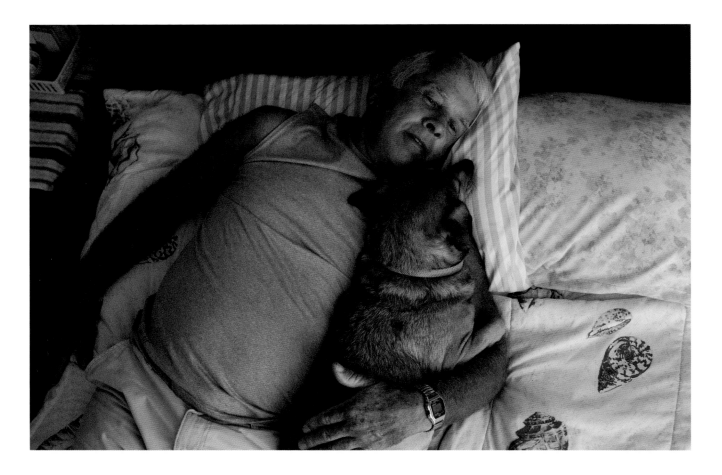

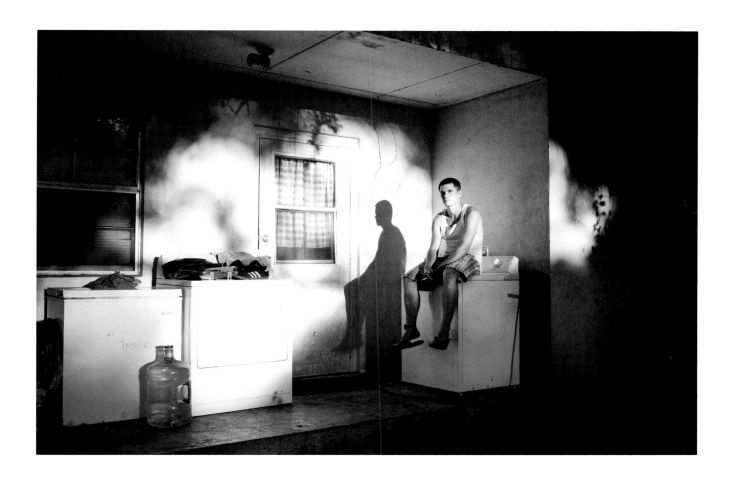

(continued) Residents of Miracle Village include people sentenced for offences such as the possession of child pornography, and a man who at the age of 18 had sex with his 16-year-old girlfriend. Many are tagged with ankle monitors, must obey a nighttime curfew, and cannot own a laptop or mobile phone. Facing page, top: Ben plays with his cat, Cindy, on his day off. He works four days a week at his mother's office, one-and-a-half hour's drive away, and needs to be back for a 10 pm curfew. Below: Gene takes a nap beside his dog, Killer. Above: Doug helps out with gardening and maintenance work around the community. He was unable to go home after serving his time, and lived in a tent in the woods.

Laurinda, a young Kamilaroi girl from Moree, in New South Wales, Australia, plays with her dress as she waits for the bus that will take her to Sunday school. Many disadvantaged communities in Australia face entrenched poverty, racism, transgenerational trauma, violence, addiction, and a range of other barriers to health and wellbeing.

Raphaela Rosella / Australia, Oculi

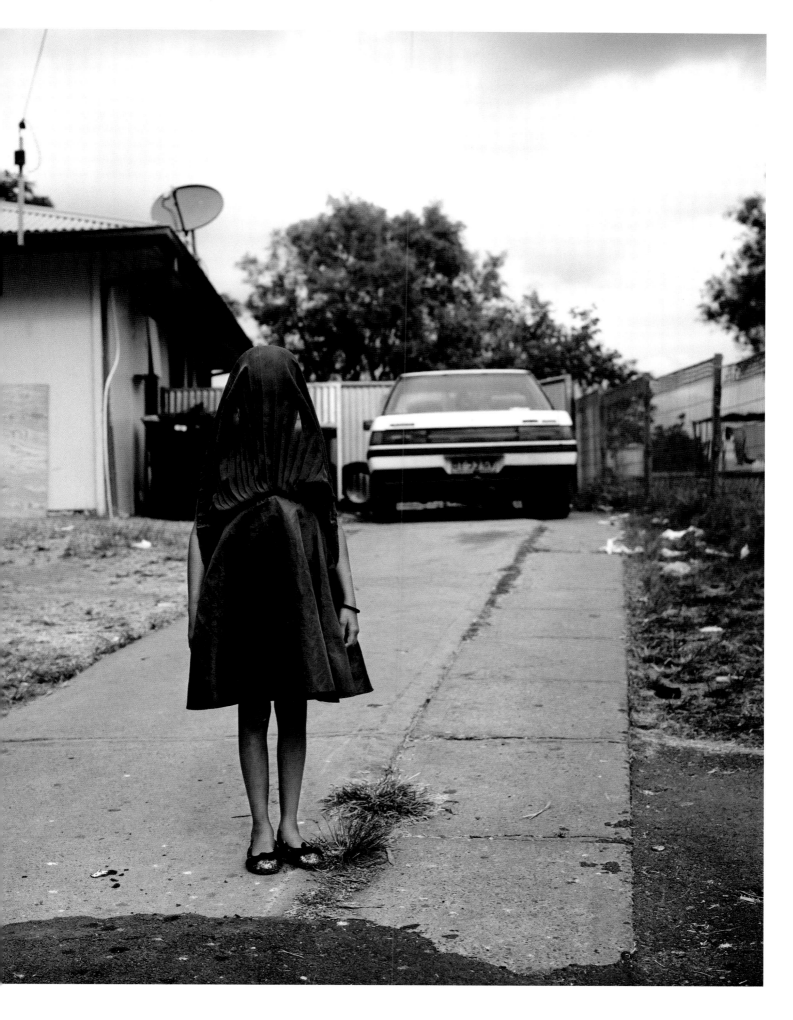

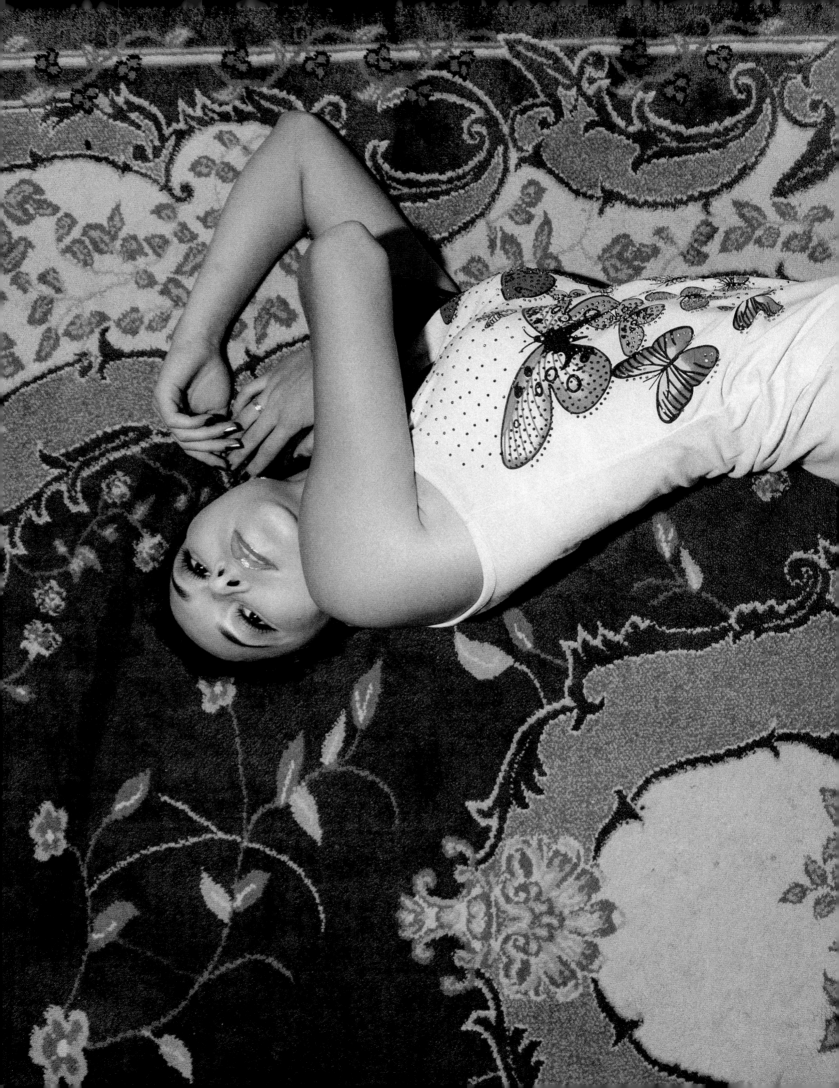

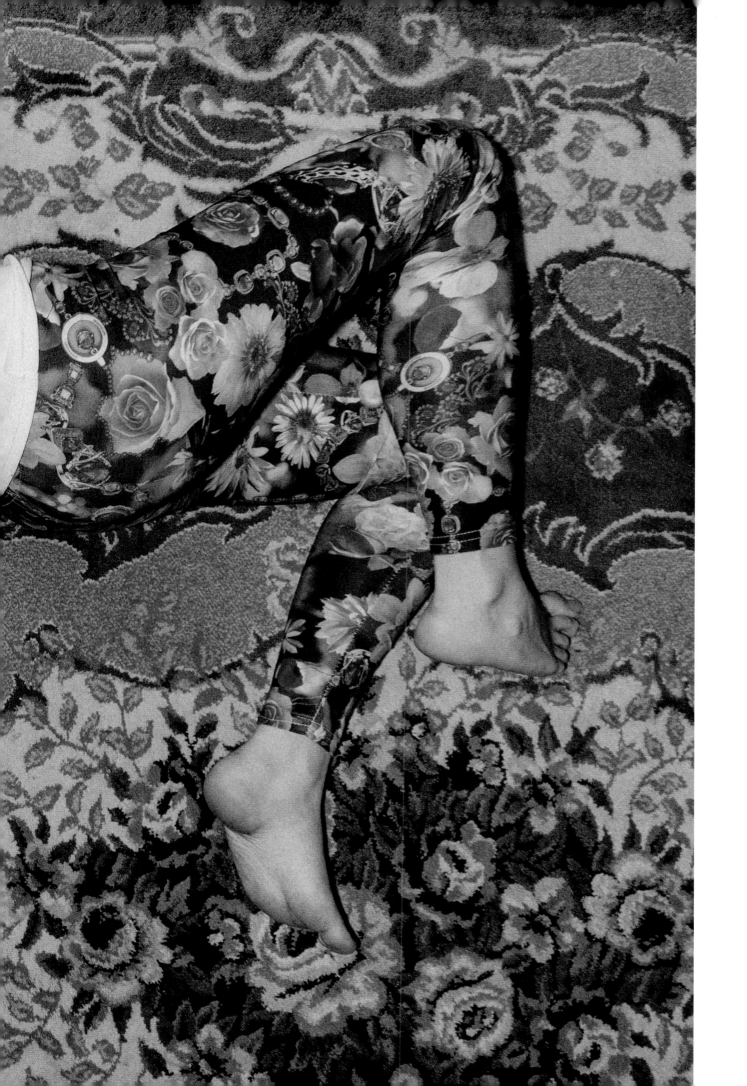

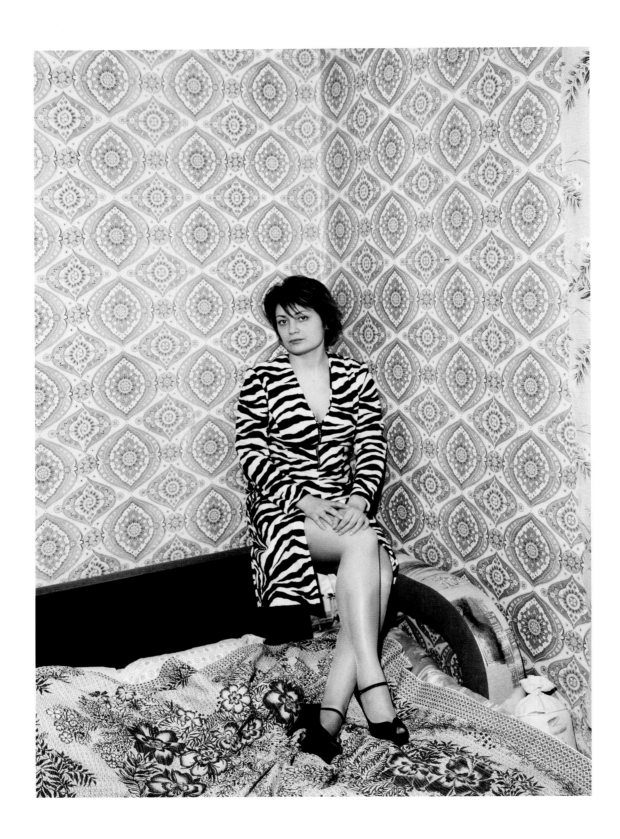

Russian women are portrayed in the interiors of
their own homes, in the moments just before or
after posing for a photograph that would be used
for a dating website.

Andy Rocchelli / Italy, Cesura

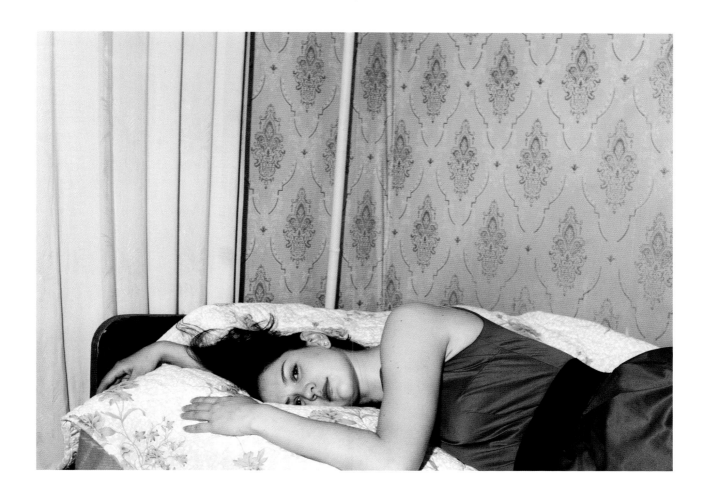

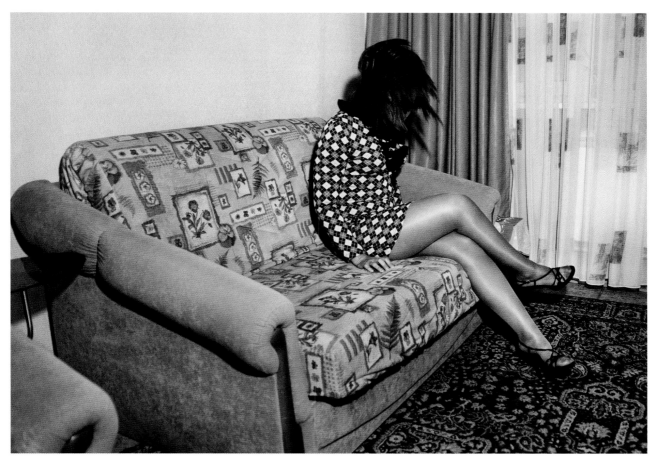

Amorie West, dressed as a disco girl, adjusts her gloves before a Halloween party at her housing complex, on the East Side of San Antonio, USA.

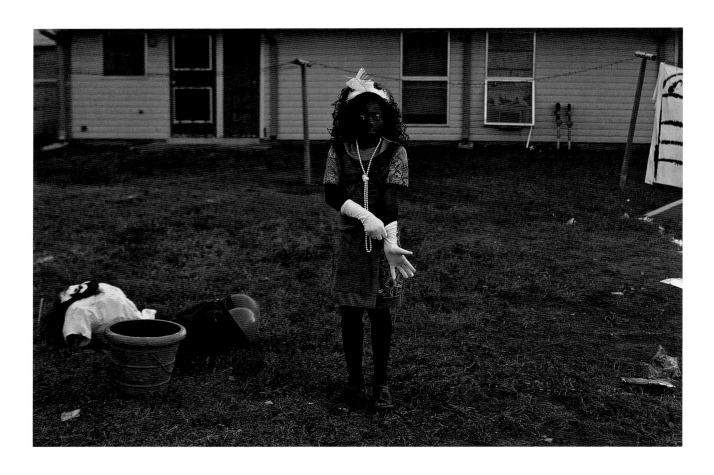

A woman suspected of being a sex worker is held for questioning, at a police station in Chongqing, southwest China. Local residents had complained about sex-workers' cards and leaflets being pushed under their doors. Prostitution is illegal in China.

For centuries, military academies across Europe have upheld traditions of soldierly honor and discipline. Young officers-to-be are schooled not only in matters of combat, but are instilled with a sense of their heritage. Portraits of cadets in some of Europe's most prestigious military academies. Left: Royal Air Force College, Cranwell, United Kingdom. Right: Hellenic Naval Academy, Piraeus, Greece. (continues)

Paolo Verzone / Italy, Agence Vu

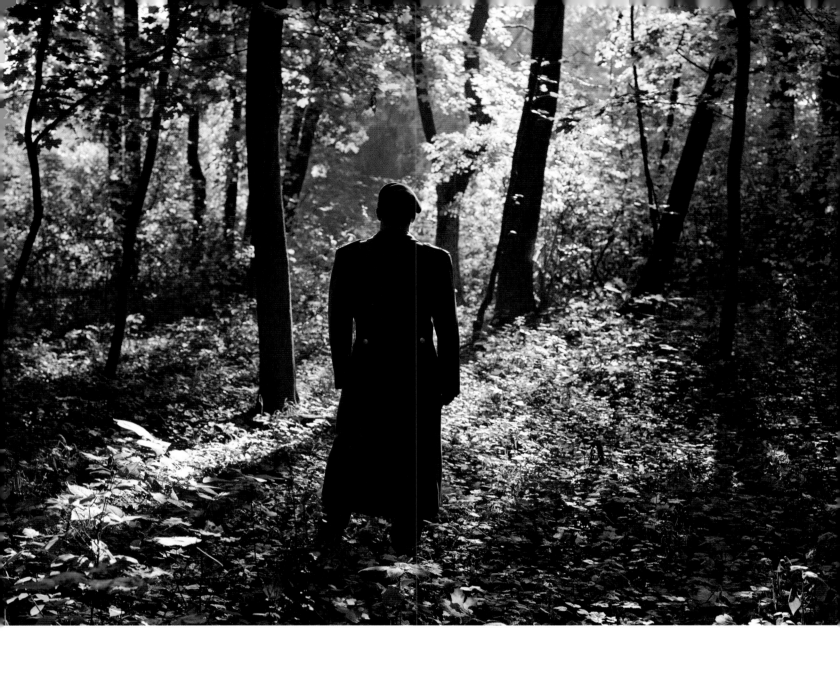

(continued) Portraits of cadets in some of Europe's most prestigious military academies. Left: The Royal Netherlands Naval College, Den Helder, the Netherlands. Right: Theresian Military Academy, Wiener Neustadt, Austria.

"The jury came together, face-to-face in Amsterdam... to engage in the most thoughtful, high-caliber, respectful discussions."

Michele McNally

Photos: Bas de Meijer/Hollandse Hoogte

The 2015 Contest drew entries from around the world: 97,912 images were submitted by 5,692 press photographers, photojournalists, and documentary photographers from 131 countries. The jury spent two weeks in Amsterdam to view all the entries and they gave 45 prizes in eight themed categories to 41 photographers of 17 nationalities, from Australia, Bangladesh, Belgium, China, Denmark, Eritrea, France, Germany, Iran, Ireland, Italy, Poland, Russia, Sweden, Turkey, UK and USA.

Michele McNally
Chair
USA, director of photography and assistant managing editor *The New York Times*

Walter Astrada
Argentina, freelance photographer

Mark Baker
Australia/New Zealand, Southeast Asia photo editor The Associated Press

Patrick Baz
France/Lebanon, photo manager for the MENA region Agence France-Presse

Pamela Chen
USA, editorial director Instagram

Bruno D'Amicis
Italy, photographer

Mariella Furrer
Switzerland, photographer

Peter-Matthias Gaede
Germany, journalist and consultant executive board member Gruner + Jahr

Alessia Glaviano
Italy, senior photo editor *Vogue Italia* and *L'Uomo Vogue*

How Hwee Young
Singapore, regional chief photographer China region European Pressphoto Agency

Bob Martin
UK, photographer

Cristina Mittermeier
Mexico/USA, executive director Sea Legacy

Laura Pannack
UK, photographer

Azubuike Nwagbogu
Nigeria, director African Artists' Foundation

Mikko Takkunen
Finland, associate photo editor *Time*

Munem Wasif
Bangladesh, photographer Agence Vu

Donald Weber
Canada, photographer

David Campbell
Secretary
Australia, writer, professor and producer

Simon Njami
Secretary
Cameroon, independent curator, lecturer and art critic

Maria Mann
Secretary
USA, director international relations, European Pressphoto Agency

About World Press Photo

World Press Photo 15 informs and inspires, helping to create a better understanding of the world through high-quality photojournalism.

In an increasingly visual world—one dominated by imagery—photojournalists and documentary photographers play an important role in giving pictures a meaningful context, and putting stories into a perspective that makes sense. News reports, interactive documentaries, and long-term photo projects appear daily in newspapers, magazines, and on our screens. For 60 years, World Press Photo has been working to support and to advance high standards in photojournalism and documentary photography worldwide.

At a time when you can never be quite sure of the agenda behind an image—of commercial interests or the manipulations of propaganda—World Press Photo strives to bring you photos of integrity, bearing reliable information from independent journalists.

World Press Photo is more than just this book!

→ View this year's complete photo stories, watch interviews with the photographers, and discover more of their work online.

→ Go online, too, to explore our archive and discover thousands of stories in a collection of news and reportage that goes back 60 years. Then make your own fan board to share your favorites.

→ Follow us on Facebook and Twitter to get updates of our activities, and to give us feedback on the exhibition.

→ Visit one of our exhibitions! The World Press Photo 15 exhibition will tour to 100 cities in 45 countries around the world. The tour will conclude only after next year's winners are announced.

www.worldpressphoto.org

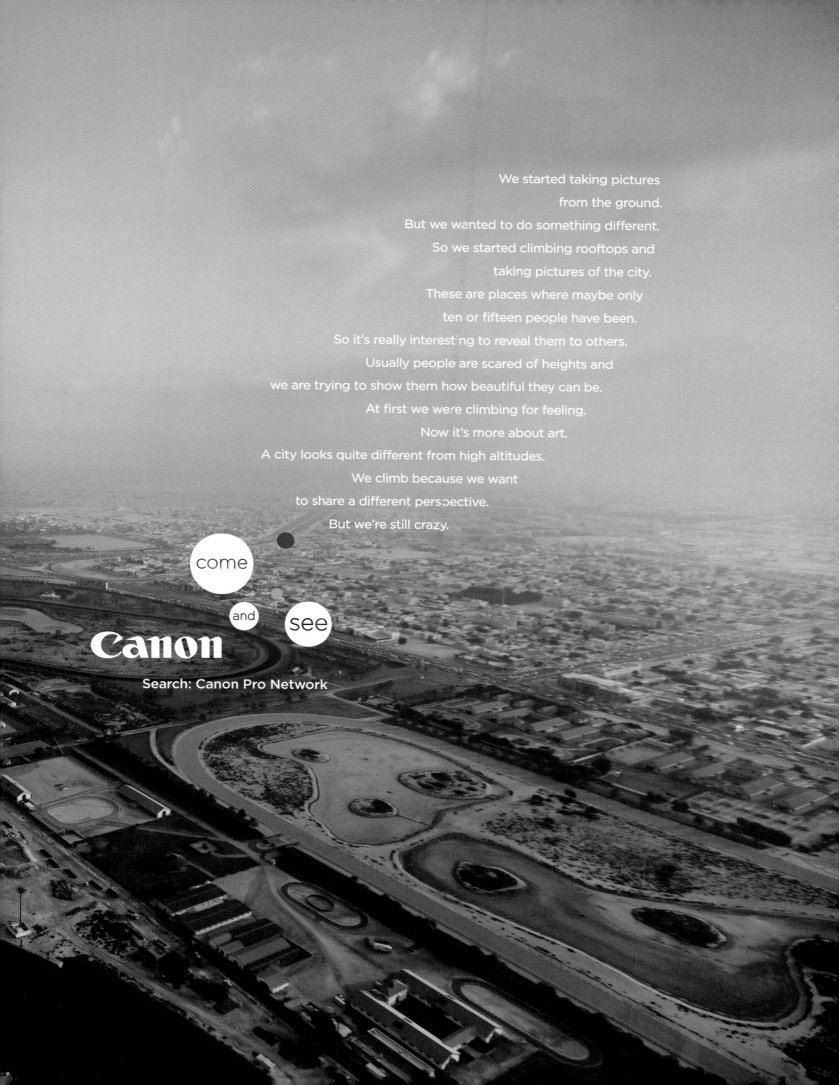

We started taking pictures
from the ground.
But we wanted to do something different.
So we started climbing rooftops and
taking pictures of the city.
These are places where maybe only
ten or fifteen people have been.
So it's really interesting to reveal them to others.
Usually people are scared of heights and
we are trying to show them how beautiful they can be.
At first we were climbing for feeling.
Now it's more about art.
A city looks quite different from high altitudes.
We climb because we want
to share a different perspective.
But we're still crazy.

come
and
see

Canon

Search: Canon Pro Network

Copyright © 2015
Stichting World Press Photo, Amsterdam,
the Netherlands
Schilt Publishing, Amsterdam, the Netherlands
All photography copyrights are held by
the photographers.

First published in Great Britain in 2015 by
Thames & Hudson Ltd,
181A High Holborn, London WC1V 7QX
www.thamesandhudson.com

First published in the United States of America
in 2015 by Thames & Hudson Inc.,
500 Fifth Avenue, New York, New York 10110
thamesandhudsonusa.com

Art director
Teun van der Heijden
Advisor
David Campbell
Design
Heijdens Karwei
Production coordinators
Anaïs Conijn
Femke van der Valk
Picture coordinators
Noortje Gorter
Jurre Janssen
Anna Lena Mehr
Thera Vermeij
Captions
Rodney Bolt
Editorial coordinators
Manja Kamman
Laurens Korteweg
Jennifer Noland
Editor
Kari Lundelin

Color management
Andre Beuving
Eyes On Media, Amsterdam, the Netherlands
www.eyesonmedia.nl

Paper
BVS FSC Mixed Credit 150 grams, cover 350 grams
Papierfabrik Scheufelen GmbH, Lenningen,
Germany
www.scheufelen.com
Print & Logistics Management
KOMESO GmbH, Stuttgart, Germany
www.komeso.de
Lithography, printing and binding
Offizin Scheufele, Stuttgart, Germany
www.scheufele.de
Production supervisors
Maarten Schilt
Yasmin Keel
Schilt Publishing, Amsterdam, the Netherlands
www.schiltpublishing.com

ISBN 978-0-500-97066-9

This book has been published under the auspices
of Stichting World Press Photo, Amsterdam,
the Netherlands.

World Press Photo
World Press Photo is run as an independent, non-profit organization with its office in Amsterdam,
the Netherlands, where World Press Photo was founded in 1955.

Patron
HRH Prince Constantijn of the Netherlands

World Press Photo holds the official accreditation for good practices from the Central Bureau on
Fundraising (CBF).

**World Press Photo receives support from the Dutch Postcode Lottery and is sponsored worldwide
by Canon.**

*Canon has been a corporate partner of World Press Photo since 1992 and even though the nature in
which journalists tell their stories continues to evolve, images are still as important and influential
now as they have always been. Canon's longstanding relationship with World Press Photo is fuelled
by Canon's passion to empower anyone to tell a story.*

Supporters
Ammodo Foundation • Asahi Shimbun • Delta Lloyd Group • Deutsche Bahn • Mondriaan Foundation •
The Netherlands Ministry of Foreign Affairs

Contributors
Associates of World Press Photo
Acquia • Allen & Overy • Aris Blok, Velsen-Noord • The Associated Press • Capgemini • DoubleTree by
Hilton Hotel Amsterdam • Drukkerij Mart.Spruijt • Fiat Group Automobiles Netherlands B.V. • Human
Rights Watch • ING Bank • Insinger de Beaufort • NDP Nieuwsmedia • Protocolbureau • Schilt
Publishing • SkyNet Worldwide Express • Stichting Sem Presser Archief • Unique • VCK Logistics

Office
World Press Photo
Jacob Obrechtstraat 26
1071 KM Amsterdam
The Netherlands

Tel. +31 (0)20 676 6096
Fax +31 (0)20 676 4471

office@worldpressphoto.org
www.worldpressphoto.org

Managing director: Lars Boering

For more information about World Press Photo and the prizewinning images, for interviews with the
photographers, and for an updated exhibition schedule, please visit: www.worldpressphoto.org

On the front cover
Mads Nissen, Denmark, Scanpix/Panos Pictures
'Jon and Alex during an intimate moment,
St. Petersburg, Russia'
World Press Photo of the Year 2014

On the back cover
Massimo Sestini, Italy
'Refugees on a boat off the Libyan coast'

Medicine
at a Glance

EDITED BY

PATRICK DAVEY

Consultant Cardiologist
Northampton General Hospital
Northampton, and
Honorary Senior Lecturer
Department of Cardiovascular Medicine
John Radcliffe Hospital
Oxford

Blackwell
Science

© 2002 by Blackwell Science Ltd
a Blackwell Publishing company
Blackwell Science, Inc., 350 Main Street, Malden, Massachusetts 02148-5020, USA
Blackwell Publishing Ltd, 9600 Garsington Road, Oxford OX4 2DQ, UK
Blackwell Science Asia Pty Ltd, 550 Swanston Street, Carlton, Victoria 3053, Australia

First published 2002
Reprinted 2002
Reprinted with corrections 2003

ISBN 0-632-05893-5

Catalogue records for this title are available from the British Library and the Library of Congress

Set in 9/11^{1}/$_2$pt Times by Graphicraft Limited, Hong Kong
Printed and bound in Italy by G. Canale & C. SpA, Turin

Commissioning Editor: Fiona Goodgame
Editorial Assistant: Vicky Pinder
Production Editor: Jonathan Rowley
Production Controller: Kate Charman

For further information on Blackwell Science, visit our website:
www.blackwellpublishing.com